Designer
Women

made by God

Dear Mary Anne —
Love to meet you. I send
this to you encouraging you to
stand as a PILLAR in
God's Kingdom!
Lovingly,
Ruth

Ps. 144:12 b

6/14/13

Ruth Tuttle Conard

Designer Women

made by God

Authentic

COLORADO SPRINGS • MILTON KEYNES • HYDERABAD

Are women today all that different from the women in the Bible? This wise, compassionate book written about biblical women, by a woman, is for both women and men. It is particularly significant for Christians today when the role of women is still controversial. As the author's own fruitful life interfaces with the stories of women in Scripture, we gain profound insights about God's purposes and plans for women and their vital significance in human society.

LUCI SHAW
Writer in residence at Regent College and author of *The Crime of Living Cautiously* and *Breath for the Bones*

With fresh and imaginative insight Ruth Tuttle Conard brings the lives of more than ten women of the Bible to life. Never before had I reflected as deeply about the lives of these women as I have after reading Ruth's excellent book, *Designer Women*. I was left with the belief that each of them deserves a place right alongside the male heroes of the faith we have admired for so long.

Thank you, Ruth, for inviting us into your heart and into the lives of these women of God. And thanks for living what you write about and for raising daughters who themselves are strong pillars.

JOE BOERMAN
Senior pastor, Immanuel Church, Gurnee, Illinois

Ruth Tuttle Conard is God's kind of feisty women! And she has introduced us to all sorts of energetic and exuberant women of the Bible—women who have much to give us today and whose lives will inspire us to courage, faith, honesty, and grace. Every mother, daughter, sister, wife, grandmother, aunt, friend, and mentor should read this.

VINITA HAMPTON WRIGHT
Author of *Dwelling Places* and *Days of Deepening Friendship*

Women of all ages can see themselves in the pages and stories of *Designer Women*. As I read these pages I was encouraged again to let it be the One who created me and loves me to define me and my life's purpose—not culture or tradition, but through God's own revelation in Jesus Christ, through the Holy Spirit and the Scriptures. The biblical stories in *Designer Women* point to our purpose as women as well—to be disciples, yes followers, of Jesus Christ. *Designer Women* finds real life, by giving up self-absorbed and self-protective ways to take on Christ's way, his truth and his way of life—counter-cultural and courageous in any age. Our worship and praise go to God.

JEAN L. LEIH
Founder of Restoration Ministries

Ruth brings a needed perspective about women to the genre of character studies from the Scriptures. Her insights are solid, heartfelt, creative, and inspiring. She makes these women's lives come alive in significant ways. Take a fresh look at the Scriptures through the eyes of these women and enhance your Christian spiritual journey.

DR. RONALD W. SAARI
Senior pastor, Central Baptist Church, St. Paul, Minnesota

DEDICATION

To my daughter
Christina Colleen Davis
who follows hard after God
and
to my sisters around the world
who actively pursue the Way

Authentic Publishing
We welcome your questions and comments.

USA 1820 Jet Stream Drive, Colorado Springs, CO 80921 www.authenticbooks.com
UK 9 Holdom Avenue, Bletchley, Milton Keynes, Bucks, MK1 1QR
 www.authenticmedia.co.uk
India Logos Bhavan, Medchal Road, Jeedimetla Village, Secunderabad 500 055, A.P.

Designer Women
ISBN-13: 978-1-934068-75-5

Copyright © 2008 by Ruth Tuttle Conard

10 09 08 / 6 5 4 3 2 1

Published in association with the literary and editorial agencies of Sanford Communications,
Inc., 16778 S.E. Cohiba Ct., Damascus, OR 97089, www.sanfordci.com

A catalog record for this book is available through the Library of Congress.

Cover and interior design: projectluz.com
Editorial team: Bette Smyth, Dan Johnson, Michaela Dodd

Printed in the United States of America

ACKNOWLEDGMENTS

This book began as the work of many women. *Designer Women: Made by God* was a vision that became reality in a medium-sized church in the western suburbs of Minneapolis. It germinated, grew, and blossomed with an energetic, creative, God-seeking, fun-loving team of women. I couldn't have wished for a better, more dedicated team than that one! To all of you, thank you!

But I would be remiss not to mention by name Heidi Hoard and Margaret Terry, whose seeker views and literary prowess refined my own expressions; Andrea Hebeisen, Karla Larsen, Heidi Dick, Pam Christiansen, Jill DiLoreto, and Linda Pellmann, whose encouragement, graphic expertise, and technical acuity made each week powerful.

Designer Women

For several weeks, hundreds of lives were blessed and changed as we pored over the stories of ten women in the Word of God—women very much like you and me—with reflection and prayer in small groups after each message.

Also, I'm so grateful for the patience, kindness, and continued encouragement of Sanford Communications, Inc., especially for David and Renée Sanford, Rebekah Clark, Elizabeth Jones, and Elizabeth Honeycutt. Without them, this book would not have had a beginning or a life. A special thank-you to Alison K. Littauer, working in the library of Gordon-Conwell Theological Seminary in Charlotte, North Carolina, whose adeptness and presence of mind saved me from imminent disaster at the close of my research time.

And to the wonderful people at Authentic/Paternoster Publishing—thank you for making this possible! Especially to my editor, Bette Smyth, whose patient questions stretched this writing into something worth reading, and to Dana Carrington for her very creative guidance and bright spirit.

My deepest thanks to Bill, my husband, friend, and soul companion, for the joy of his participation with me on this special journey, searching out the breadth and depth of God's love and acceptance. To Melody and Steve, Timothy, and Christina and Kelly, who have also walked with me, laughing and applauding, and at other times, weeping and praying—thank you, dear children, my friends. This humble book would look very different without the love of you six!

May all glory and praise rise to the triune God and to the Word of God—a lamp on our path, a light in our darkness, a joy for our mournings.

CONTENTS

My Own Journey

When I pick up a book, I often wonder how the author arrived at this point in her life. As for me, I have been on a long journey to find a "consistent" God for women. I accepted Jesus into my life at a very young age and was baptized. I loved God, Jesus Christ, the Holy Spirit, the mission of the church, and the church family, which was like my own family. And why not? It was composed of a lot of my relatives. I followed that path of love for God by dedicating my life to missionary service and immersing myself in Christ's Word and teachings.

But something happened. When I was twelve years old, a gymnastics teacher saw that I had scoliosis of the spine—one shoulder protruded and the curve in my spine was obvious. My mother took me to a specialist who greatly encouraged us by saying there was

nothing he could do and that by forty years of age I would probably be crippled, literally bent out of shape. Praise God, through prayer, I believe, the growth stopped within six months. I still have one shoulder larger than the other and a curving spine, but that specialist's prognosis never came true.

With that discovery, I was suddenly relieved about one thing: I would *never* have to do gymnastics again. I hated gymnastics. Even at the age of twelve, I was tall and ungainly. My normal-sized friends seemed to hit that mat and bounce up again like it was a fluffy, down-filled springboard. To me the mat looked like it was seven feet below me and once down . . . forget it! There was no way I could just bounce up. I had to unwind my legs, think about positioning my arms and hands in a proper position to hold my weight so I could struggle to my feet. So, I was overjoyed—no more hoops, trampolines, bars, or balancing acts.

But never did I dream that the most painful gymnastics for me would take place in a much larger and totally unexpected arena, the arena I loved most dearly: the church.

For me, one "hoop" had to do with the head covering of 1 Corinthians 11. In some churches I had to wear it if I sang or played the piano. In others, no. In some places, I had to wear it if I spoke, even if speaking only to women. In others, no. In some I had to wear it even though I was expected to sit quietly, not permitted to say a word. And in other churches what was on a woman's head had nothing to do with anything at all. No one seemed to care.

Then there were the questions that always plagued me regarding spiritual gifts, as well as the part women could, would, and should play and *had* played in the church. To these questions, two answers

were normally given. Of course, they were always given in a most thoughtful manner.

One answer was, "That is a *theological* question." The word *theology* (which simply means the study of God) became like a wall that I could never and, in my mind, should never even attempt to scale. Something that was too wonderful for me, that only certain types of people could ponder. Obviously, I was not one of them.

The second answer was, "Well, Ruth, you know the *Greek* says. . . ." I realized sometime ago that actually many of my questions had to do with an era before the Greek language appeared. It was Hebrew that held the answers. But the Greek language also became a perceived barrier for me in understanding God and women.

These answers, along with divergent church practices, became like huge bars on which I slipped and slid. Eventually, the struggles filled my mind with an enormous, resounding *No! No!* to questions. *No!* to what I sensed were the gifts God had given me. *No!* to the exuberant joy I had felt in walking with Christ since childhood. And, oh so sad, *No!* to the missionary spirit God had sewn into my very being.

Why, I reasoned, *should I invite other intelligent, gifted women into the church only to have their fervent, creative, God-given hopes squelched?* Life became burdensome, the light in my eyes fading, the curtains of my soul closing. Hope diminished.

God never left me. He would not leave me in the pit of despair. His love and compassion reach even there. He gave me friends with a broader perspective. The faculty, staff, and students of Bethel University and Seminary met me at the crossroads of my life, replacing those darkened curtains with hope-filled vistas. God led me to

books that flowed from the wisdom of his Word and fed my very being. He took me through experiences and life affirmations that expressed his deepest desire for all women—"our daughters will *be like pillars* carved to adorn a palace" (Psalm 144:12, emphasis added).

I have found a consistent God!

- Consistent in his love and esteem for women
- Consistent in redeeming us from the curse
- Consistent in acknowledging us as responsible and dependable disciples
- Consistent in gifting us with the gifts of his choice
- Consistent in calling us to minister with him, alongside our brothers
- Consistent in blessing us with love unimaginable and the outpouring of his Holy Spirit

So, come along with me and find that the Scriptures lift high God's design for us, God's blessed daughters, *designer women*, made intentionally, lovingly by God, and *pillars* in his kingdom.

Blessings and great hope be yours,
Ruth Tuttle Conard

Part I

God Values Women in the Old Testament

INTRODUCTION

Imagine for a moment that you are on your way to a spa for a day of relaxation and pampering. You can't wait to walk through the door. You've seen the fancy advertisements. Your friends have described the "out of this world" atmosphere that awaits you, plus the incredible treatment you'll receive. You expect to come away from this experience refreshed, rejuvenated, and feeling like a queen.

You push open the iris-motif, frosted door and step inside. The deep, scintillating aroma of green tea fills the air. Dimmed lighting creates an incredible ambiance as gentle music wafts through a lacy grapevine ceiling. It's everything you imagined! You long to kick off your shoes, take a seat, and relax. A kind voice welcomes you while a fluffy robe is placed on your shoulders.

"Just push back the curtain and walk straight down the hall," the voice gently urges. You are more than ready to follow the instructions. The velvet curtain falls into place behind you as you pass through.

But, hey, wait a second. What just happened? Who turned out the lights? Where's the music? It feels cold. Immediately, you realize that this area doesn't seem at all like the cozy foyer. It's immense. Lonely. There's too much haze in the air. And where's *your* special room? Did you miss something? What just became of the prospect and promise of feeling like a queen?

The above scenario describes what I used to feel about leaving the beautiful biblical foyer of God's plan in the first two chapters of Genesis and heading out into the uncertain and unexplained vastness of the Old Testament. No one ever explained to me why I felt such shock at the seeming change of landscape, so I'm here to help you on your journey.

For me, there was such overwhelming evil during Old Testament times. Too much manipulation, domination, and competition between men and women, too much emphasis on the body, too much slugging it out (in Old Testament maneuvers and customs) just to get a man. And way too much concern about the womb and what the sex of an emerging baby might be. And what about all the laws against women?

First, we must continually remind ourselves that between the foyer of God's original plan (Genesis 1–2) and the vast outlay of the Old Testament lies the narrow, dark hallway of Adam and Eve's sin (Genesis 3). God loved them so much that he gave them the opportunity to choose. And they chose to follow their own willful desires instead of an intimate, obedient, loving experience with their Maker

and with one another. Their choice taints all the rest of Scripture's pages, as well as our own lives today.

The results of their choice, described by God in Genesis 3, are carried out within the context of the patriarchal system that formed the parameters of their society. Patriarchy, says *Webster's* dictionary, is a social organization marked by the supremacy of the father in the family or clan. Wives and children are legally dependent on him, and the flow of descent and inheritance pertains to the male line.

The language used in Old Testament law supposes a patriarchal society. There are many instances of this in the book of Deuteronomy. The household belonged to the man. The man initiated a divorce. In the area of inheritance, there was a significant difference between the status of sons and daughters. Property, family name, and children were all owned and given from the father to sons, not to daughters.[1]

However, the law does not depersonalize women: women, as well as men, are held responsible for violations of criminal law; mothers, as well as fathers, are to be honored by their children. While there are few examples of equality between spouses, real affection did exist between many husbands and wives, as well as fathers and daughters. In the patriarchal structure of the Old Testament, men were responsible for the well-being of their families. Many of the Mosaic laws (which today may seem ridiculous to us) were for the protection and health of nomadic women and their families in severe desert conditions.[2]

The main point to remember is that *the law was not developed to make a statement about male-female relationships. The patriarchal system and male domination did not exist because God favored one sex over the other.* The law was given so that the Israelites would be recognized as God's people, no longer belonging to Pharaoh.[3]

Sin had corrupted the relationship between Adam and Eve, as it had corrupted all things. "The situation of women reflected in these stories is a powerful witness to the truth of God's revelation to Eve of certain consequences of the Fall. It is sin, not God's will, that is displayed in the way women were viewed and treated at that time. When God told Eve 'and he will rule over you' (Genesis 3:16), the Lord was not revealing the shape man/woman relationships *should* take, but rather the shape sinful human societies would impose on womankind."[4]

Second, we must remember that God is completely faithful. He keeps each and every one of his promises. What he promised in Genesis 3:15—to send someone (Jesus Christ) to crush the success of the one (Satan) who had tempted Adam and Eve and won their allegiance—he would and did accomplish.

Thousands of years later, God fulfilled his promise. Jesus was born to Mary. He lived and preached, "The time has come. . . . The kingdom of God is near. Repent and believe the good news!" (Mark 1:15). He did many miracles, suffered, died, and rose again, victor over Satan and sin. The whole New Testament resonates with the theme: "For God so loved the world that he gave his one and only Son, that whoever believes in him shall not perish but have eternal life" (John 3:16). This is what we must keep in the forefront of our minds as we read the Old Testament.

Yet, despite all the devastation, God's *redeeming, initial plan* continued to emerge. For among the many women pictured in the Old Testament, not all were consumed by custom, body-centered mania, and fear of men. No, God kept sending bright and glorious shafts of light into the gloom of Satan's insidious lies. It was as

though God kept saying, "Hello. Remember the initial plan? Here is a good example of it." These women, as leaders and strong examples in varied facets of life, did not act because there were no good men, but rather because *they were good women*, created in God's image, gifted by God, and working in obedience with their Maker.

Throughout the entire Old Testament, there are God-infused, courageous women of strength, pillars in home, society, and faith communities. Think about a few of them:

- Strong in faith—the widow at Zarephath in 1 Kings 17:15
- Strong in ideals and family values—as portrayed in Hebrews 11:23
- Strong in courage—the midwives Shiphrah and Puah in Exodus 1:15–17
- Strong in good deeds—the Shunammite woman in 2 Kings 4:9
- Strong in wisdom—Abigail in 1 Samuel 25:32–33
- Strong in knowledge—the mother of King Lemuel in Proverbs 31
- Strong in public worship of God—Miriam in Exodus 15:20–21
- Strong in leadership—Deborah in Judges 4:4
- Strong in prophecy—Huldah in 2 Chronicles 34:22
- Strong in prayer—Hannah in 1 Samuel 2:1–10
- Strong in saving their nation—Esther in Esther 7 and Jael in Judges 5
- Strong in creativity—Jochebed in Exodus 2:3
- Strong in suffering—Hagar in Genesis 16:9
- Strong in standing for their rights—daughters of

Zelophehad in Numbers 27:4

* Strong in willingness to die for faith—Hebrews 11:35

These are the foremothers of all the women we celebrate within the pages of the New Testament: Mary, Elizabeth, Anna, Dorcas, Priscilla, and a myriad of others. And they are *my* foremothers and *your* foremothers with much to teach us. Theirs was an ancient culture, so distinct and difficult for us to understand thousands of years later. Yet the God of Eve was with all of these women. And God, the original designer of Genesis 1 and 2, moved among them, accomplishing his eternal purposes of which we are the blessed recipients today.

As you read the following accounts of Old Testament women, rejoice in God's continual love, guidance, and gifting of women down through the centuries. And still today, the Spirit of God's love and leading pours over each one of us.

As you study these vibrant accounts of our courageous foremothers, may the words and actions from God's living Word refresh your outlook, rejuvenate your being, rekindle your passion, and fill you with hope and courage in the midst of our own unbridled and unpredictable world. As the author of Hebrews wrote, "Jesus Christ is the same yesterday and today and forever" (Hebrews 13:8).

DESIGNED TO BE LOVED

Eve

New beginnings. Yes, they can be daunting, but then again, they can be wonderfully energizing. A clean white page for writing. A renewed relationship. The soft green of an awakening spring. The sparkling white of fresh snow. Signs of a new beginning give me hope.

There have been times in my life, however, when I've lost all hope of even the possibility of beginning anew. Several years ago, soon after we moved to Minnesota, life for my husband, Bill, and me hit a seemingly impossible brick wall—one of those kind of circumstances where you grab your head in your hands, rock back and forth, and groan, "I'm finished!"

We've had orchids in our home since Bill began raising them in the early 1970s while we were serving as missionaries in colorful Peru, South America. Orchids normally blossom only once a year.

Beautiful, exotic blooms last from two to three months; then the plant is dormant for the next nine to ten months.

During our time in Minnesota, we had an orchid that had not bloomed for about three years. Frankly, I was very tired of cleaning around it. This orchid had been removed from its glorious glass shelf to a remote, dark corner of the dining room. I distinctly remember getting down on my hands and knees to check it out and threatening, "Look, if you don't produce, just between you and me, you are out of here!"

A couple of weeks later I looked again. Were my eyes seeing things? It seemed like I saw just the tiniest tinge of pale green among the sticks. Or was it mold from sitting around too long? When Bill arrived home from work, I called him over to the table. And I asked him, "Do you see what I see?" He managed, without much enthusiasm, to tentatively concur that just perhaps there might be the slightest possibility of some minute growth.

Amazingly enough, that plant began to grow again. I said to Bill, "This is a sign from our loving God that he is restoring hope to our lives. We *do* have a future, and we *do* have a new day coming. God has not abandoned us." We both laughed . . . Bill a little more nervously than I, because I am into signs and wonders somewhat more than he is.

The day came when that orchid sent out a shoot and the heads of blossoms began to form. Eventually those blossoms opened. We thanked God. Every time a blossom fell, a new one formed. And you know what? Almost in pace with the blooming of that plant came new opportunities in our lives.

The orchid kept blooming . . . not for just three months, not even for six. It eventually passed the twelve-month mark. We watched in amazement. The plant was soon into its fifteenth month of blooms. This plant was truly what you'd call a "bloomin' idiot." For eighteen months, that orchid put out white blooms, fresh and exotic. Our God *is* a God of new beginnings. For him there is nothing impossible.

So let us journey into the topic of courage. There is no better place to begin than with God, the originator of *all* beginnings, and with Eve, the first woman who so needed a fresh start. How did she have the courage to tell God the truth about her actions? Or does it have a lot more to do with God than with Eve?

Don't we need a fresh understanding of God and who he is for us as women?

"In the beginning God" (Genesis 1:1). The Bible begins with four amazing words. Most likely, Moses received these carefully inspired words from God on Mount Sinai after bringing the children of Israel out of four hundred years of slavery in Egypt. How critical it was for this budding nation of Israel to hear these words: "In the beginning *God*" (emphasis added). The Hebrew word here for *God* is *Elohim*. While plural in form, it is not signifying gods. Instead, it emphasizes the One who completely possesses all the divine attributes and power.[1]

These beginning chapters of Genesis describe a *holy* God—the complete opposite of the plethora of gods worshiped by the Egyptians and all other nations that would surround the Israelites. If you read ancient literature, you'll find that the other gods are arbitrary with their bevy of goddesses and despicable immorality, using humans as their pawns. These gods filled humans' lives with terror and demanded

appeasement over and over again—often in the form of child sacrifices.[2] Not so, the one-and-only God of "in the beginning"!

In the first two chapters of Genesis, the focal point is God—this holy, faithful, covenant-loving, in-community God—and those he created in his image. Let's look a little closer.

In that pristine beginning, the first woman was formed. We all stand in awe of her. We all, in some small part, can relate to her. There has never been, nor will there ever be, another woman like Eve. Her name means "life giver" or "mother of all living."[3] She was perfect in form, in spirit, in intelligence, and in emotions—fashioned by the Creator's own hands.

Yet she could never relate to many of the Scriptures that we quote and love. Certainly, she would not understand much of Psalm 139 because it says, "You knit me together in my mother's womb." Eve never knew a mother's womb, the love of a mother, or the guidance of a father. No sibling rivalry, no aunts or uncles, no cousins. No childhood friends, no childhood. No female to explain the functions of her body or how to ready herself for the wedding night. No Lamaze classes or midwife beside her as she birthed. No experienced woman to give suggestions as she stared down at her first naked, crying baby boy. Except for her husband, Adam, she was utterly alone.

In a very small way, I can understand her aloneness. As newlyweds, twenty-two years of age, Bill and I moved to Peru. Though I knew I was exactly where I should be, I spent a lot of time crying. Now I realize that was partly because—after a fifteen-hour flight—I had left my total support system on another continent.

To spread God's Word, we traveled to remote areas by bus, truck, train, even on foot, sometimes accompanied by young men. My

Peruvian sisters would moan, "You poor thing. You shouldn't be going alone!" And I, the young, independent North American woman, would quip right back, "Oh, I'm not going alone. I'm going with my husband." They would retort, "That's exactly what we mean!"

In their eyes, I was alone. There was no other woman beside me. They understood, much more than I at that point in life, the deep camaraderie, friendship, companionship, and laughter that, in many instances, only a woman can supply another woman. Had I heeded their advice I might have avoided some times of deep loneliness and depression.

So we look at Eve in amazement and ask, "*How?*" How did she manage? How did she do life so alone? But maybe our exclamation should be, "*Wow!*"

For this woman knew God in the most unique and utterly incomprehensible way, as we never will. Eve could truly have said as no other woman, "You know me, O God. You fashioned my body and soul."

Remember, God created something new each day. And with each closure of new creation, he proclaimed, "It is good!" (author's paraphrase). Then he created Adam from the dust of the ground and breathed into him the breath of life, and Adam became a living being. God placed him in a large, beautiful garden and gave Adam the first work of humanity—to be a gardener.

But here is where we see the digression from God's previous pattern. In Genesis 2:18, God said, "It is *not* good" (emphasis added). What was not good? "For the man to be alone." So God said, "I will make a helper suitable for him."

The animals were made and brought before Adam for naming. Undoubtedly, each had a companion. But Scripture continues, telling us: "But for Adam no suitable helper was found. So the LORD God caused the man to fall into a deep sleep; and while he was sleeping, he took one of the man's ribs and closed up the place with flesh. Then the LORD God made a woman from the rib [or portion] he had taken out of the man, and he brought her to the man." And at that point, "the man said, 'This is now bone of my bones and flesh of my flesh; she shall be called "woman," for she was taken out of man.'"

Notice that there is another name introduced for God. The name is *LORD*; in Hebrew it is *YHWH* (Yahweh). It is a *personal* name. It means "I AM." To me this means I AM the actively present God in your life. Always present, I act and I speak. I am your personal God.

We don't know how long God and Eve were together. We know that Adam was asleep when God formed Eve. We know that he breathed into her the breath of life. I like to imagine that when Eve's eyes opened, they looked straight into the eyes of the One who, in love, had created her! I personally believe that God and Eve were alone long enough for Eve to sense her Creator's great love for her, the first created woman.

In the Hebrew language, names are important. Within the language, there is a lot of play on names. *Adam*, used as both a personal name and a general noun referring to humankind, in Hebrew literally means "taken out of the red earth."[4] It is a fitting name for this first man created from the dust of the earth. When Adam got his initial glimpse of Eve, the first poetic lines in Scripture spilled out of his mouth. In my personal view of this verse, he exclaimed something

like, "Oh, my goodness! She's not a giraffe! She's not an elephant! She actually has bones like mine and flesh like mine. Why, she's a . . . a . . . woman!" In Hebrew the word for *woman* sounds like *man*. He was not naming her, but simply exclaiming over the fact that she's like him. And was he happy to see her!

Let's focus for a few minutes now on Eve and her relationship to God. We all know that in a few moments we will arrive at that point in Eve's story when she turned her back on God and made a fatal choice. What a choice! What far-reaching, monumental, catastrophic consequences!

What choices are before you today? Have you thought about the far-reaching consequences of your choices? How did Eve have the courage to face God after the choices she made? You and I can have the courage to face God whether our choices are good or bad, because of *who God is.*

We're going to consider three points about who God is and who Eve becomes. Remember, this is the God of all beginnings. This is the God of the *very* beginning. And this God sets the tone and parameters for all of his dealings with women throughout Scripture, all of history, and with us today.

God Is Giving; Eve Is Receiving

To begin with, we are going to see that God is always the initiator. He is always moving toward us—and he is always *giving.* Conversely, Eve *receives* from this abundant giver.

When God created Eve, he made a "helper suitable for him [Adam]." What do you think about when you read that? Perhaps lots of jokes come to mind. But the Hebrew word for our English *helper*

is *ezer*.[5] It is a word used to define God. Found in the Old Testament (more than twenty times), it refers to God and the Holy Spirit. It is never used to refer to a subordinate. It is used of either equals or a superior. It is a word of strength, of power, of wholeness, with no hint of weakness. It indicates an equal helper.

That's quite different from what I was taught. Reflect on a little child. It could be your own child or grandchild. And you say, "Oh, honey, come and be Gramzy's little helper." ("Gramzy" is what my five grandsons call me.) "Will you make these cookies with me?" None of that connotation is found in the Hebrew word *ezer*. *Helper* in the Hebrew is a word of strength. God brought Eve to Adam to provide what the man did not have. He was lonely. He could not supply for himself what would fill his loneliness. She would provide what was lacking in him in other aspects, including the physical aspect.

And then we must consider the word *suitable*. It comes from the Hebrew word *knegdo,* which means "corresponding to him" or "completing him."[6] The woman, being relatively different from the man, yet essentially equal, would be the man's fitting complement. The *Expository Dictionary of Bible Words* notes, "In Eve, God provided a 'suitable helper' (Genesis 2:20). Eve was suitable because she shared with Adam the image and likeness of God—the image that permits human beings to relate on every dimension of personality (emotional, intellectual, spiritual, physical, etc.). Only another being who, like Adam, was shaped in the image of God would be suitable."[7]

And David Freedman, a Semitic language specialist, after examining all the Old Testament uses of these two words, concluded, "When God creates Eve from Adam's rib, His intent is that she will be—unlike the animals—'a power (or strength) equal to him.'"[8]

Some years ago Bill returned from a trip to Africa, bringing me two beautifully carved wooden heads—one of a man and one of a woman. I would stare at them and think, *They are so beautiful. They are so strong. How should I position them?*

These African heads have symbolized our marriage over the years. When Bill first brought them to me, we were in the positions of leader and follower. I took the heads and set the man out in front, placing the woman just a little behind him. Then I'd walk through the house a few days later and think, *Oh, she looks so strong. Certainly, she adds to and completes what he does.* So, I'd put her just a *little* farther ahead of him. I thought, *Nobody will notice anyway, and they're mine. I'll do with them what I want!*

On other days when I would get upset with Bill, I would think, *Is that the way it's supposed to be?* And I would put those figurines back to back! Other times when I didn't understand what was happening in our relationship, I'd grab those heads, put them in a drawer, and slam it shut.

But as I continued to walk with God, explore the Scriptures, and live and work together more with Bill, the words *suitable helper* began to make sense. I brought those heads out again. If you enter our living room today, you'll see them on the mantel, face to face, soul mates, beautifully equal, completing one another. That's what *ezer knegdo* means.

Don't you long for a friend-partner like that?

For many years Bill would say to me, "You're my closest friend." I would murmur, "Uh-huh." It took me many years before I could respond, "Yes, and you are mine."

Face to face was God's design for men and women. Companions, partners, friends, soul mates—each completing what is lacking in the other, recognizing each other's gifts, complementing and supplying for the other. It has nothing to do with one-upmanship. It has nothing to do with being a doormat or domineering. It has everything to do with recognizing the likeness of God in one another and working together to show the image of God and his love to a fallen world.

First, God gave to Eve—and to women in her train—this beautiful strength of being a suitable helper, making her whole and complete. But there's a second item he gave her in Genesis 1 that is so basic to this wholeness and completeness.

Genesis 1:26–28 says, "Then God said, 'Let us make man in our image, in our likeness, and let them rule over the fish of the sea and the birds of the air, over the livestock, over all the earth, and over all the creatures that move along the ground.' So God created man in his own image, in the image of God he created him; male and female he created them. God blessed them and said to them, 'Be fruitful and increase in number; fill the earth and subdue it. Rule over the fish of the sea and the birds of the air and over every living creature that moves on the ground.'"

Notice the pronouns in this passage. God said, "Let *us* make . . . in *our* image, in *our* likeness" (emphasis added). Here is the Trinity—God, at the very beginning, in community—Father, Son, and Holy Spirit. God makes these two beings in his own image, to be in community one with the other.

Here is God, three in one, in community, encompassing within the Godhead both maleness and femaleness. And God speaks and

creates two from one in order to show the image of God: male and female.

Adam and Eve both bear the *imago Dei*, the image of God. That is what is imprinted in you, dear reader—*imago Dei*—the very image and likeness of God. What does that mean? It is not easy to describe; theologians have long recognized the profundity, mystery, and greatness of this concept. We do know, however, that it sets us apart from the animal kingdom. We have the ability to reason, to be morally responsible, and, especially, *to be in community*. "Ultimately we reflect God's image in relationship."⁹

Within you God has shaped a void that only he can fill—an endless longing for communion with your Creator. Nothing else can fill it—not a new house, not a new spouse, not a new dress, not a makeover at a spa. Only God can fill that void because he's imprinted on you his very own image. And because of that, you are of great value. You are of great esteem. You are a great treasure in God's eyes. You are loved by God, your Creator.

God then proceeded to bless both Adam and Eve. He longed for their happiness.

At some point in your life, you've probably had someone say, "May I pray for you right now?" or look you straight in the eye and say, "God bless you . . . " on that marathon you're running, or in your home, or with your child. Whatever it was, you were blessed, weren't you? Even now, you might recall that feeling of blessing. In an even greater way, God blessed Eve.

God then gave responsibilities to the man and the woman. To both he gave the *responsibility of parenting*, to nurture together the children they would bring into the world. For those women who

do not marry, they still have the responsibility to nurture the community of humanity in whatever ways God gifts them.

Along with Adam, God gave Eve *authority* and *dominion over creation*. Many of you are leaders. You lead in areas of your church and community. You lead in areas of your home. God has given that gift to women as well. We are to lead effectively, responsibly, under God's guidance, and with God-given integrity.

And so here we have God's original, divine plan. Here we see our uniqueness as individuals, yet our interdependence as humanity. We are to mirror the Trinity. As God the Father, Son, and Holy Spirit work together, work in community to accomplish our salvation, so God intends that we do likewise as men and women bearing the *imago Dei*.

Our example, the Trinity, is a great and holy mystery. We see a mutual dependence among its members. The hierarchy that is found within the Trinity (see 1 Corinthians 15:23–28) is loving and benevolent, a bending toward one another and a working with one another to accomplish the ultimate good. Nothing is demanded by force nor retained through force, as we read from Christ's example in Philippians 2:5–8. Christ "*made himself* nothing" and "he *humbled himself*" (emphasis added). That was God's original plan for us as men and women—that our interactions would be based on love, respect, and mutuality.

But now we enter the infamous third chapter of Genesis. It begins by introducing us to Satan. Genesis 3:1 tells us, "Now the serpent was more crafty than any of the wild animals the Lord God had made. He said to the woman, 'Did God really say, "You must not eat from any tree in the garden"?'"

We need to recognize that this was not just an earthworm gone bad that sidled up to Eve that fateful day. If you want a chilling description of Satan, who is as real now as he was then, all you have to do is turn to Revelation, chapters 12 and 20. He is called the Devil, the accuser of those who follow God. It is said that he is the one "who leads the whole world astray" (12:9). This is the one whom Eve was facing.

Satan asked Eve about the trees. In Genesis 2, God gave Adam the command not to eat from one particular tree. Undoubtedly, Adam transmitted that information to Eve. But the original command came to Adam. Sometimes I have thought, *Where was Adam? Why didn't Eve run off and find him?* But Scripture indicates that Adam was right there with her, in silence (see Genesis 3:6).

When Satan asked her, "Did God really say, 'You must not eat from any tree in the garden'?" Eve took it a step further—drew it out a little differently. She replied, "We may eat fruit from the trees in the garden, but God did say, 'You must not eat fruit from the tree that is in the middle of the garden, and you must not touch it, or you will die'" (3:2–3). God had not said anything about touching the fruit. But Eve was on a roll, and she was being deceived. She was also making choices at that point. Satan egged her on, saying (and I paraphrase): "You know what? Certainly, you won't die. God just knows that when you eat of it your eyes will be opened, and you will be like God, knowing good and evil."

Genesis 3:6–7 says, "When the woman saw that the fruit of the tree was good for food and pleasing to the eye, and also desirable for gaining wisdom, she took some and ate it. She also gave some to her husband, who was with her, and he ate it."

Now we could get into a discussion about the tree and ask what it really meant. We could wonder about the other trees in the garden. However, the real importance of that tree lay in the opportunity it presented for the man and woman to say yes or no to God.

God is a loving Creator. He did not create robots. He wanted us to follow him willingly. Here was the opportunity. "Will you believe me?" asked God, "or will you follow the deceiver?" Eve and then Adam made a choice. At that very moment, "the eyes of both of them were opened."

What horror! What sadness! In chapter 2 it says that they were both naked and that they didn't mind. They had no shame, no taking advantage of each other, and no guilt. They were naked and open— no secrets, enjoying their bodies and all God had intended for them to be.

Suddenly, that all evaporated. Sin entered the world. They realized they were naked, "so they sewed fig leaves together and made coverings for themselves" (3:7). First, we see a God who is the Giver. Then we see Satan enter, the one "who leads the whole world astray," and he began by deceiving our sister Eve.

God Is Seeking; Eve Is Hiding

God entered again in this beautiful portion of chapter 3. If I had been God at that point, I would have been even more severe than I was to our orchid plant when I threatened, "You produce, or you are out of here!" That's how I treated a plant. Think of the almighty God with the children he had made. But there is no evidence of harshness or threats on God's part.

I'm so glad we have a God who *seeks*. In response to her sin and shame, however, we find that Eve *hides*.

It's not that God is standing there, seething in anger and thinking something like, *Let them run. I have angels with swords. They will get them—then I'll just start over.*

No, God had made Adam and Eve. He had implanted within them his very image. God started seeking; the first words we hear from God's lips in Genesis 3:9 are, "Where are you?" We see the grace of God in his seeking. The great grace of God advancing toward them, as Adam and Eve hid in great fear, shame, and guilt.

God posed a series of questions. Adam began blaming, "The woman you put here with me—she gave me some fruit from the tree, and I ate it." And then we reach verse 13.

One of the amazing points of this chapter is that God allowed no triangulation within this conversation with Adam and Eve. He didn't ask Adam to speak for his wife. He didn't say to Adam, "And what about that spouse of yours? Has she had a bad day or what?" No, he talked directly with Adam. Then he talked directly with Eve.

God loves the voices of women, his daughters. He expects us to answer for ourselves. God said to the woman, "What is this you have done?"

The woman said, "The serpent deceived me, and I ate." Now, some have said that she was also into the blaming game. But she wasn't. She spoke the truth. "The serpent deceived me, and I ate." Her answer was the truth. She was deceived. The apostle Paul agreed in 1 Timothy 2:14. Adam, in a sense, was not deceived; he sinned deliberately. He had received the command directly from God—and

God reprimanded him on this point in Genesis 3:17. Adam stood there with Eve. But the serpent came to Eve and deceived her.

This does not mean that because Eve was deceived, that women, in general, are more prone to deception than men. In 2 Corinthians, the apostle Paul, addressing the whole church—including men— feared that they would all be deceived "just as Eve was" (11:3). We need to keep in perspective the evil strength embodied in Satan, who, in Revelation 20:3, is described as the one who deceives entire nations. Men are also deceived by the Evil One.

Eve spoke the truth: "The serpent deceived me, and I ate." She could have vented and whined at God, "Well, God, you know I've never seen such a creature like that, so I couldn't help myself!" But she didn't. She stated the truth succinctly and stopped.

The first two chapters of Genesis hold God's original *prescription*. But then everything established in God's original plan went topsy-turvy. So, did Genesis 3 become God's original plan? Absolutely not! Chapter 3 is a *description* of what they could expect because of sin's entrance. God, in his seeking, extended grace and asked direct questions of each participant, but most importantly, he was just. He was just with Adam. He was just with the serpent and the ground. And he was just with Eve. However, there are consequences to their sin.

For the serpent, God administered a curse, saying, "You will crawl on your belly." For the man, the ground was cursed, bringing pain and suffering in his work that he had never experienced before. For the woman, pain and suffering would permeate the joy of her childbearing. God went to the basics in both of their lives. And regarding the relationship between the man and woman, Genesis 3:16 reveals that the beautiful design of Genesis 1–2 became twisted.

The experience of *knegdo*—being face to face in a loving, esteem-filled partnership—was replaced with domination, manipulation, and competition. This is the opposite of God's original plan; it is the opposite of the Trinity's model of community.

But there is a redeeming third point about our loving God. In the middle of this chaos, this great upheaval, God is providing a way out—a redemption plan!

God Is Providing; Eve Is Becoming

In the remainder of the chapter, we discover that God *provides*. And as God provides, Eve *becomes*.

In Genesis 3:15, God spoke these words to the serpent: "I will put enmity [war] between you and the woman, and between your offspring and *hers*; *he* will crush your head, and you will strike *his* heel" (emphasis added).

What does this Scripture mean? It involves the woman. Eve, the first to sin, was also the first to receive a promise of hope from God. God told Satan that there would be war between humanity and Satan. But God promised that he would redeem the *imago Dei* in his people. There would come One (Jesus Christ) whose heel Satan would strike by taking him to the cross, but he would rise again and would crush Satan's head. That One would come through the body of a woman redeemed from sin. What a beautiful promise!

Eve had embodied the beauty of perfection. But now she bore the weight of death. God had said, "If you eat of this tree, you will surely die." And in the moment she and Adam ate, the death process began within them. But God provided a way out. With this promise, Eve became a woman of hope.

The promise of a Savior alluded to in these opening chapters of Genesis is carried forward and accomplished throughout the Scriptures. Jesus Christ was born of a woman. He did die on the cross and rose again. Through his death and resurrection, he secured eternal life for those who put their faith in him.

But God didn't stop there. In his love he provided for Adam and Eve's *present* circumstance. He didn't shame them more. He didn't say, "Get out! Go on with your twigs and your leaves. Get out of my sight!" No, he turned and, for the very first time, killed one of the beautiful animals he had created. Why? To provide his children with clothing, a covering. Genesis 3:21 says that he "made garments of skin" for them. Then he sent them out of the garden.

We have no further words from Adam. But from Eve we have two further statements—statements of faith as she acknowledged Yahweh. We read in Genesis 4:1, "Adam lay with his wife Eve, and she became pregnant and gave birth to Cain. She said, 'With the help of the LORD I have brought forth a man.'" She had not forgotten where she came from. She had not forgotten those eyes of love. She had not forgotten the blessing poured out on her and the experience of the *imago Dei*. And as she birthed, I can almost hear her saying, "Adam, this isn't just about you and me. God has not left us. This is about *God*, you, and me. It's God who gives life. It's Yahweh, the ever-present God."

And this is the same God present with you, present with me, and working on our behalf.

Genesis 4:25 says, "Adam lay with his wife again, and she gave birth to a son and named him Seth, saying, 'God has granted me another child in place of Abel.'" This child, Seth, was the beginning

God's Initial Work with Woman

Our God is a God of new beginnings! "In the beginning God" (Genesis 1:1).

GOD	EVE
1. Giving	**Receiving**
• **"Helper-equal-to"** (Genesis 2:18) helper = *ezer* suitable = *knegdo*	• wholeness/ completeness/strength
• **"*imago Dei*"** (Genesis 1:26–27) • blessing • responsibility	• authority— "uniqueness yet interdependence"
2. Seeking	**Hiding**
• to give grace (Genesis 3:9) • to ask direct question (Genesis 3:13) • to administer justice (Genesis 3:16)	• shame/guilt
3. Providing	**Becoming**
• a promise (Genesis 3:15) • a covering (Genesis 3:21)	• a woman of hope • a woman of faith (Genesis 4)

"His divine power *has given us everything we need for life and godliness* through our knowledge of him who called us by his own glory and goodness." —2 Peter 1:3 (emphasis added)

of the fulfillment of the promise given in Genesis 3:15. For as you trace the genealogies, the family lines, through the Old and New Testaments, Jesus comes through the line of Seth.

How will you respond to this God of Eve today? This is the same God who loves *you* and loves to hear *your* voice. This creator God is a giver of wholeness and completeness for *you*. God is always seeking *you* in order to extend grace. Will you let him find you? This God is providing everything *you* need for life and godliness. Will you accept his provisions for your needs?

Despite her failure, Eve trusted the love and the goodness of God and proved that he did not fail. May we follow in her footsteps of trust, becoming women of faith, hope, and courage.

eyes of love . . .

What was it like to open her eyes,
gaze into the face of her Lord,
Creator and Lover,
Designer of form,
applauded, embraced,
adored?

What was it like to have her eyes opened,
look into that Face of great sorrow,
feel the horror erupt
deep within her own soul,
wrapped in skins
walk an unknown tomorrow?

Yet that's the beginning of our path with Eve,
for God's holy presence remained.
In the hours of birthing
what ne'er was before,
she called out
her closest Friend's name.

— Ruth Tuttle Conard

DESIGNED TO SPEAK UP

Zelophehad's Daughters

The courage to speak up is not a simple topic, is it? *When* do we speak up? *How* do we speak up? *Why* should we speak up?

Women have battled with this down through the ages. From the first-century church, we have documents verifying the actual names of some of the women who spoke up. In essence, they said, "We are Christians and we will not bow to the Roman Emperor [who was considered a god]. We will bow only to Jesus Christ."[1] They were thrown to lions and gored by wild heifers in the Roman coliseum.

On December 1, 1955—a seemingly normal Thursday evening in Montgomery, Alabama—a middle-aged African American, Rosa Parks, was riding home on the public bus.[2] She had just put in a full day's work as a seamstress in a large, downtown department store.

Designer Women

Rosa was a quiet-mannered woman of principle. She was a strong believer in God and sensed his presence in her life.

Legally, at that time in Montgomery, Alabama, black people were not allowed to sit in the same row with white people, nor could they sit across the aisle from anyone who was white. The black people had to pay at the front door, exit the bus, reenter by the rear door, and find an appropriate seat.

As white people boarded a city-owned vehicle, any black person riding on the bus was obliged to move to the rear seats once the "white section" had filled. Since black people, not white, composed the majority of bus riders in Montgomery, this bus segregation law was an especially humiliating daily reminder of the city's widespread racial intolerance.

On this night, Rosa happened to be sitting in the fifth row of seats, the first row of the "colored" section. When a white man remained standing without a seat, the black bus driver ordered the fifth row to give up their seats and move back. At first no one responded. When three people near Rosa got up and moved back, she remained seated. It was the first time in her life she had defied the segregation laws.

"I do not remember being frightened," she later said. "But I sure did not believe I would 'make it light' on myself by standing up. Our mistreatment was just not right, and I was tired of it. The more we gave in, the worse they treated us. I kept thinking about my mother and my grandparents and how strong they were. I knew there was a possibility of being mistreated, but an opportunity was being given to me to do what I asked of others."

Rosa suffered the humiliation of being handcuffed, taken to jail, and put behind bars. Debra Evans recounts in *Women of Courage*, "Once Rosa was locked in her jail cell, she reflected on what had happened that evening. The people she knew on the bus had remained quiet. No one had tried to defend her. No one had even called her husband to tell him what had happened. Feeling isolated and alone, the unlikely hero of the American civil rights movement prayed silently and waited for someone to come to her defense. But she did not cry."[3]

Later Rosa commented: "I did not get on the bus to get arrested. I got on the bus to go home. Getting arrested was one of the worst days of my life." Rosa Park's actions (including her refusal to pay the fourteen-dollar fine leveled against her peaceful act of civil disobedience) and arrest were the starting point for a history-making bus boycott. On December 20, 1956, black people finally rode the city buses again—and for the very first time, they sat wherever there was an available seat. *By remaining seated, Rosa Parks had spoken up.*

Thirteen years later on a secluded beach along the Pacific Ocean in northern Peru, a young white missionary woman rode in a Land Rover with her husband, children, and a visiting Canadian friend and her family. I was that missionary woman.

It was a beautiful, sunshiny day. We set out happily—four adults (longtime friends from college days) with six children ranging in ages from three to seven, along with our favorite cocker spaniel, Princess.

Since this was our friends' last day with us, we decided to celebrate with a picnic beside the Pacific Ocean. In the afternoon they would board the only flight for Brazil. It was a great day together. We

didn't notice how late it was getting. When we did realize the time, my husband decided that we would go along the beach instead of the road, since it would be faster. And, anyway, to a four-wheel-drive vehicle, the beach is like pavement. We all thought the tide was going out.

As the Land Rover crested the hill, coming down to the beach, two people in that vehicle wanted to shout, "Let's not do this. Let's go on the road." I was one of those two, and the husband of my friend was the other. For different reasons, neither of us opened our mouths.

Within minutes we reached a point where a high cliff jutted out into the sea. As we began our way around it, one of the front wheels caught between rocks. At that moment the ocean rolled closer; and to our horror, we recognized that the tide was coming in, not going out! A wave splashed over the hood. The motor died. No amount of work, pushing or pulling, would budge that truck. Still in our bathing suits, we hurried the children, tent, and dog onto the beach. When the ocean was up to the door handles, Bill and Neil finally gave up and struck out across the desert to find help. It would take them five long hours.

Later, while my friend Meredi and I pitched the tent, peeled the last three bananas, and bedded the children down in sandy towels, one question haunted me: *Why hadn't I spoken up?*

Whether it's a matter of sharing or declaring our faith, standing up for our own dignity or that of others, or for an ethical or moral reason in our workplace, homes, or in a myriad of venues within our communities, *we will have opportunity to speak up.* One of the best

role models of this in Scripture comes from the story of Zelophehad's daughters—a historical happening we seldom remember.

Think again for a moment about Eve in the garden of Eden. We saw that she and Adam were made in the image of God, equally blessed by God, given responsibility in parenting and caring for humanity, and given authority to rule and manage the planet on which God had placed them.

We also walked through those moments of disobedience with Eve. We heard the dire pronouncements made by God regarding Eve's grief in childbearing and Adam's grief in eking out a living. We also witnessed the disruption that sin brought into their personal relationship. Dominance, manipulation, and competitiveness entered, altering their oneness and changing the community of trust God desired between humans, as evidenced within the Trinity.

But remember Genesis 3:15 where God gave the first glimpse, hundreds of years in advance, of a coming Savior—Jesus Christ *would* come. He *would* crush the evil that Satan set in motion. The promise predicted that he *would* restore wholeness and healing to humankind—to each one of us individually as we acknowledge our need for Jesus to be our personal Savior, confess our sins to him, and invite him to take over the direction of our lives.

A simple yet complete outline for the entire Scriptures, then, is:[4]

- Genesis 1–2: Creation
- Genesis 3: Disruption
- Genesis 4–Revelation 22: Restoration

Designer Women

Each of the ten vignettes of women in this book is part of a story planned by God. They are not isolated instances, but part of a whole plan. The Bible is God's story, God's love story of restoration. Women, as well as men, play a critical role in God's story.

The book of Numbers, where we find Zelophehad's daughters, is the fourth book in the Old Testament. The Israelites had left the slavery of Egypt, and this event occurred on the heels of the second census taken. The first one was taken thirty-eight years before. Thousands more had been added to this immense group of people. They were almost ready to cross the Jordan River and claim the land that had been promised to them. There were twelve tribes, and these were divided into clans. Each group would receive land depending on the size of its tribe and clan.

In that ancient culture, possession of land and preservation of the family name were intrinsically connected. God worked within their cultural system, just as God works within our cultural system. God works with us where we are. The setting of this story is a patriarchal culture.

Numbers 27:1–11 gives us the account of these brave sisters:

> The daughters of Zelophehad . . . belonged to the clans of Manasseh son of Joseph. The names of the daughters were Mahlah, Noah, Hoglah, Milcah and Tirzah. They approached the entrance to the Tent of Meeting and stood before Moses, Eleazar the priest, the leaders and the whole assembly, and said, "Our father died in the desert. He was not among Korah's followers, who banded together against the Lord, but he died for his own sin and left no sons. Why should our father's name disappear from his clan because he

had no son? Give us property among our father's relatives."

So Moses brought their case before the LORD and the LORD said to him, "What Zelophehad's daughters are saying is right. You must certainly give them property as an inheritance among their father's relatives and turn their father's inheritance over to them.

"Say to the Israelites, 'If a man dies and leaves no son, turn his inheritance over to his daughter. If he has no daughter, give his inheritance to his brothers. If he has no brothers, give his inheritance to his father's brothers. If his father has no brothers, give his inheritance to the nearest relative in his clan, that he may possess it. This is to be a legal requirement for the Israelites, as the LORD commanded Moses.'"

We need to imagine what these five sisters were really facing. It's not as if they each owned their own private, souped-up camel on which to mount each morn. They didn't lope off decked out in designer clothes, cool sunglasses perched on suntanned noses with Starbucks lattes in hand to follow their careers at the nearest oasis. No, these were ancient, nomadic women. At this point, their father—their major social security holder—had died, and they were unmarried. That was *not* good. Why? Because the inheritance of land always went through male heirs. For these sisters, this posed a huge dilemma. They had no brother, which meant no land and which, quite frankly, equaled destitution. In plainer terminology, these five sisters were completely, totally dependent on and, may I add, at the mercy of others.

Just try to imagine these sisters in this life-threatening predicament. Do you have four or three or two sisters? Are you all alike? Of

course not. I have two older sisters, and we are so different one from the other. My parents' fiftieth wedding anniversary made that very evident. My oldest sister wants to be sure everything's in order—not too many surprises. My middle sister has a hard time deciding what she thinks, but, let me tell you, she has a networking system to get people involved like you can't imagine. And I, well, I will provide the gusto and the creative touch to it all (if they let me . . . and they do) that could make it a memorable event.

I can just imagine these five sisters in their tent, weeping, wailing, biting fingernails, giggling, and some perhaps moaning, "We can't possibly do this. It's never been done. Anyway, Jehovah God has decreed that this is the way it will be. Who are we to rock the boat?" Another chimes in, "I am not going! Go by yourselves. It's just too embarrassing. What will people say about us? I can just hear them saying, 'Oh, those Zelophehad hussies. What would their father think of them now?' We'll never live it down!"

But there must have been at least one—maybe two—thoughtfully, quietly pleading, "Let's at least try. Let's try to think carefully; perhaps there's hope. What about other women who will come after us? What about our cousins who are poorer than we? Some we know are not as resourceful as we are. They're even more timid. If our action works, imagine what it could mean for them!"

How incredibly daring were Milcah, Noah, Mahlah, Hoglah, and Tirzah in coming forward to speak *personally* and *publicly*, not only to the great Moses, but also to all the other leaders beside him. This was no private affair, such as, "Pssst . . . Uh, oh Great Moses, may we have a little word with you in your office, uh, after hours?" No, everyone saw them, and many heard them.

What will Moses' response be? Even more important, what will God's response be? The rustle in the crowd is almost palpable. All eyes are focused on these approaching five sisters . . . as they speak . . . as they all wait together.

Then suddenly, an announcement rings out: "What Zelophehad's daughters are saying is right." What an astounding victory for those five women!

What can we learn from this ancient setting? What can we glean from these words that the Spirit of God has deemed important enough to keep for us after all these years? These five sisters embodied four very practical and necessary steps to make their desire known: they had valid support, they used their voices, they were vulnerable, and they demonstrated maturity.

They Had Valid Support

Numbers 27:1 says, "*They* approached" (emphasis added). At least two of those sisters went together. We need different kinds of support, don't we? If you're thinking of speaking up on an issue, do you have one or two others praying for you? Have you read any material concerning the matter to back up your point? Is there someone you feel safe discussing the issue with? Do you have a spiritual director or mentor who might give you other ideas or support your feelings?

Be sure those who say they support you will stick with you—and not turn against you in the heat of battle—which, by the way, does happen. People will support you in different ways. Not every one has the capacity to stand with you in the same way. We must give allowance for that.

Rosa Parks certainly didn't have anyone sitting down with her when she remained seated. But history proves that many supported what she did and came to stand beside her in her action.

They Used Their Voices

Numbers 27:2–4 says that the sisters approached the leaders "and said . . . 'Give us property among our father's relatives.'" These sisters set the best straightforward model for us women. They opened their mouths and spoke truthfully what they wanted.

We women are accused of sometimes using other tactics. We may insinuate what we think we want, not voicing it straight out because of fear, wrong motives, or maybe we've been taught that's not the nice thing to do. So we hope that someone else will read our minds and voice the real desire we have.

Or we may try to manipulate the situation, without saying anything. It might go like this in our mind: If I do this, then that will probably happen. And I'll get what I want without anyone knowing that's really what I wanted in the first place. I won't have to say anything! And I won't be blamed.

A third way is to be passive-aggressive. We have many negative examples of women in the Scriptures practicing this last little scheme. One of the best known is the story in the book of Genesis of Rebekah, the mother of Jacob. She helped him disguise himself as her firstborn (which he wasn't), so that he would be given the firstborn's birthright. She seemed to be lovely and good (passive) on the outside, yet underneath and behind the scenes she was orchestrating and controlling everything she could (aggressive).

Over the years since the demise of our Land Rover in the Pacific Ocean, I have come to see my part in that accident. I did not speak up, but I should have. I did not say, "Let's not go on the beach. I don't think it's safe." At that point in our marriage, it was much easier for me to later say, "I told you so," and to blame Bill. (God did use that tragic and serious event in our marriage to bring our relationship to a much healthier and honest level.)

But have you ever been there? Not speaking up? Not speaking the truth? It's not a good place to be.

Many times women who feel they have no power act in this way. And believe me, these ancient women (as well as many women today) had very little power over their own destinies, their own bodies, even their own futures. And yet we have multiple examples in Scripture of women who did not succumb to their cultural norms but trusted in God, knew themselves, and marched forward with integrity, living out their gifting and following the call of God.

Whoever you are today and whatever your situation, it *is* possible to find your voice, to make the choice to turn away from manipulation, insinuation, passive-aggressive behavior, and the "Oh, woe is me" complex. To do that, *you must choose*. You must choose how you are going to live. You must choose, before God, to know what you want and be able to voice that. It's not easy.

We are given so many options today. It will take time to figure out what you want. Our choices will differ—mine from yours, and my timing from your timing. I remember in Peru when I finally felt it was the right time to do concert piano work. A leading musician in the city where we lived asked, "Where have you been? Why have you waited so long to do this?" I didn't tell him, but I knew why. It hadn't

been the right time. It had been the time for me to concentrate on rearing small children and being faithful to that particular calling at that particular time. We cannot do everything at once.

But we can choose if and how we will speak up. We can make choices. We can ask God to help us, and he will, just as he helped the daughters of Zelophehad. God is calling you today to follow him, to see yourself as he sees you—a person of worth and dignity, a woman with choices.

They Were Vulnerable

Numbers 36:10 tells us that they "did as the LORD commanded." Sometimes when we speak up about something, we probably would like it to go all our way. But if we speak up—speak the truth about something—it's pretty likely someone is going to speak truth back to us. We may not want to hear that. For these women it wasn't, perhaps, exactly as they thought it might be. The daughters of Zelophehad received the land they had requested, but with that concession also came a responsibility. They had to marry sons of their father's brothers so that their inheritance remained in the tribe of their father's clan. And the Scriptures tell us that they did just that.

Every choice we make has a consequence, that is, comes with a responsibility. So we must be vulnerable—*open*—to what may happen, *open* to where God may lead. And it may be in a way we'd not thought about.

A few years ago, my boss demanded that I state exactly what I wanted. I went before the Lord in prayer, and I talked with my husband. We decided that there were three things I could justly ask for. The first one "was no biggie," the man said. The second one he said

he would never concede to me. With the third one, he responded bluntly, "I will stand against you." But I felt a great relief. I then knew, beyond a shadow of a doubt, where I stood, and I knew what my options were. Scary? Yes! Freeing? Yes! And, in good time, the Lord removed me from that place into wider fields of ministry than I could ever have imagined.

When you have the courage to state the truth, you must be ready to:

- **Discern truth**. Is this person speaking the truth to me? How much is the truth? Who can help me sort this out?
- **Receive the truth**. This person is speaking truth to me. Lord, help me to receive this graciously and work on places in my own life where I need to apply this.
- **Negotiate**. I've spoken the truth. Now, I must be willing, in some cases, to work together with another for both of us to accomplish what needs to be done.

They Demonstrated Maturity

Ephesians 4:15–16 says, "Instead, speaking the truth in love, we will in all things grow up into him who is the Head, that is, Christ. From him the whole body, joined and held together by every supporting ligament, grows and builds itself up in love, as each part does its work."

If we as women are not willing to speak up, if we refuse to speak up, refuse to have an opinion, *we will not grow up*. In essence, that is what this verse says. We are to speak the truth *in love*. That is extremely important. We are to allow ourselves to be controlled by

the Spirit of God and exemplify the fruit of the Spirit as set out in Galatians 5:22–23. And we are also to *speak the truth*. Sometimes we are so worried about the "love" part, or that we may offend someone, that we forget to speak the truth!

I cannot imagine that someone was not offended that day when the daughters of Zelophehad broke the rules, broke a tradition, and asked for something new to be put into place. I just imagine that someone was offended. But God Almighty rewarded them for speaking the truth. They demonstrated maturity and grew up in a new way that day. They had a voice, and they were honored. Because they spoke up, others in the future were blessed.

These two verses in Ephesians tell us that one way to grow up is to speak the truth. Within ourselves we must speak the truth. "In Christ" we must know and acknowledge the truth of just who we are. We must learn to acknowledge our gifts, acknowledge our shortcomings, and acknowledge our hopes and dreams. Within community we must also speak the truth. When we are able to do that, Scripture says that we are mature and that we help the rest of the body of Christ to grow up as well.

How, where, when is God asking you to speak up? Is someone in one of your circles being treated unfairly? Are you being treated unjustly? Is there a fearful place in your life where you feel you do not dare to speak truth? Who can you go to who will help you in that situation?

Will you speak up and so let God "grow you up," or will you once again avoid confrontation and so avoid growth?

Remember, you are God's child. You are precious in his sight. Don't forget Zelophehad's daughters. God "grew" them, and he would love to "grow" you! Trust him.

brave quintet...

To see the need for change,
To ask when others don't,
To stand while most still sit,
To move when others won't.

This is the work of justice
embodied in so few.
Yet five brave sisters rose as one,
and God rose with them, too.

Where should my rising be, O Lord?
Who, unheard, remains?
Where will I question, stand, and act;
Remove another's pain?

— Ruth Tuttle Conard

3

DESIGNED TO BE DIFFERENT

Zipporah

The oldest symbol of friendship in my house is a one-hundred-year-old stool. As a child I sat on that stool in the kitchen so I could be close to my mother while she rolled out piecrusts, shredded cabbage for coleslaw, or canned fruits and vegetables. From this stool my mother and I formed a lifelong friendship. There was no question she ever avoided—not even about dirty words I'd blurt out and ask innocently, "What does that mean?" She'd take a deep breath, look down at her flour-covered hands, and say, "Well, Ruthie . . ." I felt embarrassment. She covered hers well.

The stool also represents to me a woman who was *different*. My mother truly was. She certainly wasn't perfect. In fact, one of my most ardent prayers as a young woman in college was, "Oh God, please don't let me be like my mother!" (By the way, I've found that

most young women pray this at some moment or other.) At the same time, I admired her deeply.

This was a woman who never wore a bra. Only on special occasions—such as our weddings—would she succumb to this restrictive device. And we three sisters took note of that. We appreciated the fact that for us she would give in to this constraint for the sake of looking proper. She always had problems with her feet and so wore orthopedic shoes. They were very unsophisticated, heavy-looking, lace-up black pumps (a type of low heel). Yet, for our weddings, she would endure the pain of some rather normal-looking dress-up shoes.

But there was so much more to my mother than those idiosyncrasies. She was extremely faithful and frugal. She was a thinker and a leader. She was the church historian for forty years as well as a Sunday school teacher for that same length of time. She not only reared her own three daughters but also consoled and guided the five daughters of her sister who were left when their mother, my aunt Mildred, died unexpectedly.

She was courageous and strong. Her childhood had not been easy. She was born into quite a poor family, as her father was brought to the United States as an indentured servant at nine years of age. He never saw his native country or his family of origin again. He had to learn a new language and work very hard. Finally, he married, had five boys and two daughters, managed to acquire his own land, and at the age of fifty, very discouraged, hung himself in a barn.

That is the setting in which my mother grew. An aunt brought her to know Jesus Christ at an early age. And she continued to seek and follow him. I am so grateful.

She had the patience to sit and teach me table games. She encouraged me as a musician, though she could not carry a tune. She sewed most of my clothes from my early years through high school and, in her lifetime, stitched over forty quilts by hand. At her memorial service we decorated the church with quilts loaned to us by the people they had been given to. And, not least of all, my mother instilled in me, from the time I was a toddler, a great love for the Bible and for other literature.

She was a wonderful partner of sixty years for my father. It was because of my mother's faith in God that Daddy finally committed his life to Jesus Christ. Daddy was a hard worker, loved God, shared his faith unabashedly, and was full of fun. Mother worked steadily and wisely beside him to keep our family, our finances, and our future on course. I was shocked after my mother's funeral to learn that the father of one of my best friends had said, "Well, bossy Margaret Tuttle is gone."

Yet I too have been guilty of judging people by only a portion of what I could see of their lives instead of allowing God's grace to show me the whole spectrum and breadth of their journey on this earth—many times full of pain I could not have imagined or borne.

Certainly, if you live out a life of love to God and service to others, you must ready yourself to be misunderstood, misread, and misinterpreted.

Think of the women of strength you've had around you in life. What do you appreciate about them? Did they—do they—have some idiosyncrasies? At the same time, what kind of courage have they exhibited in the way they live their lives that draws you to them? In what ways have they influenced you for good?

Designer Women

The woman we're looking at in this chapter is certainly a woman of strength, a woman of courage, and a different kind of woman. She is Zipporah, wife of the great leader Moses. We find her in the second book of the Bible, Exodus.

Some years ago when I was teaching seminars on marriage, I said to Bill, "Can you think of a woman in the Bible who risked her life for her husband, who normally was a good man? Who did something truly unique, when perhaps she could have run the other way?" Bill thought for a while, then looked at me, and our mouths both formed the same name: "Zipporah, wife of Moses."

I then engaged the talents of two friends: one a young female artist and the other a professor in archaeology, specializing in Egyptology. The result was a stunning ink-drawn portrait of Zipporah, which hangs in our living room. Her name means "bird."[1] She was a Midianite, a descendant of Abraham's second wife, Keturah. Zipporah's father, called both Reuel and Jethro in the Scriptures, was a priest of the Midianites. The Midianites were dark skinned. In the drawing, Zipporah's attire is like that found on women from her ancient era in hieroglyphics on caves from the region of the southern Sinai Peninsula.

Zipporah is one of six women God used to protect and form the life of Moses. Each one is named in the book of Exodus. The first mentioned are Shiphrah and Puah found in Exodus 1—those two incredibly brave Israelite midwives. Remember, a new pharaoh, who did not know Joseph, had risen to power in Egypt. This ruler was frightened by the growing size of the Israelite slave community. He mandated that the two midwives kill all the Israelite baby boys and let only the girls live. But Shiphrah and Puah feared God. They

falsely reported to Pharaoh that the Hebrew women were much stronger than Egyptian women and birthed before they could even arrive. Centuries ago, these two women, our sisters, stood against abortion and infanticide. They saved a nation, including the life of the great leader Moses.

Exodus 2 introduces us to three more important women in Moses' life. Moses' mother, Jochebed, was an ingenious woman and full of faith. She hid Moses for three months because she was not afraid to disobey the king (see Hebrews 11:23). When she could no longer keep him quiet, she made a papyrus basket, placed Moses in it, and set him afloat on the Nile River. His sister, Miriam, carefully watched from the bank of the river. Pharaoh's daughter, with her retinue of ladies, went to bathe and found the beautiful baby boy in the basket. Miriam offered to find a Hebrew mother to nurse the baby for Pharaoh's daughter. The princess hired Moses' own mother to nurse him until he was weaned. Jochebed then gave Moses to the princess to be raised as her son in Pharaoh's palace.

We know the rest of the story. One day after Moses was grown, he became overwhelmed by the inordinate suffering of a Hebrew slave being beaten by an Egyptian. He killed the Egyptian. When Pharaoh heard of this, he set out to kill Moses. But Moses fled to the land of Midian.

He decided to rest by a well and found the daughters of Reuel there, defending themselves against some marauding shepherds. "When the girls returned to Reuel their father, he asked them, 'Why have you returned so early today?' They answered, 'An Egyptian rescued us from the shepherds. He even drew water for us and watered

the flock.' 'And where is he?' he asked his daughters. 'Why did you leave him? Invite him to have something to eat'" (Exodus 2:18–20).

Moses agreed to stay with the man, who gave his daughter Zipporah to Moses in marriage. Zipporah gave birth to a son, and Moses named him Gershom, saying, "I have become an alien in a foreign land" (Exodus 2:21–22).

As I mentioned earlier, the Midianites were descendants of Keturah, Abraham's wife after Sarah died. They were a very wealthy nomadic people living in the southern part of the Sinai Peninsula. Moses married into this family, taking Zipporah as his wife.

At the death of the king of Egypt, God came to Moses in a burning bush and told Moses to return to Egypt as the one to lead the Hebrews after four hundred years of slavery and great suffering. It was at this point that Zipporah bravely decided to accompany Moses. She had two boys, and one had quite recently been born.

> So Moses took his wife and sons, put them on a donkey and started back to Egypt. And he took the staff of God in his hand.
>
> The LORD said to Moses, "When you return to Egypt, see that you perform before Pharaoh all the wonders I have given you the power to do. But I will harden his heart so that he will not let the people go. Then say to Pharaoh, 'This is what the LORD says: Israel is my firstborn son, and I told you, "Let my son go, so he may worship me." But you refused to let him go; so I will kill your firstborn son.'"
>
> At a lodging place on the way, the LORD met Moses and was about to kill him. But Zipporah took a flint knife, cut off her son's foreskin and touched Moses' feet with it.

"Surely you are a bridegroom of blood to me," she said. So the LORD let him alone. (At that time she said "bridegroom of blood," referring to circumcision.) (Exodus 4:20–26)

In Genesis 17 God gave circumcision to Abraham as a sign—an outward sign—of the covenant of blessing he had promised to the children of Abraham, the Israelites. This held special meaning. Other cultures practiced this as a passage into manhood at puberty, and as a premarital rite, it was practiced widely in the ancient Near Eastern world.[2] But among the Israelites, circumcision was to be performed when the male baby was only eight days old. God was pledging his covenant blessings when the child could not yet respond with covenant obedience. And, because of the patriarchal system, the blessing came through the males. (In the New Testament, baptism is the symbol that replaces circumcision, and both men and women are the participants of that joyful experience.)

According to Old Testament law, failure to circumcise your son indicated removal of yourself and your family from God's blessings (Exodus 12:48–49). On the road back to Egypt, God was displeased that Moses, who would rescue God's "firstborn son" (the nation of Israel, Exodus 4:22), had not fulfilled the commandment to circumcise his own biological son.

This is the part of the story where commentators have often maligned the action and the words of Zipporah. Some have said that she was clearly opposed to circumcision, that she did it grudgingly and with great dissatisfaction, that it was her repulsion to the idea in the first place that made Moses disobey God's command, and that she overstepped her boundaries as a woman since the husband

always performed the circumcision. None of these views are clearly supported by Scripture.

The Midianites were descendants of Abraham and his second wife, Keturah (Genesis 25:1) and, along with other western Semites, practiced circumcision at this time.[3] The prophet Jeremiah made reference to this in Jeremiah 9:25–26. So Zipporah would likely not have been opposed to it. In the Midianite culture, it was performed, not by the father of the child, but by the oldest brother of the wife.

I believe that this whole passage deals with the obedience of Zipporah. I believe she had seen circumcision done before, and she was prepared and willing to step in and do what her husband was incapacitated to do at the time.

What do her words "Surely you are a bridegroom of blood to me" mean? These words are most likely ones of jubilation and relief that because of her obedient act—thanks to the blood of the circumcision—her bridegroom is restored to her whole.[4] Undoubtedly, both Moses and Zipporah were strengthened by this frightening, awesome encounter with the living, almighty God. They must have realized anew that they needed to have less fear of the Egyptian pharaoh and pay more attention to almighty God and his commandments. He would care for them, and he expected their obedience.

Two other points regarding Zipporah interest me. One is taken from Exodus 18:1–6:

> Now Jethro, the priest of Midian and father-in-law of Moses, heard of everything God had done for Moses and for his people Israel, and how the LORD had brought Israel out of Egypt.
>
> After Moses had sent away his wife Zipporah, his father-

in-law Jethro received her and her two sons. One son was named Gershom, for Moses said, "I have become an alien in a foreign land"; and the other was named Eliezer, for he said, "My father's God was my helper; he saved me from the sword of Pharaoh."

Jethro, Moses' father-in-law, together with Moses' sons and wife, came to him in the desert, where he was camped near the mountain of God. Jethro had sent word to him, "I, your father-in-law Jethro, am coming to you with your wife and her two sons."

Some read into this passage that Moses was so angry with what Zipporah did in circumcising their son (saving Moses' life? saving his son's life?) that he sent her back to her father's home. But I believe that at a later time in Egypt, concerned for Zipporah's safety, as well as that of his two young sons, he sent the three of them back to the tent of his father-in-law, Jethro. This fits in culturally and would be a logical and sensible step to take. And, at the close of chapter 18, we see Moses sending "his father-in-law on his way," seeming to indicate that Zipporah and the sons remained with Moses.

The last point of interest is found in Numbers 12:1–2: "Miriam and Aaron began to talk against Moses because of his Cushite wife, for he had married a Cushite. 'Has the LORD spoken only through Moses?' they asked. 'Hasn't he also spoken through us?' And the LORD heard this."

Because this passage speaks of Moses' wife being Cushite instead of Midianite, those who see Zipporah's act of circumcision in a negative light go on to say that Moses was so upset with her that he married a second woman.[5] However, the exact location of the Cushites as

well as the Midianites is not totally clear in the Old Testament; both were dark-skinned people, and at least in one instance (Habakkuk 3:7), "Cushan" and "Midian" occur in parallelism, which suggests that the terms could be synonymous. Therefore, the Cushite woman of Numbers 2 could very well be the Midianite Zipporah.[6] It is very possible that Miriam was jealous of Zipporah. In fact, the Scriptures say clearly that for Miriam and Aaron, the real issue *was* Moses' wife. Numbers 12:1 states that Miriam and Aaron criticized Moses because he had married a Cushite woman. In other words, Zipporah was never "one of them," an Israelite. And they had watched Moses' interaction with this wife—whom he loved, who had walked with him through thick and thin, borne him two sons, and saved his life. Nor is it hard to imagine that she was a counselor to him as well. She and Moses were close in life, action, and thought.

At the same time, we have a blood sister and brother of Moses who also are leaders. The Lord says through his prophet in Micah 6:4 that he brought his people out of the land of Egypt, sending before them "Moses . . . also Aaron and Miriam." Moses was the key leader, Aaron was the priest, and Miriam—the oldest—was the worship leader.

I believe that Miriam, an oldest sister and also a leader, felt that she, not Zipporah, should be the one beside her brother Moses in primary leadership, hearing from God as did Moses. But, in actuality, that was not the way it was. Zipporah was beside Moses, and, undoubtedly, Miriam desired that place.

So, we have taken a small look at the fascinating life of this ancient, unique, and brave woman, Zipporah, wife of Moses. What can we learn from her? How did she accomplish the tasks set before her?

Bear with me as I take just the first five letters of Zipporah's name and give us some pegs to hang some thoughts on:

- **Z for Zealous.** *Zealous*, a word we seldom use today, means enthusiastic as well as passionate. It has to do with applying enthusiasm and/or passion to something necessary or new that we are to do. Zipporah was zealous to do what was right at the right time. Even though the task was difficult, she would not let her husband die. She watched over her boys, making sure they would be safe and not fatherless.

 The New Testament encourages this quality in Romans 12:11: "Never be lacking in zeal, but keep your spiritual fervor, serving the Lord." God longs for us to continue to love and serve him with passion. Is that something you need to ask the Lord for? Jesus, with total passion, with total zeal, gave his life for us. He longs that we may live for him in the same manner.

 If there's something you need to do and you lack the passion for it, ask Christ to supply it. He will. In which areas does enthusiasm lack in your life? Ask the Holy Spirit to stir up zeal within you once again.

- **I for Intentional Implementation.** Zipporah had something explicit to do. She didn't hesitate. She did it. What area needs more intentionality in your life? It could be in the area of your job, your family, your relationships, your church, or another area I've not named. It may be something that *has to be done* today. Talk to God about it. Ask for a focused and intentional attitude toward it. It may

be something that's been plaguing you for a long time. Ask God for courage to begin to be intentional today as you proceed to implement a plan for action.

- *P* **for Ponder.** Ponder means to consider, to think over. Zipporah didn't take much time to ponder her action on that road to Egypt! I hope you'll never be in a life-and-death situation as she was. Yet, she must have done quite a bit of serious thinking when she first married Moses. He was raised as an aristocratic Egyptian and she as a nomadic woman. But if you're asking Christ for passion in an area of your life and if you're planning to intentionally implement a plan, you must think through what you are to do. There are five good questions to ask yourself: What? Why? When? Where? How? These questions can become good friends to guide you toward intentional implementation.

- *P* **for Praise God.** We cannot be exactly sure of the outcome of our plans. But there is One who does know—our heavenly Father. He asks us to walk by faith, trusting in his guidance.

 Psalms is a book of prayer. Almost all the psalms contain elements of praise to God. Praise shows our admiration, our appreciation, and our thanks. It shows our faith in a God who is always faithful—no matter what. Amazingly, as we praise and thank God, his Word comes true in our own daily living. As Philippians 4:6–7 says, "Don't worry about anything; instead, pray about everything. Tell God what you need, and thank him for all he has done. Then you will experience God's peace, which exceeds anything we can

understand. His peace will guard your hearts and minds as you live in Christ Jesus" (NLT 2004). So, keep praising God as you move along in what he has given you to do.

- *O for On Your Way!* You will indeed be on your way in accomplishing God's good plan for you as you live from a zealous heart, with intentional implementation, taking the time to ponder right steps, and praising him all the way!

I found out in the last weeks of my mother's life that she had always wanted to learn to play the piano and had felt the call toward missions. Both of those longings have been fulfilled through her children and her grandchildren because of her unique and persevering faithfulness to God.

Zipporah could never have dreamed of the immense blessing reaching down through the centuries, brought about because of her unusual action. Moses, the man whose life she saved, is the author of the first five books of the Old Testament, the Pentateuch or Torah, as it is called by our Jewish friends. Those five books are the basis for all the rest of Scripture. Thank God for courageous, unique Zipporah.

Zipporah and Torah ...

Unacclaimed
throughout the ages,
Undescribed
in verse or rhyme,
Unadmired; undesired,
unadvised act in time.

Does it matter
they ignore her?
Sacred pages hold her high.
Protector, parent, faithful partner;
God-filled acts are not denied.

Blessed the books
we call
Torah.
Blessed the one
who saved life,
Zipporah.

Does it matter
they may mock you?
God still guides you from on high.
Leader, agent of your vision,
He, your goal,
He, your prize.

— Ruth Tuttle Conard

4

DESIGNED TO WAIT

Hagar

Wait is an action word. I have often confused waiting with being passive, idle, or bored as in: Oh, (yawn) I'm just here patiently waiting.

But think of how the word has been used previously. For example, a common term in the mid-1800s was *ladies-in-waiting*.[1] These ladies attended queens, princesses, or wealthy, privileged women. As such, they were always at the bidding of every whim, desire, or fancy that might cross the fine lady's mind, day or night. They were actually very busy. They had to be very adept in many kinds of services. Not one moment was truly their own. To me the term *ladies-in-waiting* just doesn't match their job description. I think it should have been "ladies-in-a-frenzy."

Or consider our more modern word *waitress*. Perhaps you've worked in that position in a restaurant. Then you could fill me in,

I'm sure, on just how *un*-idle and *un*-passive that occupation is. And all of us, whether or not we have been a waitress, have been the ones who were expecting that our restaurant needs be met immediately.

The word *courage* combines well with the word *wait*. Courage means "mental or moral strength (firmness of mind) to venture, persevere or withstand opposition, danger, fear, or difficulty."[2] We need courage to wait, first, because waiting is an action and, second, because waiting itself can become the fear, the danger, or the difficulty. Third, we need courage because, I dare say, very few of us reading this page have been trained in the art of waiting. In fact, if we were brutally honest, many of us would put waiting in the same category as suffering. And we would immediately respond, "Thank you very much, but not today! I just have too much to do, and I cannot wait!"

Yet each one of us *is* waiting for some*thing*, some*one*, or some *time*. I challenge you. Pick up the phone right now and call a friend. Just try it. When she answers, ask her, "What are you waiting for?" See how she responds. She'll probably laugh, a little shocked, and say, "Well, actually, I was waiting for_____!" You fill in the blank. Frankly, most of our lives are occupied and preoccupied with some kind of waiting.

As I write these lines, I'm sitting in Singapore, far away from my home. I'm waiting for my husband, Bill, to return from another country. I'm also waiting for the time when I can see my children and five grandsons again.

One morning as I was blow-drying my hair, getting ready for work, I was also thinking about the story of Hagar. I glanced into the mirror of our bedroom. Suddenly, I became immobile.

It was as if I were no longer seeing the bedroom door through the mirror, but instead the goat-hair flap of a tent. The flap lifted. An old yet still beautiful woman squinted out across the scalding desert sand. She was not happy. I watched her lips draw back in a grimace as she grunted, "Great! I thought I got rid of her!"

The first part of this story is told in Genesis 16:1–6. This is the story of Abram, Sarai, and Hagar. Normally, the focus of this story centers on Abram or Sarai, but I want us to center in on the young, dark-skinned, undoubtedly beautiful Egyptian slave, Hagar.

According to the Midrash, a collection of early Jewish commentaries on biblical texts, Hagar was the daughter of the Egyptian pharaoh who took Sarai as his wife (Genesis 12), thinking she was the sister of Abram.[3] Even the Palestinian Targum considers her to be royalty, the daughter of Pharaoh.[4] While Sarai's life was in jeopardy, Abram received from the pharaoh male and female servants, donkeys, camels, and sheep, along with gold and silver.

But once poor Pharaoh realized he had the wife of Abram, and not his sister, perhaps Sarai received the best gift of all. It is believed that when the pharaoh witnessed the frightening miracle of the plagues brought upon him, he said, "It is better for Hagar to be a slave in Sarai's house than mistress in her own."[5]

One meaning for the name *Hagar* is "reward"—a reward given to Abram and to Sarai. Another meaning for her name is "to adorn," indicating that she was adorned with beauty, piety, and good deeds.[6]

Genesis 16:1–6 reads:

> Now Sarai, Abram's wife, had borne him no children. But she had an Egyptian maidservant named Hagar; so she said to Abram, "The LORD has kept me from having children.

Go, sleep with my maidservant; perhaps I can build a family through her."

Abram agreed to what Sarai said. So after Abram had been living in Canaan ten years, Sarai his wife took her Egyptian maidservant Hagar and gave her to her husband to be his wife. He slept with Hagar, and she conceived.

When she knew she was pregnant, she began to despise her mistress. Then Sarai said to Abram, "You are responsible for the wrong I am suffering. I put my servant in your arms, and now that she knows she is pregnant, she despises me. May the Lord judge between you and me."

"Your servant is in your hands," Abram said. "Do with her whatever you think best." Then Sarai mistreated Hagar; so she fled from her.

And so we find that Hagar served Sarai for years as her maidservant; yet, literally, she was a slave. But she was Sarai's slave and not Abram's. Unlike many women sold into slavery, she was not there to be sexually available to the men in the household. However, when Sarai gave up hope of having a child, Hagar had no voice in the decision to bear one for her.

Genesis 16:3 says that Sarai, Abram's wife, gave Hagar to him to be his wife also. This was a necessary concession if the child born from this union would have legal status as heir, but it was also a compromise that had disastrous consequences. It is the only time in the story that Hagar is called a wife.

This domestic arrangement was, evidently, short lived. As soon as Hagar discovered that she was pregnant with Abram's child, she despised Sarai. It was now apparent that Sarai was the infertile one,

and Hagar felt contempt for her mistress. She saw Sarai as less of a woman than she, the slave. Hagar had succeeded where her mistress failed. *She* had become pregnant, the greatest joy and duty of a wife at that time. But Hagar had not been purchased to be a concubine; she was a household slave.

Sarai wasted no time after talking with Abram, who rightly allowed Sarai to do what she wished with her own slave. The word used for Sarai's mistreatment of Hagar is the Hebrew word *anah*. This is the same word used to describe Egypt's oppression of Israel in Exodus 1:11–12.[7] Sarai's jealous harshness drove Hagar to flee for her life, out into the unending desert, a barren wilderness.

Genesis 16:7–15 reads:

> The angel of the LORD found Hagar near a spring in the desert; it was the spring that is beside the road to Shur. And he said, "Hagar, servant of Sarai, where have you come from, and where are you going?"
>
> "I'm running away from my mistress Sarai," she answered.
>
> Then the angel of the LORD told her, "Go back to your mistress and submit to her." The angel added, "I will so increase your descendants that they will be too numerous to count."
>
> The angel of the LORD also said to her: "You are now with child and you will have a son. You shall name him Ishmael [the name means "God hears"], for the LORD has heard of your misery. He will be a wild donkey of a man; his hand will be against everyone and everyone's hand against him, and he will live in hostility toward all his brothers."

She gave this name to the LORD who spoke to her: "You are the God who sees me," for she said, "I have now seen the One who sees me." That is why the well was called Beer Lahai Roi; it is still there, between Kadesh and Bered.

So Hagar bore Abram a son, and Abram gave the name Ishmael to the son she had borne.

Thrust into the desert to die, by a foreigner who hated her, from a career track she never chose, because of a plot she did not devise, she was found by the living God. God encountered her at a spring on the way to Shur, an area between Beersheba and Egypt, probably beside an uninhabited caravan route where flocks were pastured.

Here a stunning, beautiful theophany takes place, the first of its kind in the Holy Scriptures. A theophany is an appearance of the preincarnate Christ.[8] In the Scripture record, Christ appears *first,* not to a patriarch or to a well-known woman of faith, but to this unwanted, unknown, unloved young woman. God found her and spoke to her, calling her by name (Genesis 16:8).

So, let's focus on the *work* of waiting, for it truly requires work. Hagar shows us three important steps to take if we're going to profit from our waiting. Otherwise, we can become lazy, bitter, bored, or without hope in the process. These steps are to listen, to reflect, and to obey.

Step One: Listen

The first step in the work of waiting is to listen: Listen to the questions of God.

In my personal journey with God over the years, it is the questions I have been asked more than the answers I have been given that have awakened me to God's presence and guidance in my life. These questions have transformed my own waiting into times of growth and expectation.

Not all questions have the same effect on us, do they? Take the unexpected question, Will you marry me? If you have been asked that question, you probably still remember your first feelings.

Or take a question like our grandson Brandon, at about one and a half years of age, posed to my husband as he sat on Bill's lap, looking up into his face. Suddenly a look of horror crossed Brandon's little face as he whispered hoarsely, "Grandpa, are those cobwebs in your nose?"

Some questions stay with us. In facing them, our lives are never quite the same. A few years ago, Bill and I were sitting in a restaurant in Guangzhou, China. At our table sat the interpreter along with six other men and women we had never met before.

As we ate a delicious Chinese meal together, everyone conversed except for the young, small, fragile-looking woman at my side. Finally, out of curiosity I asked who she was. To my surprise this was the response: "Our sister is one of the finest preachers in the north of China." They saw my look (which was actually one of great awe), and they mistook it for displeasure. And then came their question: "Sister, do you have a problem with that?" I hurried to assure them that I did not. I asked about seminary training. Their laughter was an immediate indication that seminary training never entered the equation. She was gifted by God to preach and teach. Was there really another requirement?

A week later as we left that magnificent country, one question continued to haunt me. It seemed as if Christ's Spirit wouldn't let me forget it: "Ruth, do you have a problem with the way I choose to do my work? Do you have a problem with whom I choose to accomplish my purposes?" They were questions that would eventually bring focus to my whole life.

Do not deny the questions that murmur deep within your own soul. God, from his own example in the Word, has taught us to ask questions. Many people are threatened by questions. God is not threatened, nor is he afraid of our questions. In some circumstances we are taught not to ask questions, but that is exactly where we must ask questions. Is there a question you are afraid to ask? Why?

We have a compassionate and understanding God. He actually spoke to Hagar, not reprimanding, demanding, or even instructing her. No, he asked her questions to which she could respond, and in so doing, she had time to think about her actions.

In Genesis 16:8 God's first question to Hagar was, "Where have you come from?" The second followed close behind, "Where are you going?" Hagar spoke truth to the first question: she was running away from her mistress. Then she paused, because she wasn't sure where she was going.

These are relevant questions for you and me today in the twenty-first century. They are just as relevant as when they were asked by a preincarnate Christ to Hagar, our sister, thousands of years ago.

Think a little about that first question, God's question: "Where have you come from?" You might think about it spiritually. Do you know that Jehovah God intentionally made you? The psalmist David described a child's formation in her mother's womb in Psalm

139:13–14. What encouraging words these are for us as well! "For you created my inmost being; you knit me together in my mother's womb. I praise you because I am fearfully and wonderfully made; your works are wonderful, I know that full well."

Yes, truly God's works are wonderful; and you, my dear friend, are one of his intentional, wonderful works! And because he made you, you are under his loving surveillance. In Psalm 145:13 we're told that God is "loving toward all he has made." What a consolation!

Or you might think about the question of where you came from as it relates to your family of origin, the family into which you were born. That may make you either happy or sad. God knows all about your family of origin, all you may have suffered, and your journey onward since then.

He comes to ask us these questions, not to reprimand us or to frighten us, but to let us know that he is compassionate and loving. He wants to help us through those real or perceived difficulties from our past, for example, our sadness, losses, grief, and sins. As we come to him and talk to him about those things (perhaps writing any negatives we can think of from our past on a sheet of paper), God will forgive us if we ask him. In 1 John 1:9 we are told, "If we confess our sins, he is faithful and just and will forgive us our sins and purify us from all unrighteousness." What a glorious promise! Claim it, my friend!

He will also lift your burdens, share your sorrows, remove your fears, and give you the power and grace to forgive others, as you claim his peace and power in your life over where you have come from. In 1 Peter 5:7 we read, "Cast all your anxiety on him because he cares for you."

Christ can do that because he is the living God. Christ can do that because he died on the cross to save us from all our sins. Christ can do that because he was and is victorious over Satan, proving it by rising from the grave on the third day. Turn to Christ today. Put all your faith in him, the living God, full of grace and truth.

The apostle Paul wrote in Romans 8:37–39: "No, in all these things [all the issues and hardships of life we can imagine] we are more than conquerors through him who loved us. For I am convinced that neither death nor life, neither angels nor demons, neither the present nor the future, nor any powers, neither height nor depth, nor anything else [including where we have come from] in all creation, will be able to separate us from the love of God that is in Christ Jesus our Lord." Praise God!

The first question, "Where have you come from?" was a mighty good one for Hagar to ponder and for us as well. The second question stopped Hagar in her tracks: "Where are you going?" Hagar paused because she really wasn't at all sure of her future. And you may feel the same. You may feel very uncomfortable thinking about your future.

But remember, God doesn't ask us questions to frighten or intimidate us, but to help us stop and consider—consider our ways, consider our direction, consider where our actions may be leading us. And consider that he desires to be the guide of our lives. Again, take time to ponder that second question.

Step Two: Reflect

If the first step in the work of waiting is to listen, the second step is to reflect: Reflect on God's questions to your soul.

Bill and I were married for nine years when we went away alone for a weekend—the first time since our three children were born. Now that in itself was exciting! But we went with the overall purpose of seeking God as to where we were going. Where were we headed in life? What did we feel God drawing us to? Would we spend all our lives in Peru, where we had been living since marriage? We were willing to do that, but we sensed the need to pause and reflect a bit.

A guide sheet we received through the mail was a powerful and provocative tool. We prayed together and then went to separate rooms in the hotel where we were staying, so that we could think independently of one another. The sheet asked the following questions:

- What would you like to have accomplished in your life by the time you are seventy?
- What do you need to do in the next year to begin to take steps toward that goal?
- What do you need to have accomplished in the next five years and the next ten years to further achieve that goal?

As we thought about our God-given talents and our motivational passions in life, we began to sense God drawing us toward certain areas. That was many years ago. The age of seventy seemed like a thousand unlikely years away.

Bill was able to envision the future much more clearly than I. Although at that time I was thinking much more about being Bill's wife, surviving in a culture not my own, and being day in, day out with three small children, still it was a great exercise for me.

Today, by God's grace, both Bill and I have accomplished most of the goals we wrote down that day and are totally involved in the

hazy vision God laid on our hearts that weekend so many years ago. It has certainly not been a straight or easy path! But it rarely is for anyone. Yet, we have the promises of our living, loving God, who says, "Delight yourself in the LORD and he will give you the desires of your heart" (Psalm 37:4). God is your shepherd. God is your light. God is your guide. God is your provider and sustainer.

I challenge you to dream with God. Put your desires out there. I encourage you to do the exercise above. You won't see it all clearly, but God will show you little by little. We all know that if we never set a goal, we will definitely never reach a goal. God wants us to live life purposefully with him. He will help you take small steps and gently increase your vision and means and then open doors as you walk with him. And there *will* be times—many times—of waiting.

In that time of reflection, take hold of the promises of God. Hagar is an excellent example of this. In the passage we read above, Genesis 16:7–15, we see that God ministered to Hagar in her great despair. He filled her ears and her vision with his promises. He gave her a promise in verse 10, which was reminiscent of the one he gave to Abram in Genesis 13:16. He gave the son growing in her womb a name with a promise embedded in it, for Ishmael means "God hears."[9] And while the prophecy in verse 12 may seem harsh to us regarding Ishmael, it must have given hope to this young mother. God was forming within her, not a weak child, but a very strong one—strong enough to survive and do well in the desert wasteland in which they would live, strong enough to provide for his mother, and strong enough to build a kingdom with twelve princes surrounding him.

What promises is God whispering into your ear in this time of waiting? Be very attentive to them. Write them down. Memorize them. Put your faith anew in the Lord, who gave them to you. They will take you through this season—whether it be long or short, sweet or painful; God's promises will give you hope. And he will fulfill them.

This, I believe, is how Hagar managed to live fourteen more years in the same tent with Sarai. God's promises were embedded in her thoughts, her heart, and her actions. Hagar endured.

Step Three: Obey

After listening and reflecting, the third step in the work of waiting is to obey: Obey God in your present situation.

I don't know what that means for you. For most of us, it is not easy. Certainly, it wasn't for Hagar. I'm sure with every sandaled step through the hot sand, headed back to Sarai's tent, she thought, *I cannot believe I'm doing this! What am I thinking?* But because she had an encounter with the living God, I can also imagine her heart singing, *He sees me. He knows me. There's hope for my son. There's a future. I will obey him!*

Maybe you will be asked by Christ to voice your opinion, to serve others, to stand up to injustice in your situation, to preach the Word, to humble yourself, to remain longer in a job than you had hoped, to share his love, or to make a home for a child. I don't know. I just know that the Word of God says in Luke 16:10 that when we continue to be faithful in that which we may consider small, God recognizes that we will also be faithful in larger areas as well. God's

timing is everything. In the obeying, we learn patience and empathy with others and trust in God, who gives us his promises.

Hagar returned to the tent of Sarai and Abram. God blessed them with their own son, Isaac (Genesis 21). At a special party for Isaac, Sarai became angered over the way Ishmael was treating Isaac. Once again, she demanded of Abram that he turn Hagar and Ishmael out into the desert. Imagine the distress of Abram as he watched his beloved son Ishmael leave. Imagine the deep sorrow and fear of Ishmael, leaving his father and his little brother. Imagine the horror of Hagar. Genesis 21:14 says, "She [Hagar] went on her way and wandered in the desert of Beersheba."

But God did not take his eye off Hagar and Ishmael. He had created them in love, just as he had Abraham, Sarah, and Isaac. He had plans for them. From Hagar, Ishmael, and their descendants have come more than a billion Arabs and Muslims. These are people who God made and for whom Christ died. These are people God deeply loves. Once she was in the desert again, God drew near to Hagar and to her teenage son, Ishmael.

The third question to Hagar came in her darkest hour. The setting is found in Genesis 21:14–21. God asked gently, as he found Hagar sobbing, "What is the matter, Hagar?" It's not that he didn't know, but that he is kind and gave her a chance to respond.

God added some other words in that instance to let Hagar know that she did not stand condemned or judged or in ridicule for her tears. He said, "Do not be afraid." Isn't that beautiful? God understands us.

It reminds me of another time in another place when Jesus (God walking on this earth) spoke to Mary Magdalene in the garden

after he had risen from the grave. He found her crying because she thought someone had carried his body away. And he said gently in John 20:15, "Woman, . . . why are you crying? Who is it you are looking for?"

When I was a young mother, I had many tears. I cried out of loneliness. I cried out of desperation. I cried because I had questions that no one seemed able to answer, I had worries that didn't seem to be resolved, and I had real and perceived fears. Often, if someone asked, "Why are you crying?" my answer was, "I don't know." And that was that.

I wouldn't or I couldn't pause long enough at that point in my life, nor was I sure who I could really trust to help me discover the source of my tears. That was not good, certainly not for me and most certainly not for those around me.

As I slowly stumbled along, totally aware of my own fragility, Jesus put friends along my path, true friends—those who would say, "Do not be afraid, Ruth. Why are you crying?" And there came that time when I could cry freely and speak honestly as if it were to Jesus. But, actually, I was speaking to a flesh-and-blood spiritual mentor or a mature friend, a live person before me who really heard me, quietly talked with me, and prayed with me in tenderness and compassion. Today, I am healed of that deep weeping.

My dear sister, Jesus truly desires that you have that kind of friend. He most certainly *is* that kind of friend! But God has also gifted those in his body with special gifts of discernment and a praying spirit—without judgment, without criticism—to guide others on their way to victory and hope. They do not give the answers, but they, like Jesus, ask the right questions. Seek out those people. Ask

God to put them in your path. You will be blessed, your life will be filled anew with hope, and great healing will come to your soul.

Remember, *wait* is an action verb. So, which action are you pursuing? Listening? Reflecting? Obeying?

Are these some of the questions near to your heart?

Where have you come from?

Where are you going?

What is the matter?

Why are you crying?

I hope you will take time to write your thoughts around these questions and discuss those thoughts with Christ as you talk with him. Perhaps, in the quietness, he may even impress on your mind some other questions.

And so, Sarah lifted the tent flap and discovered moving toward her what she most dreaded, the return of Hagar. For some fourteen to sixteen years those two women again inhabited the same living space. Hagar birthed Ishmael. The two women continued in the same space . . . together. Ishmael grew and developed and bonded in a strong and loving relationship with his father, Abraham, Sarah's husband. Still, those two women inhabited the same living space. Did their relationship improve? Did some aspects improve while others remained the same? Nothing from the text indicates improvement.

When Sarah erupted again in anger, demanding of Abraham that Hagar and Ishmael be cast out, she referred to Hagar—not by her name nor as "wife"—but rather as "that slave woman" or "bondservant."

Have you had to put up with someone or some unexpected circumstance in your life? Perhaps over a long number of years? How have you responded? Or how are you responding?

After we returned in 1984 from being full-time missionaries, I spent the next fifteen years working in an area in which I did not feel competent. I found this shocking. Never in my life had I imagined that the call of God would take me where I found myself, and I did not always want to be there.

During those years there were times when I kicked and screamed, making life miserable for everyone around me, including myself. I pleaded with God over and over again to release me from what I considered bondage. What on earth would become of me? Would this be my life forever? What about the pastoral and teaching gifts I had so enjoyed using in God's kingdom work? How could I possibly continue honing those primary gifts that gave me such satisfaction and had been used to enrich others while I worked forty hours a week in another area?

Nothing is wasted in our lives when we keep loving God and seeking his will. Nothing is wasted—not any sorrow, suffering, grief, or loss, nor is time. God loves us and will redeem it all—for his glory and our pleasure—as we continue to follow him in humble obedience. Not that I have always followed him humbly. God is also gracious and patient.

"The real journey takes place within," writes my friend Joann Nesser.[10] Will we continue to be faithful to God when we do not understand the unexpected turns in the road? The unimagined delays to our plans? The unplanned events in the course of life? Will we

allow the transformation within us that God lovingly desires to bring about?

From those years of working outside my perceived strengths, God greatly enriched my life in ways I never dreamed possible. He gave me strong, life-giving friendships among people with a much broader view of life than I had embraced. He satisfied the deep longing I had for study by shepherding me through five years of upper-level studies at a greatly reduced cost. He designed unique opportunities for me to serve among students as well as others outside of campus life. He gave me a compassionate understanding for the woman who must leave her home every day and work outside, while she struggles to maintain her family. And he gave me an understanding of women, like myself, who need a few hours reprieve daily from the home, in order to return refreshed and creative to fulfill its joys and demands. Through those fifteen years, God also gave my husband and me a deeper appreciation of what it means to be partners together in God's kingdom work.

Those fifteen years of working in an area I would not have chosen became the God-designed springboard for the very rich current years of ministry. What seemed impossible for me has happened and is happening. One example is that as I work on this chapter, I'm actually sitting in Cairo, Egypt, looking out my window, watching Hagar's daughters stroll along the ancient Nile River. I receive it all as a gift.

Sometimes in the ups and downs of life, with its passions and its problems, we lose sight of the big picture. God never does. Today he holds your desires, your life, and your future in loving hands, with

deepest regard for you, his one-of-a-kind, precious daughter. Trust him. Seek him. Accept his timing. Move forward with him.

God fulfilled all his promises to Hagar. She was blessed. She was able to find an Egyptian wife (from her own people) for her son Ishmael. And we know that Ishmael and Isaac came together once again when they met to bury their father, Abraham. Genesis 25:9 says, "His sons Isaac and Ishmael buried him in the cave of Machpelah near Mamre."

What do you see as you lift the flap of your tent? How will God use it in your life? "Wait patiently for the LORD. Be brave and courageous. Yes, wait patiently for the LORD" (Psalm 27:14 NLT 1996). "Put your hope in the LORD. Travel steadily along his path" (Psalm 37:34 NLT 2004).

So, wait . . . actively . . . because God has much in store for you!

unlikely recipient . . .

In wilderness vast,
the Lord who still loved her,
(designing the child
in her womb),
drew near to Hagar,
engaged conversation,
released her
from harsh,
gritty doom.

For Christ she was somebody,
precious, esteemed.
Not a nobody—loser—
built to demean.
By a well, Living Water
called her
to dream.

Hagar, with promise
to offset the fears.
Hagar, with future
through more slavish years.
Hagar, with hope
for she saw the Unseen,
embraced the impossible,
Hagar—
redeemed.

— Ruth Tuttle Conard

5

DESIGNED TO TAKE CHARGE

CRuth

"Would you please take charge of this?" What emotions surge through you when you hear that question? Satisfaction that you are considered competent? Terror at being responsible for something you never imagined? A sense of *No big deal—I certainly can do that.* Or maybe you have felt, *Well, it's about time—that's what I've wanted from the beginning!*

My own experience in this arena has produced a wide range of emotions. I've gone from feelings of great gusto to paranoia, to doubting my own abilities and "rights" as a Christian woman, to even humiliation and horror. And it's an event surrounding that last state of emotions that I want to begin with.

For a number of years in the late 1980s, my husband was the international coordinator for a West Coast evangelist. He was asked

to travel for one month throughout the Far East. This included China, Hong Kong, Japan, Thailand, and Singapore. The purpose of the trip was to explore possibilities for our evangelist friend to have meetings in those countries. Bill invited me to accompany him. I was greatly honored. Our three children were teenagers at the time. As you can imagine, it took weeks to organize everything that needed to be taken care of for our children, our house, and my part-time employment, while Bill and I traveled.

As we flew out of Portland, Oregon, my heart was happy, yet I clung to the phrase out of Psalm 65:2 that I'd read that morning, "O you who hear prayer." It was the first time I'd ever been gone so long and so far away from our children. While my body sat in the seat beside my husband, a majority of my inner self fretted over those vibrant teenagers—in continual prayer for them.

Tokyo was our first stop. Somehow we missed our point person there and spent the first couple of days smiling and gesturing with our hands, trying to make sense of this foreign world. In restaurants I again fussed with God over how he'd made me so tall and ungainly. Japanese men and women, upon being seated, shed their soft shoes immediately, lifting their legs neatly and comfortably under them, cross-legged on the restaurant chairs—something I've never been able to do, even as a child. The pain from that posture far outweighs all thoughts of fitting in cross-culturally.

We also ended up sleeping not in a tourist hotel, but in a *riojan*, an authentic Japanese inn. This meant our bathroom had a very deep, very short bathtub, and fresh kimonos were supplied each morning. At night we unrolled reed mats and slept on the floor.

Tokyo is an immense and fascinating city, the second largest in the entire world. So while I enjoyed looking and experiencing, Bill raced around to find his work contacts and finalize a special meeting with ten key Christian leaders who were to arrive from outlying cities.

Bill is very competent in making presentations, even through an interpreter. The presentations were built around an excellent video that Bill had worked on for weeks to perfect and use throughout our trip.

The morning of the important encounter dawned. Bill asked if I would carry his briefcase holding the video, so he could take care of the rest of our luggage. We laughed together as he commented that he was "handing me his life" and that he would be a "dead duck in the water" if I lost it. Well, of course I wouldn't lose it! I mean, this was my chance to *do* something on this trip, other than just follow him around. I was capable of taking charge of at least a measly (yet very important) briefcase.

The taxi came for us—a taxi that looked exactly like the thousands of other black taxis in Tokyo. There was much presenting and bowing, opening and closing of umbrellas, since it was raining, struggles to get our luggage in the back, and then we were on our way with two of our Japanese hosts. I gently lowered the heavy briefcase to the floor beside me and slid closer to Bill, whose hands were full of other paraphernalia.

Suddenly, we were in downtown Tokyo. The pace picked up considerably. The very narrow streets encased hundreds of honking cars. We paused to jump quickly onto the sidewalk, drag out our luggage plus umbrellas, and enter the lobby of a skyscraper. Our

Japanese friends put us into the small elevator and ran out to pay the cab driver. The doors closed. Bill began to count the pieces we'd brought with us. Truth dawned simultaneously for both of us. The all-important briefcase was still back in the taxi cab!

There wasn't much time for anger, remorse, tears, or even "I'm so sorry!" The elevator doors opened. Bill deposited me with the luggage in a roomful of gawking Japanese men half my height and disappeared once again into the elevator, hoping to encounter that taxi. It had vanished, of course, while several hundred clones raced by.

Frankly, I was in no way prepared for what had just occurred to me. In a foreign country, with an unknown language, at a major first meeting for my husband, I had just failed miserably at taking charge.

I think Ruth and her mother-in-law, Naomi, could identify with the kind of feelings we often have when it comes to taking charge.

The book of Ruth in the Old Testament is indeed a unique book. Only two books in the Bible are named for women. Ruth is one and Esther is the other. Esther was a Hebrew woman who married a Gentile king. God used her in a strategic time in the history of Israel to preserve the nation from destruction. Conversely, Ruth was a Gentile woman who married a Hebrew man. God used her to perpetuate the line of the Messiah, the Lord Jesus Christ.

Interestingly, the book of Ruth is the only Bible book written from a woman's perspective. The main characters are women. Other women are in the background, giving comments—almost like a chorus. And in the male-oriented society of those days, where women received their major value through marriage and bearing male heirs,

we find not only two *single* women, but, even lower on society's scale, *widows* with no living children.

There is no one to take charge of them or take responsibility for them. One is a foreigner in a strange land. The other is now leaving all she has known to become a foreigner. Yet God has always had an eye out for the widow, the orphan, the poor, and the foreigner. Even today he continues to use the improbable, the impossible, the ignored and unseen around us to accomplish his eternal purposes.

In my home is a slim wooden figurine that comes to mind as I think of taking charge. It's of two women leaning toward one another in an embrace. It speaks to me of mutual support, perhaps of mentoring one another. It could be two friends. It could be a mother and daughter. It could be Elizabeth and Mary in the New Testament or Naomi and Ruth in the Old Testament. In any case, we, as women, need other women.

What can these two courageous women, Ruth and Naomi, teach us about taking charge of our lives in the twenty-first century? What can we learn about our loving God and his involvement with us?

Let's begin by reading the first lines in Ruth: "In the days when the judges ruled, there was a famine in the land, and a man from Bethlehem in Judah, together with his wife and two sons, went to live for a while in the country of Moab. The man's name was Elimelech, his wife's name Naomi, and the names of his two sons were Mahlon and Kilion. They were Ephrathites from Bethlehem, Judah. And they went to Moab and lived there."

The book of Ruth takes place in the time of the judges, an era marked by weak faith and irresponsible conduct. The theme verse of this time is found in the book of Judges, the last verse of the last

chapter: "Everyone did as he saw fit" (21:25). And they did. It was a time of lawlessness and heinous crimes toward women and men. This is the backdrop for the book of Ruth. However, this book shows us that even in the worst possible times of *every* era in history, there are individuals seeking God, and God is faithful to them.

The Moabites, Ruth's people, were a pagan nation that often warred against Israel. At one point, Israel was dominated by Moab for eighteen years. In Numbers 25 we find Moabite women seducing Hebrew men to worship their pagan fertility gods. In the book of Deuteronomy, God said that "no . . . Moabite or any of his descendants may enter the assembly of the LORD" (23:3). But the Hebrew Elimelech chose to take his family to this land when famine struck Israel.

Let's read on: "Now Elimelech, Naomi's husband, died, and she was left with her two sons. They married Moabite women, one named Orpah and the other Ruth. After they had lived there about ten years, both Mahlon and Kilion also died, and Naomi was left without her two sons and her husband" (Ruth 1:3–5).

Naomi was left alone with perhaps her worst nightmare. She was a foreigner in enemy territory, an older woman with no men to protect her, no grandchildren to delight her, and her two Moabite daughters-in-law living with her. At that point, Naomi heard that, once again, there was food in Israel. And she made a monumental choice.

Here we encounter the first step of three that we need to follow if we're going to take charge of our own lives. These steps are (1) accept the responsibility of choice, (2) accept the companionship of positive others, and (3) accept the process of time.

Accept the Responsibility of Choice

Amy Carmichael[1] was a missionary to India and a prolific writer in the 1800s. One of her one-liners is "In acceptance lieth peace." I didn't like that statement until I realized that Amy Carmichael was no wallflower. She wasn't saying, "Lie down and play dead. Let others step on you. Ask no questions. Submit to whatever your life circumstances are." Absolutely not!

This single missionary woman in India was a crusader for justice. Over a period of fifty years, she rescued girls from temple prostitution, risking her life to give them a safe environment, life skills, and hope for this life as well as for life eternal. I believe that the phrase "In acceptance lieth peace" does not mean accept and *stop*, but, rather, accept the reality of where you are and *continue on* from there, with God's help and according to his will.

Are we responsible? Will we accept the responsibility of having choices and options? We North American women have more options and choices than any other women on the face of the globe. Yet, at times, we act as though we had none. Buying and selling, beauty and fashion, eating and chatting threaten to consume us.

Often we would rather pretend that we are weak and can't make it or that we don't understand the process of decision making. Do we want another to make all our choices, so later we can blame him or her if it doesn't turn out as we anticipated? Do we hope (unrealistically) that someone else will care for us all our life? Do we believe that we deserve more and more, because we are women or that we are too fragile to take any risks? Do we actually believe that someone else (maybe a husband or another good man) will stand before God on that final day and plead our case for why we did not reach out, take

a risk, and use the gifts God has given us? Dear friend, if you think you have no options, no choices, then you are living at a dead end, in a fanciful and unrealistic world.

Helen Keller, without physical eyesight, had a wonderful perception of reality. She said, "Security is mostly a superstition. It does not exist in nature, nor does humankind as a whole experience it. Avoiding danger is no safer in the long run than outright exposure. Life is either a daring adventure or nothing."[2]

Back to Tokyo. As I sat behind a divider, choking on seaweed tea, I had *a choice to make*. I could be angry with myself and pout. I could try and blame Bill. I could cry. I could choose to be in fear of what Bill would say and become immobile. Or I could pray! At that moment it was my only hope. I had only prayer and my Bible.

It was October 14. That morning I had read Psalm 66. If you read five psalms a day, Psalm 66 is one of the five for the fourteenth day of the month. I opened my Bible. Psalm 66, verse 7, again drew my attention: "His eyes watch the nations."

I began to pray, "O God, you see all the nations. You see Japan. Your eyes are watching over this vast city, Tokyo. O Lord, you see me and my husband in this terrible dilemma. And you see that *one* black taxi among the thousands. And my loving God, you even see Bill's briefcase in that taxi. Please, God, protect it and bring it back to us."

I have no idea what *you* need to take charge of as you read this. Maybe it's within your home. Maybe it's in your work setting. Possibly it's a lie you accept because you feel intimidated and have a mind full of fear. Perhaps you are struggling with an addiction. Or there is a conversation that you need to initiate, some straightforward

truth you need to say to someone. Maybe it has to do with priorities in your life or your attitude toward someone or something. Possibly you live in denial concerning the reality of your life. Maybe your relationship with God is in shambles.

Whatever the Spirit of God brings to your mind in these moments, I invite you to accept the responsibility of choices and options that you have and *take charge*, with God's help, of that area of your life. God will give you courage, peace, ideas, and strength to persevere.

Naomi took charge. It certainly wasn't easy. She realized there was food in her home country; she probably thought about her advancing age as well. At home she would at least be in her own community among people who had previously known her. Not envisioning that anyone would accompany her, it meant leaving two daughters-in-law behind.

From the text I think it is obvious that these three women had come to care for and respect one another. The two young women had watched the faith of their mother-in-law in the one true God, Yahweh. They had watched God's comfort and sustaining power over her as she weathered much personal trauma.

Naomi's choice also meant that she would walk fifty long miles alone through embattled, dangerous territory from the far side of the Dead Sea, around its northern tip, to Bethlehem. She had no idea what awaited her. It was a hard decision, a courageous decision. She analyzed her situation, faced the truth, and took charge of her own life.

Chapter 1 continues the narration of this heart-wrenching drama. The two daughters-in-law decided to go with her. But somewhere

beyond the city gate, Naomi had a heart-to-heart talk with Orpah and Ruth, underscoring the fact that she could have no more sons. She counseled them to turn back to their people with the hope that they would remarry. (How a Jewess could encourage two young women to return to their false gods is difficult for me to understand.) Orpah took the advice and, weeping, turned back to her city.

Not Ruth. She broke forth into this famous, impassioned cry: "Don't urge me to leave you or to turn back from you. Where you go I will go, and where you stay I will stay. Your people will be my people and your God my God. Where you die I will die, and there I will be buried. May the LORD deal with me, be it ever so severely, if anything but death separates you and me" (1:16–17).

Ruth decided to leave all she had ever known—what a choice! She would be a foreigner, an alien, in Judah. Without a husband she would have no social status or security. There would be strange new customs and no support system in the adjustments. But she made this extraordinary choice in order to accompany her mother-in-law. In Naomi, Ruth had seen persevering faith in the throes of desperate circumstances. Ruth had witnessed Naomi's deep allegiance to Yahweh. And this one true God had never failed her. Ruth's new faith in Naomi's God enabled her to step into the unknown.

They journeyed together. As they reentered Israel and the area around Bethlehem, the townspeople recognized Naomi. They were stirred and amazed to see her again. The women whispered to one another, "Can this be Naomi?" Remember—it had been more than ten years since they had last seen her. She had just limped in from an arduous trip—fifty miles of dusty road that undoubtedly brought

sleep deprivation, hunger, and anxiety with every step. Beside Naomi walked a strange young woman they did not know.

All the faith that Ruth had witnessed in Naomi mingled with the dust of Naomi's sandals in her opening declaration to old friends: "'Don't call me Naomi [which means pleasantness[3]],' she told them. 'Call me Mara [bitter], because the Almighty has made my life very bitter. I went away full [she had a husband and sons, although physically she probably had been rather empty, since they left Israel during a famine], but the LORD has brought me back empty [I have no husband or sons]. Why call me Naomi? The LORD has afflicted me; the Almighty has brought misfortune upon me'" (1:20–21).

And this is why the second point in taking charge is so important.

Accept the Companionship of Positive Others

In one sense, Naomi had returned "full." Beside her walked the Moabitess. Ruth was young and strong, vibrant, a trustworthy companion, and dedicated to Naomi, in whom she wholly believed and fully trusted. But at this point, Naomi was blind to that beautiful companionship. Bitterness had warped her vision as well as her soul.

How important it is to recognize the positive companions beside you as you seek to take charge of a part of your life. They may not be family members or your best friends. God may choose to bring someone new, someone different to walk beside you for this period. God may even choose to relocate you geographically. If that is the

case, draw near to God, and be willing to accept those changes to enable and empower you to take charge of your life in obedience to Christ's call.

At this point, Naomi could see only what she had always known. To her, all was loss with no gain. To her, *fullness* meant a husband and sons. And she vented against God.

What have you taken fullness to mean in your life? A good job? Marriage? Perfect kids? Never moving? Staying in the same church? But now, for some reason, your world has been shaken. Look around carefully. Accept the companionship of others who positively believe in you and are faith filled, believing what God is calling you to.

In Tokyo the door opened to the room where I sat praying. A Japanese man entered, motioning for me to follow him. I slipped out. "I think I can find that taxi if you give me some information," he said in halting English. *Oh, sure!* was my first mental response. I was totally cynical.

"Let's walk down to the police box on the street. We'll find it." *Oh, sure!* I again countered inwardly. I explained to him that our family had just lived in another large city of the world for seven years. Nothing lost was ever found, and you still paid a hefty price for even wanting to find it. He assured me that Japan was different.

So we entered the tiny police box on the corner, in the center of two busy streets. I proceeded to give descriptions, as best I could, of time, place, size of briefcase, and what the taxi looked like. *As if that taxi looks any different from the thousands roaring around us at this very moment,* I grumbled to myself.

As my companion accompanied me back to the seventeenth floor and deposited me behind the dividing screen, I wondered, *Is*

he the answer to my prayer of God's eyes being on the nations? Or just a kind person wanting to appease a disgruntled tourist? At this point *I* was Naomi, and the good gentleman was my hope-giving Ruth.

As we return to the narrative of Ruth and Naomi, we find the third point in taking charge of our lives.

Accept the Process of Time

The two women stumbled into Bethlehem sometime around the month of April, "as the barley harvest was beginning. Now Naomi had a relative on her husband's side, from the clan of Elimelech, a man of standing, whose name was Boaz" (1:22–2:1).

We need to remember as we read this story that their customs were unlike ours. Ruth was poor, a woman, and a foreigner—three strikes against her, *except* that she was upright in her actions, courageous, and not ashamed to work to supply for Naomi and herself.

A good Israelite law, prompted by God's love and care for the poor and the alien (Leviticus 19:9–10), provided disadvantaged people with work. They were allowed to pick up the leftover grain from the fields after the male reapers had finished.

Ruth 2:9 and 2:22 tell us that it was not an especially safe work for Ruth, alone among men in the fields. She had to be careful as a single, foreign woman. She needed to stay close to the other women and never look at the men who worked in the vicinity.

Ruth was willing to do this work, and Naomi (shedding some of her bitterness and beginning to think of others) encouraged her to do so. God was watching out for Ruth as well. Unknowingly, she found herself in the fields of Boaz, Naomi's relative.

Boaz was a good and strong man, respected by his workers, capable, efficient, and living an exemplary life in the community. Boaz noticed Ruth. They had a conversation that involved more than a simple discussion about how she could be safe in his fields. Boaz said in 2:11–12, "I've been told all about what you have done for your mother-in-law since the death of your husband—how you left your father and mother and your homeland and came to live with a people you did not know before. May the LORD repay you for what you have done. May you be richly rewarded by the LORD, the God of Israel, under whose wings you have come to take refuge."

Ruth's good works spilled out ahead of her, a life-giving fragrance that was attractive even to those who had not yet met her. She finished two seasons, from April to June (the barley and wheat harvests), still protected in the fields of Boaz.

Naomi recognized Boaz as a "close relative . . . one of our kinsman-redeemers" (2:20). The Hebrew word for *kinsman-redeemer* is *goel*.[4] It means a close family member who has the obligation to redeem, to take or buy back. Buy back what? Land. The land had been lost to Naomi (and thus to her clan) because her husband, Elimelech, was dead. Remember, in ancient Israel land was extremely important. It was a person's immediate source of livelihood and, usually, assured some kind of future.

But that was not the only responsibility involved (see Deuteronomy 25:5–10). This man was also to marry the widow to carry on the family line. However, in the case of Naomi, childbearing was no longer possible. Although Ruth was free to marry whom she would choose, if a male family member was found willing to

take this step, Ruth (as the widow of Elimelech's older son, Mahlon) could enter into this type of marriage to continue the family line.

As we come to chapter 3, we find Naomi and Ruth working as compatible companions. While Ruth worked hard every day in the fields to provide for Naomi, Naomi's mind worked hard to come up with a plan that would provide a future for Ruth (3:1–4). Ruth, again taking the risk of rejection, stated, "I will do whatever you say," in response to Naomi's plan.

That night, after darkness fell, Ruth went quietly to the threshing floor where Boaz lay asleep, protecting the grain. She lay down near him, uncovering his feet. This was a symbolic act that was completely proper in that time and place.[5] The text says he awoke, startled that a woman was near him. There was no expectancy of this on his part. She declared who she was and asked that he spread a corner of his garment over her, "since you are a kinsman-redeemer."

Boaz recognized this action as an appeal that he respond to, not only as *goel*, redeemer of Elimelech's land, but also as one willing to marry her. Boaz spoke beautiful words of affirmation to Ruth and quieted her fears (3:10–14). He praised her for her kindness, for her self-discipline with younger men, and for being known "by all my fellow townsmen" as a woman of noble character. He told her not to be afraid, that he would do all she asked. Under cover of early morning's deep darkness, Ruth returned home with her shawl full of grain that Boaz had poured into it.

There was one glitch. Boaz stated this honestly to Ruth. There was a kinsman-redeemer closer to the family than Boaz himself. This man had first dibs for the land *and* for Ruth.

"Oh no!" we groan. But isn't that the way it is? We take a step of faith. We have anguished over it. We feel, and others assure us also, that we have taken the right step. And then, horrors! A wall is erected in front of us, a person stands against us, the timing becomes crazy, and smooth waters suddenly erupt in turbulence.

At this point, all three characters—Naomi, Ruth, and Boaz—give us insight regarding obstacles. Whatever the despair was that filled Ruth's heart, *Naomi's advice was wise.* She said (and I paraphrase), "Wait, Ruth. Wait until we see what actually happens. Trust Boaz to fulfill his promise. Don't freak out. Continue being the faithful and faith-filled woman you are" (3:18).

And Ruth? *Ruth took the advice of this wise woman and waited.* I don't think she threw a hissy fit over what might happen if it didn't work out with Boaz. I don't think she pouted, flounced around, or said she didn't feel like working in the fields the next day. I don't even think she toyed with the idea that maybe all her worship of Yahweh and love of Naomi had been in vain. No, I think she simply waited.

Scripture tells us in Psalm 27:14, "Wait for the LORD; be strong and take heart and wait for the LORD." And Isaiah 30:15 states, "In quietness and trust is your strength."

In the meantime, *Boaz fulfilled his verbal commitment to Ruth.* No matter what Boaz felt inside (actually, we have no indication of romantic feelings), he committed the situation to God and took the right steps. He publicly spoke honestly and kindly to the nearest kinsman-redeemer in the presence of witnesses. How hard it can be at times to just simply *do the right thing.* Speak up, wait, say the truth in love, be patient for others to understand, love when others speak

against you, be in silence, and pray. Boaz was a man of his word and did the right thing.

At first the kinsman-redeemer said he could buy the property. But when he realized there was marriage involved, he said he could not marry Ruth. The kinsman-redeemer then removed his sandal, symbolizing that Boaz had the right to walk on the land as his property.

Before the whole town, Boaz was not ashamed to name his wife as "Ruth the Moabitess" (4:10), because he saw her as a "woman of noble character" (3:11). He respected her as a worthy person (even as Jesus Christ sees you and me) and was proud to take her as his own.

In Tokyo, after the meeting (which actually went well) and many goodbyes, we immediately boarded the bullet train for a distant city. Without the briefcase. That evening and through the night we waited, tossing and turning in our bed. Even during the night, Bill inquired at the front desk of the hotel, in case we had misinterpreted a word of instruction or overlooked some positive Japanese signal. But there was no sign of the briefcase.

We arose in the morning with heavy hearts. No further word of the briefcase. Late in the afternoon, as our hopes were plummeting with the setting sun, we heard a soft knock on the door. Bill and I almost collided as we raced across the room together. Bill swung open the door. A hotel porter bowed, handing us—you guessed it—the briefcase! It was intact, complete. Not one item had been moved or removed from it.

This *process of time* is critical as we take charge of our lives. Even the phrase sounds antiquated to us. It is. In our culture, "process of time" is truly countercultural. Through North American ideals,

and especially via the media, we are taught to demand and expect instant gratification. It doesn't matter how we get it. In our culture it has nothing to do with good or bad choices. It doesn't matter how young, inexperienced, or naive we are. It doesn't matter how old we are or how undeserving or lazy we have been all our lives. We feel we deserve something and should have that something now!

Often we may desire or even covet something, but we don't want to do the hard work to obtain it. We don't want to be patient; we expect to receive immediate rewards. Yet, that is *never* God's way. Readiness is always preceded by and nurtured in the process of time. In that process of time, there are four components:

- **Routine**. For Ruth it was the hard work of gleaning. Day in, day out. Truly backbreaking labor. What will it be for you? Are you being faithful where you are today? Do you have a goal? How long will it take? Start to make a plan.

- **Risk**. For Ruth it was leaving her land, being out in those fields with rough men, going to the threshing floor and laying out her plan with the possibility of being rejected. In taking charge of an area of your life, what is the risk for you? Rejection? Upsetting the norm? Waiting while you fulfill previous obligations, even though the culture tells you to hurry? Do you believe that God will give you the courage for that risk?

- **Renewal**. For Naomi it meant losing her loved ones, yet renewing her faith in God while taking new steps. This renewal process always involves mistakes and blessing. Naomi went through a period of great bitterness. But God was with her, and God will be with you. He understands

our frailties and the need to readjust a plan, to realign a vision, or to reaffirm a goal. He even understands our need to "catch up" with his good plan for us. Are you in a period of renewal? Seek God. Take his promises as your own. Allow him to renew your spirit and your vision.

- **Refocus**. The end of chapter 4 is beautifully breathtaking. The book of Ruth begins with death, famine, and estrangement. The book ends with new life and extended family in celebration. Ruth had a husband, strange customs, and a new baby to refocus her life on. She had a home to administer, with servants to direct and meals to plan. Suddenly, there were extended family members and old and new friends coming to see little Obed, the baby. Where do you need to refocus today? Are you grateful for what God has already given you? What blessings surround you today that perhaps you haven't been able to see before?

Naomi had other refocusing to do as well. Her woman friends came to share her joy and announced, "Praise be to the LORD, who this day has not left you without a kinsman-redeemer. May he become famous throughout Israel! He will renew your life and sustain you in your old age. For your daughter-in-law, who loves you and who is better to you than seven sons, has given him birth" (4:14–15). Naomi needed to get her eyes off gloom and doom and recognize the greatness of God in her life through her own daughter-in-law, who, amazingly enough, the women told her was better to her than seven sons.

God embraced Ruth the Moabitess into the very lineage of his Son, Jesus Christ. Ruth is the mother of Obed, the grandmother

of Jesse, and the great-grandmother of King David. In Matthew 1 the genealogy of Jesus Christ is given, and Ruth is one of only five women named.

She and Boaz rest in the lineage of Jesus Christ, *our* great Kinsman-Redeemer. For Jesus, with his own blood, has bought us back from Satan's kingdom. He has washed us clean, spreading his righteousness over us. With him, we have a secure future and a living hope (1 Peter 1:3–5). God honored Ruth in her tenacity to love, follow, and obey him.

Always remember, "God did not give us a spirit of timidity, but a spirit of power, of love and of self-discipline" (2 Timothy 1:7). God can free you from *any* fear you are experiencing at this time. In prayer, reject that fear in Jesus' name. Have others pray with you and over you. Romans 8:31–32 says, "If God is for us, who can be against us? He who did not spare his own Son, but gave him up for us all—how will he not also, along with him, graciously give us all things?"

There are many brave and courageous women reading these lines—women who have taken charge of their lives as they never thought they would have to or would want to. *God stands with you.*

Some of you in the past week have written a letter or had a conversation to straighten out a broken relationship, bringing God into it, refusing to sit immobile and be filled with fear. *God stands with you.* Some of you have admitted and faced addictions. Do not give up. *God stands with you.* Others of you have started your own business. *God stands with you.* Perhaps you are embracing a spiritual gift that has long been your passion. *God stands with you.*

God stands with *you!* I challenge you to accept the responsibility of choice, accept the companionship of positive others, and accept the process of time in taking charge of your life as God leads you. Look at the beautiful outcome of Ruth's life.

moving on . . .

Dawn awakens,
the gates swing wide,
Ruth charts a course,
no longer a bride;
An adventure unheard of
in Moab's grim nights.

Not knowing the road
doesn't keep Ruth from going,
for the friends she makes are signs:
Naomi: faith
Boaz: protection
God: courage giver
who makes the selection
to tuck in Ruth's name
in an unusual mode:
Greatest Grandma
to Jesus—
the only true road.

Saintly women applaud,
united in voice,
cuddle her baby,
shout out their joy—
"Hallelujah! Sing praises!
Ruth made the right choice!"

("And, Naomi, dear friend,
please get a grip;
God's not abandoned you—
He's *brought in* your ship!")

— Ruth Tuttle Conard

Part II

God Values Women in the New Testament

INTRODUCTION

We're now going to step across four hundred years of Jewish history. Visually, we close the door of the Old Testament and open the door of the New Testament. In our Bibles those four hundred years in between the two doors are the blank pages between the last book of the Old Testament, Malachi, and the opening verse of the New Testament, Matthew.

To the Jewish people, these years, in a sense, were like blank pages also. Although history marched on with war and suffering, births and deaths, there seemed to be a huge silence from above, from Jehovah God.

As in our own personal lives, when it seems God is silent, we tend to begin talking more and louder ourselves, conversing, babbling, and imagining until we forget that, just perhaps, God might

have a word or two for us. Or perhaps, what he has already said to us is sufficient, and we need to let it sink into the core of our being and act on it.

The Jews were no different, especially the religious leaders, the Pharisees and scribes. They began to write, write furiously, in fact, adding, imagining on paper, heaping up through pen and scroll law upon law upon law. "Thus saith the LORD" became "Thus say we, the righteous."

The Law, to the Jews in New Testament times, not only emphasized the Torah in particular (the first five books of the Old Testament) but also what is called the oral law ("the recollection of earlier teaching of those called sages"[1]). The Old Testament was truly given by God. Except for a few instances, the laws given within it describe broad principles that every human should use to order his or her personal and community life.

In Jesus' time, it was in regard to this oral law, later called the Mishnah, where the Pharisees and scribes really got carried away.[2] They became so enamored by their own imaginations of what they thought God demanded and so proud of their own devised righteous acts to fulfill all they had imagined that during the time between the Old Testament book of Ezra and the Christian Era, or the New Testament book of Matthew, these religious leaders added an enormous number of regulations, restrictions, and detailed rules for the daily conduct of life in order to ensure the fulfillment of Torah.

The Mishnah fills a book of several hundred pages, composed of sixty-two treatises.[3] Remember, these are all pages of laws to guide one's *daily* life! Adding to that are the commentaries on the Mishnah.

These commentaries are called the Talmud, which is composed of twelve Jerusalem volumes and sixty Babylonian volumes.

Two whole treatises in the Mishnah are totally devoted just to all the details of proper conduct on the Sabbath, the Jewish holy day of the week. If men bowed beneath the weight of all these laws, women *crawled* beneath their weight.

One of these treatises, called the "Shabbat," lists some thirty-nine principal classes of prohibited actions.[4] Each of these primary classes is further discussed and elaborated, so that actually there come to be several hundred actions a conscientious, law-abiding Jew could not do on the Sabbath. Why would you even want to leave your cot from Friday sundown until Sunday morning? Why not fast and pretend you're asleep every weekend to avoid even the appearance of sin?

For example, the prohibition about tying a knot was far too general, and so it became necessary to state what kinds of knots were prohibited and what kinds of knots were not. It was decided that allowable knots were those that could be untied with one hand. A woman could tie up her undergarment (well, thanks, guys!) and the strings of her cap. (Did you ever try to untie the bow of your bonnet under your chin with one hand if it's caught in a knot? How I wish my great-great-grandmother could have read this. Her lower lip became disfigured for life when her nightcap strings, hanging loose, caught fire from the candle she was carrying.) A woman could tie up the strings of her girdle, the straps of her shoes and sandals (imagine if they hadn't let her!), of skins of wine and oil, and of a pot of meat. She could tie a pail over the well with a girdle, but not with a rope.

Do you begin to get the picture?

Briefly, along with the Jewish male view that women, primarily, were responsible for the sin in the world, especially sexual temptation and sin, and that their primary position was that of wife and mother, the Jewish male prayed three benedictions three times daily. One of these blessings spoken to God was for the favor that he, a man, had "not been made a woman."[5] Frankly, I can't imagine God ever feeling blessed by that prayer raised to him millions of times over!

Jewish academicians and thinkers upheld these views, as well. Josephus, a first-century Jewish historian, when writing of women, attributes to the Law that they are "inferior in all things to the man. . . . Let her accordingly be submissive."[6] Philo, a first-century Alexandrian, Jewish Bible commentator and philosopher wrote, "For the minds of women are, in some degree, weaker than those of men, and are not so well able to comprehend a thing which is appreciable only by the intellect."[7] Another writer, Sirach, believed that "the birth of a daughter is a loss."[8]

There were positives within the Jewish culture for women. Usually, their husbands and sons loved and esteemed them. It is even thought that there is evidence that some women may have held offices within the synagogue system in ancient Judaism.[9]

And then the door of the New Testament opens, and we find Matthew tracing the seed of Abraham through all the myriad of generations to Joseph and Mary and . . . to a very special baby named "Jesus, for he shall save his people from their sins" (Matthew 1:21 KJV), Jesus, who in adulthood would say, "I am the gate; whoever enters through me will be saved" (John 10:9).

Have you ever wondered, as I used to, about Jesus Christ and his relationship with women in the New Testament? Why did women

follow him? Why did they trust him? Why did they risk their lives for him, remaining last and unprotected at the cross and coming alone at dawn to the tomb?

Didn't they have anything else to do? Well, now that's sort of ridiculous to even think about, isn't it? They had a huge amount to *do* and, remember, *not to do* just on the Sabbath, just concerning the world of knots!

Plus, we all know they had nothing electric or, in our sense, modern, with which to work: no washers, dryers, refrigerators, telephones, vacuum cleaners, or televisions. The list is endless and so was their work, whether they were single or married.

Ever mull over the fact that maybe Jesus was handsome and alluring? Forget it. Scripture says, "He had no beauty or majesty to attract us to him, nothing in his appearance that we should desire him" (Isaiah 53:2). Much to our twenty-first-century dismay, this man's attraction had nothing to do whatsoever with being only skin deep.

It had everything to do with his being the most perfect human, ever. Jesus made both women and men long, in their deepest being, to be like him. Love, strength, sensitivity, power, compassion, truth, verbal potency, cleanliness in thought and action, tenderness, humor, and tears—you name it. Jesus Christ embodied it. He was *the* perfect human, and *he is God*.

And that is extremely important to remember as we consider his interaction with women. *He is God.* The same God that was "in the beginning" of Genesis 1 and 2. The same God who fashioned the heavens, the animals, man *and woman*. The same God who clothed Adam and Eve and sent them from the garden. The same God who

walked with them and fulfilled his promises to them and to their descendants.

As a student at the University of Michigan, I was crossing the vast campus one autumn day when a guy caught up with me, matching my gait. We began to converse. When he learned that I had just graduated from Bible school, he jumped in with both feet. "Really!" he exclaimed as he stopped us both in our tracks and stared at me in astonishment. "Tell me, how can a nice, intelligent, young woman like you believe in that bloody God of the Old Testament?" Then he went on, of course, to say how wonderful and believable Jesus Christ is in the New Testament—loving and forgiving.

Some questions haunt you forever. That one did. First, there are not three Gods in the Bible. There is one. A mystery—but God is God the Father, God the Son, and God the Holy Spirit. And these three are one. Second, God is not a "bloody God." The apostle John told us that "God is love" (1 John 4:8). He is a God of love in the Old Testament, and he is a God of love in the New Testament. Being a God of love does not disannul the fact that he is also holy and that he is also just. In love, God is patient. In love, God is kind. In love, God always gives encouragement, parameters, and warnings. In sacrificial love, God forgives. And in love, God metes out judgment.

Jesus Christ became a human being like no other, before or since. He was countercultural, especially in the area of gender. In the book of Luke, one of the four gospels, written by a Gentile medical doctor whose life Christ had changed, we find Jesus reaching out to and identifying with the weak, the poor, and the disenfranchised— children, the elderly, the sick, and *women*.

No off-color jokes, no demeaning attitudes, and no avoidance of women. He never abused them in word, action, or thought. When they raised questions, he never said, "Not goin' there!" and then snickered with the male disciples. He respected them and their actions toward him, even when others in his party scorned them. He listened to women, dialogued with them, and sought them out. He didn't define the parameters of their lives. He was not afraid to touch them in public, accept their worship, commend their faith, and heal them. He talked straight to them about their sin and his expectation that they would turn from sin and do right. Nor was he backward in treating them as full-blown, intelligent, competent adults.

Are you still wondering why women followed this God-man? Wonder no more. Instead, weep with joy! Fall down; praise and adore him! This same Jesus walks beside you and me today!

Here is a short outline I've found helpful in backing up scripturally what I've written above.[10] I hope it will encourage you as much as it has me. Every point could be developed more extensively. I'll leave that up to you, with the Holy Spirit's promptings.

I. Jesus' Treatment of Women as Persons of Dignity and Worth
 A. Called "Daughter of Abraham"
 Luke 13:11–17 describes Jesus' encounter with a woman crippled for eighteen years. He called her forward. He acknowledged her and touched her. He healed her in public, on the Sabbath, in the synagogue. Astounding—but perhaps just as astounding is that he gave her a title never given to women: "daughter of Abraham." In public he acknowledged her intellect, and he acknowledged her spiritual significance.

B. Healed by Jesus

Jesus healed various unnamed women: Peter's mother-in-law (Matthew 8:14–15), the daughter of Jairus, and the woman with the twelve-year flow of blood (Matthew 9:18–26; Mark 5:21–43; Luke 8:40–56). The last healing is especially important since, according to Levitical law (Leviticus 18:19), she would have been considered ritually unclean. Jesus touched or was touched by each of these women.

C. Affirmed in Sexual Integrity

There are two accounts where Jesus accepted and forgave two women understood to be guilty of sexual sins. In Luke 7:36–50, Jesus accepted this woman's actions as those of love toward him. He declared, "Your faith has saved you; go in peace." In John 7:53–8:11, Jesus said, "Neither do I condemn you Go now and leave your life of sin." This was done in the presence of male critics who had brought only the woman to Jesus, overlooking the man involved.

1. Concerning adultery, Jesus said in the Sermon on the Mount that he placed the blame for men's lust on men; this was quite unusual in ancient Mediterranean cultures (Matthew 5:27–30).

2. In Jesus' encounter with the Samaritan woman, the disciples were offended that Jesus was talking with a woman but dared not ask him why he was doing it (John 4:27), further indicating their negative sexual assumptions.

3. In Jesus' debate with the Pharisees on divorce (Matthew 19:3–9), reference seems to be made to the dominant position that men could divorce their wives for virtually any reason. Jesus responded by going back to the original plan of God in Genesis 2:24, which affirms the concept of "one flesh," giving sexual equality to both women and men. Clearly, he placed Deuteronomy 24:1–4 in a secondary position to Genesis 2:24.

D. Exemplified Positively

Many times Jesus used women as positive examples in stories and events as those who responded to God with appropriate faith. He used women in parallel with men to describe the faithful and faithless at the time of the arrival of the future kingdom (Matthew 24:41; Luke 17:35; Matthew 25:1–13).

1. He talked of women as persons of faith, for example, the widow at Zarephath in Luke 4:26. Jesus was using as a primary example not only a woman but also a Gentile and a widow. The Jewish crowd was so furious that they attempted to kill him by throwing him down a cliff. He did this in Nazareth, in the synagogue. It was his first time back to his own town after his temptation. And *he chose* to speak publicly of a faith-filled woman. When he spoke of how we should pray, his example was the persistent widow in Luke 18:1–8. In Luke 21:1–4 Jesus spoke of the widow's "mites" (KJV) and promoted this woman as one who fulfilled Jesus' requirements in regard to discipleship and material possessions.

2. In the parable of the lost coin in Luke 15:8–10, a woman is the finder who rejoices with a party. This is the same role portrayed by the shepherd and the father in Luke 15. In all three stories, this person images God, who rejoices over repentant sinners.

II. Jesus' Teaching of Women as Accepted Disciples

Disciple simply means "follower." During Jesus' time there is no evidence of any Jewish rabbi having a female disciple, but Jesus encouraged it. Jesus taught women, with the understanding that they could respond with obedience and commitment to the word of God.

A. Women Who Followed Jesus

All four New Testament Gospels attest to the fact that a group of women followed Jesus in Galilee and on to Jerusalem. They were present as faithful and active disciples at the crucifixion, burial, and resurrection of Jesus. We find these accounts in Matthew 27–28; Mark 15–16; Luke 23–24; and John 19–20.

1. Luke 8:1–3 describes women traveling with Jesus and the Twelve, providing materially for them as well, which is undoubtedly an indication of upper-class status and/ or comparative wealth. They may have become disciples because of the healing they had received.

2. Women are found praying with men at Pentecost. In the initial formation of the church at Pentecost, the Holy Spirit

was poured out on women and men alike. This had been predicted long before the coming of Christ in Joel 2:29, as referred to in Acts 2:17–18.

B. The Cost of Discipleship

This is clearly defined by Jesus in relation to motherhood and obedience. The traditional role for women, at this time, was marriage and motherhood. But in two Scriptures, Jesus seems to indicate that a woman's response and obedience to God's word (discipleship) is above motherhood. This we see in Matthew 12:46–50, which is parallel to Mark 3:31–35 and Luke 8:19–21. Jesus was saying that his true family is those who hear the Word of God and do it. In Luke 11:28 we find Jesus responding to a woman's affirmation of his own blessed mother: "Blessed *rather* are those who hear the word of God and obey it" (emphasis added). What Christ asks of a man in following him, he also asks of a woman—obedience and faithfulness to his Word.

1. Mary of Bethany

In Luke 10:38–42 is the most astounding visual of a female disciple that God gives us in the New Testament. She assumed the known and accepted posture of a disciple, in front of everyone with her in that room, by *sitting at the feet* of Jesus, listening to his words. Despite Martha's objections, based on the traditional female role and obligation to prepare the meal, Jesus affirmed Mary's choice: "Mary has chosen what is better, it will not be taken away from her." Since there were undoubtedly men in that room also, here women are

portrayed as disciples in equal partnership with men.

2. Martha of Bethany

Martha was also a true disciple of Jesus Christ. Her confession in John 11:27, verbalizing belief in the Lord as the Christ and the Son of God, parallels Peter's famous confession in Matthew 16:16.

III. Jesus' Trust of Women as Proclaimers of Truth

A. Jesus' Birth

The Gospel writers used five humans, speaking by the power of the Holy Spirit, to provide us with a divine interpretation of the meaning of Jesus' birth for the history of God's salvation. Three of those humans are women. Elizabeth declared Mary, the mother of Jesus, as "the mother of my Lord" (Luke 1:41–45). Mary declared prophetically the saving work of God (Luke 1:46–48). Anna, a prophetess, praised God for the Messiah and spoke about Jesus to "all who were looking forward to the redemption of Jerusalem" (Luke 2:36–38).

B. Jesus' Ministry

In John 4 we find Jesus seeking out the Samaritan woman. He entrusted her with something he had not yet said plainly even to his disciples—that he is the Messiah (vv. 25–26). Though her sin was known throughout the community, Jesus, her Creator, also knew her deep spiritual thirst. Through the testimony of this first-recorded New Testament missionary—a woman—many of her townspeople believed Christ and his word. They believed

that "this man really is the Savior of the world" (v. 42).

C. Jesus' Resurrection

All four Gospel writers report that the female disciples of Jesus were the first ones to receive the angelic account of Jesus' resurrection and were commissioned to go and tell the male disciples of this. (See Matthew 28:1–8; Mark 16:9–11; Luke 24:1–12, 22–24.) In John 20:14–18 Mary Magdalene was commissioned by Jesus Christ to tell the disciples what she had seen and heard.

Women were among Jesus' most trusted companions throughout his life. And he entrusted women first with the greatest message: his resurrection. He commissioned them to go and tell. Because of the women's faithfulness and their report, the disciples gathered together and heard Jesus give the Great Commission.

And to this day, that commission stands for us as women. When Jesus appeared to Mary and commanded, "Go instead to my brothers and tell them," he gave her *a call* and *a mission*.[11] Dear friend, you and I have that same call and mission from Jesus today.

Are you willing to go? Are you willing to tell? Are you willing to share, in every way possible, by any means possible, the great love that Jesus Christ has for everyone he puts in your path?

What a privilege! What an honor to be trusted and empowered by the living God!

"All this is from God, who reconciled us to himself through Christ and gave us the ministry of reconciliation." So we are ambassadors for Christ, since God is "making his appeal through us" (2 Corinthians 5:18–20).

...do ꟼ, will ꟼ?

Do I cry
God's deeds of power,
Or in this hardened setting,
under quiet,
cower?

Can I share
God's power seen,
Or in this humdrum hour
mumble platitudes
in between . . .

the normal chatter;
Dishes clatter.
Does it matter
God's deeds of power?

Amazed, perplexed,
some wonder how.
Others sneer;
disregard this awe-filled hour.

Yet, God's deeds of power stand.

Open my eyes, my ears,
my mouth, my hands,
to proclaim; reclaim,
O Christ,
Your children
in my land.

— Ruth Tuttle Conard

6

DESIGNED TO WORSHIP

The Crippled Woman

The story is told of a woman diagnosed with a terminal illness. She'd been given three months to live. As she was getting things in order, she invited her pastor to the house to discuss certain aspects of her final wishes. She told him what songs she wanted sung at the memorial service, what Scriptures she would like read, and what dress she wanted to be buried in. And, oh yes, she wanted her favorite Bible beside her.

As he was turning to leave, the woman suddenly recalled something else. "There's one more thing," she said excitedly. "What's that?" he asked. "This is very important," the woman continued. "I want to be buried with a fork in my right hand." The pastor just stood there looking at her, not knowing quite what to say.

She went on, "I know you're puzzled, but in all my years of attending church socials and potluck dinners, I always remember that when the dishes from the main course were being cleared, someone would inevitably lean over to me and say, 'Keep your fork.'

"It was my favorite part because I learned that this meant that something better was coming . . . like velvety chocolate cake or deep-dish apple pie. Something wonderful and of delicious substance! So, I just want people to see me there in that casket with a fork in my hand, and I want them to wonder, 'What's up with the fork?' Then I want you to tell them: 'Keep your fork; the best is yet to come.'"

The pastor's eyes filled with tears as he hugged her—first, because he knew this was one of the last times he'd see her on earth and, second, because he knew that this woman had a better grasp on the reality of heaven than he did. She knew that something better was indeed coming, awaiting her up ahead.

Now, that's a woman with real faith. Faith in the unseen. Faith to believe Jesus Christ's promises as she faced death. But what about you? What about me? What kind of faith do we have today as we face life?

Most of us, I realize and actually hope, do not go around carrying a fork as a symbol of our faith. But what lies just under the exterior of your being as you wake up each morning, get ready, fix meals, set off to work, go shopping, perhaps care for others—whether parents, husband, kids—maneuver through the ins and outs, ups and downs of everyday life?

Do you have the Word of God tucked into your heart and mind? Do you have a chorus or hymn playing through your thoughts, encouraging you to trust him in all things today? Do you carry a

symbol of belief and hope in the *living, present* Christ? Belief in the resident Holy Spirit *to speak to you* in your unique situation? Hope for *a miracle* today?

I love the story we're going to look at now. It's probably the woman I most identify with in Scripture. It's a spectacular, monumental account told by Dr. Luke of one woman's healing in the very presence of Jesus. A story that—if you let yourself forget for a few moments where you've just come from and where you're going a little later today—could be *your* story.

This woman may or may not have expected healing as she struggled out to the synagogue that morning long ago. Except for her physical condition, she was probably much like you and me, with a tiny seed of faith barely planted in a garden of doubts.

The One who is truly spectacular is Jesus—the same living, loving Lord who longs for our healing today, whether that's inner or outer healing, whether it's visible to others or not. Jesus longs to heal us today so that, no matter our circumstance, we may rise up and worship him with heart, voice, and life—without shame, believing that he's removed all of that.

This account is found in Luke 13:10–17:

> On a Sabbath Jesus was teaching in one of the synagogues, and a woman was there who had been crippled by a spirit for eighteen years. She was bent over and could not straighten up at all. When Jesus saw her, he called her forward and said to her, "Woman, you are set free from your infirmity." Then he put his hands on her, and immediately she straightened up and praised God.

Indignant because Jesus had healed on the Sabbath, the synagogue ruler said to the people, "There are six days for work. So come and be healed on those days, not on the Sabbath."

The Lord answered him, "You hypocrites! Doesn't each of you on the Sabbath untie his ox or donkey from the stall and lead it out to give it water? Then should not this woman, a daughter of Abraham, whom Satan has kept bound for eighteen long years, be set free on the Sabbath day from what bound her?"

When he said this, all his opponents were humiliated, but the people were delighted with all the wonderful things he was doing.

There are four key words linked together in this passage that spell trouble right from the start. They are *Sabbath, synagogue, Jesus,* and *woman.* Yes, they're all lined up for *trouble!*

Have you ever had the feeling that you were the wrong person in the wrong place at the wrong time? I'm sure this woman felt that, as the drama of the morning unfolded with her on center stage. But guess what? Jesus can change all of that in your life even as he did in hers.

We've discussed the Jewish synagogue in a former chapter. Its main purpose was not for public worship, but rather for instruction in the Holy Scriptures—to educate all people in the law.[1] The congregation was separated, with men on one side and women on the other, with more prominent members sitting on the front seats. It was normally directed and controlled by the men.

The Sabbath comprised the Jewish holy day. No one was to work on the Sabbath. Healing was considered work by the teachers of the law. Jesus had an annoying habit, annoying at least to the Pharisees and others who prided themselves in following every jot and tittle of the law (including the parts added by men); Jesus liked to heal on the Sabbath.

As we know, Jesus is God. And he found it fitting to be in the right place at the right time with the right people—one of those being a woman he had created on purpose and with great love. And this woman was not just an ordinary woman. This woman was bent over double. She was so crippled by "a spirit" that she had not been able to stand up straight for eighteen long years.

Pause a moment. Why don't you stand up right now, right where you are, and then bend over double? What do you see? How do you feel? Can you imagine being in this position for eighteen years?

How easy was it for our sister to get herself out of the house that morning? How easy was it for her to stumble through the town to get to the synagogue? Her view of life was mostly dust, feet, and garbage. What jokes or slurs directed her way did she overhear? How did she dress? How did she sit down? So many hows. We can only painfully imagine.

Maybe the sickness didn't come until she was twelve, when her parents were thinking about the right man for her. Perhaps she was the only daughter, and they were so proud of her. And then . . . the crippling. Unnoticed at first, yet, slowly, methodically, silently working against standing straight and tall. Until, there she was, bent over—totally. Suitors recede into the background. No laughter with other young women, no marriage, no children. There must have

been pain and tension over an uncertain future. Certainly, as Jews, she and her family must have also wrestled with the question over the relationship between sickness and sin. But let's suppose that her father and mother stood by her, loving and always encouraging her.

Let's imagine that on that special morning her mother implored, "Abigail, please come with me to the synagogue. Please. I've heard that Jesus will be there. I've heard him speak; he's wonderful, Abigail. Perhaps you'll find encouragement. And, Abigail, I've heard that some have even been healed by him."

Did Abigail complain at first, struggling to believe? Struggling to muster up the strength and courage to face the town, the stares, and the disappointment if this Jesus didn't encourage her in any way?

She took that first step. In essence, she held up her fork—some belief, some hope, some trust burning weakly within. Can you do that? Will you do that? Whatever is crippling you, will you look beyond your circumstances, your unforgiveness, your doubt, your grief, your "it will never be the same again," and take that first step toward belief?

Jesus was there. And this is what he did. He took six steps toward her that were completely countercultural, the same steps he will take toward you today: Jesus saw her, called to her, spoke to her, touched and healed her, defended her, and gave her a title of honor.

Seeing Her

First, Jesus saw her. With everyone else there, especially all the important, bearded, erudite men, Jesus saw *her*. He actually looked at her and did not look away. He didn't glance over, see her awful

disability, and immediately look away, thinking, *Oh my goodness. Poor woman.*

I'm sure the religious leaders thought it would be business as usual, musings on the musty law. But they miscalculated; Jesus was there. Jesus marched into their practice of pride, gloom, and doom. Jesus set out to break the bars and wrench off the chains that had confined this woman far too long.

In the same way that Jesus saw her, Jesus' gaze stays fixed on you today. Whoever you are and wherever you are, Jesus loves you. He sees you. You are not a shadow to Jesus, hidden behind someone else, or invisible because someone else chooses to ignore you. You are Jesus' precious daughter, and he sees you.

Remember that Hagar's name for God in Genesis 16:13 was *Elroi*, which means "You are the God who sees me."

Calling to Her

Second, Jesus called to her. Amazing! Rabbis didn't speak to women in public. They just pretended the women weren't there. "Even conversing with a relative publicly was considered inappropriate for a scholar, since onlookers might not realize that she was a relative and could (presumably) suspect flirtation on his part. Indeed, so important was this matter, later rabbis reasoned, that God himself avoided speaking with women."[2] But Jesus called out to her! He "called her forward" (v. 12).

Imagine: Abigail is all bent over, seated behind the others, in the corner. But Jesus sees her enter. Her mother leans down and whispers loudly, "Abigail, he's calling you. He's calling you, daughter, to come forward to him." Then slowly, tentatively, Abigail rises, moves out

and forward, one foot at a time, passing one robe hem after another . . . through the men, to Jesus.

In John 10:3 Jesus said, "He [the good shepherd] calls his own sheep by name and leads them out." And in verses 14 and 15 Jesus continued, "I am the good shepherd; I know my sheep and my sheep know me—just as the Father knows me and I know the Father—and I lay down my life for the sheep."

Jesus is your shepherd. He knows you. He knows me. He knows our names. He keeps calling us to come to him, in order to heal us, to bless us, and to give us his joy—a joy deeper than what we can imagine and much more freeing than what we are clinging to so tightly.

His words still stand for you today: "Come to me, all you who are weary and burdened, and I will give you rest. Take my yoke upon you and learn from me, for I am gentle and humble in heart, and you will find rest for your souls. For my yoke is easy and my burden is light" (Matthew 11:28–30).

Speaking to Her

Third, Jesus spoke to her. Yes, Jesus had words to speak to her. Again, totally amazing! I imagine that the other men were standing there, grumbling inside, biting their beards along with their tongues, wondering when on earth this could all be over with and "synagogue as usual" could proceed, tradition could be followed, and the normal could take over, with no surprises.

But Jesus was there. And Jesus is compassion. And when you come to Jesus, listen and you will hear his words, words of love, perhaps of quiet conviction, words that will give rest to your soul.

Touching and Healing Her

Fourth, Jesus touched her and healed her. He actually touched a woman and with that touch had the audacity to heal her! In the synagogue! On the Sabbath! Oh dear! The ruler of the synagogue was furious (v. 14). But before he could vent his great indignation, something beautiful transpired.

This woman did not run away out of shame. She didn't meekly slip out the side door. She didn't whisper goodbye and melt into the crowd. She began to unbend. To straighten up, inch by inch, second by second, in front of them all. And when she was tall and straight, for the first time she gazed directly into the eyes of her Lover, her Creator, her Healer, Jesus Christ! And she exploded in worship!

Yes, suddenly, probably for the very first time, that particular synagogue heard the ringing tones of a woman's voice giving praise and glory to the One who had made her, who loved her, and who had miraculously healed her. And Jesus basked in her praise. He didn't try to quiet her. He welcomed this woman's public praise of him in a synagogue on the Sabbath.

This happens when Jesus touches us and heals us. We cannot keep still. When Jesus heals you of whatever needs his healing, your heart will erupt in praise to him, in love to him. Tears may come and words spill out on paper or in song or in prayer or in public worship—and many times you will feel that they're not enough and not nearly eloquent enough—to worship this One who has touched you in the darkest part of your soul and set you free. Christ said, "So if the Son sets you free, you will be free indeed" (John 8:36).

Have you asked and let the Son heal you and make you free? Jesus longs to do that for you, so that you will be a woman of praise and gratitude and worship.

I spoke in the preface of this book about having curvature of the spine and knowing that Christ healed me of that through the prayers of many. Yes, I still have one side of my back larger than the other. But never, over the years, have the negative predictions of the specialist come true.

It may be because of that slight curvature that I have found it hard to stand straight and tall over the years. I am taller than many women, so perhaps I became too used to bending down a little to hear others. I only know that the day I was ordained, as I entered the sanctuary, a very close friend said to me, "Ruth, stand up. Stand tall."

That struck me. There are other ways in which we can be bent out of shape. Sometimes, it's within. It may come from listening to many negative voices within and without or focusing too much on ourselves, on our weaknesses.

It was in the Alps of Switzerland, near the birthplace of my great-grandfather, that the Holy Spirit spoke to me forcefully from the Word of God in August 2000.

I was wrestling with the Lord over ordination—should I? Shouldn't I? I was scared to death over taking that step and what I would face. I was reading Matthew 9:18–26, and my attention was fixed on the woman who had suffered for years from hemorrhaging. It says, "Jesus turned and saw her. 'Take heart, daughter,' he said, 'your faith has healed you.' And the woman was healed from that moment."

The very strong word to me was: "Ruth, you *are* healed. Your faith *has healed you.* You *are* redeemed. You *are free* to follow me. Stop asking. Stand and come."

Those words are not new words. Yet, in that moment, they seemed as new words to me, strong, encouraging, freeing words. I stood and followed.

I don't know what Jesus may be calling you to. Don't let Satan tempt you into thinking you're only a woman, or you're not good enough, or if you had only . . . , or what will others think? My dear friend, Jesus pleads with us to come to him. When he heals, when he forgives, then you are healed; you are forgiven. When you come to him, he empowers you to worship him and serve him.

Defending Her

Fifth, Jesus defended her. When the leader of the synagogue could no longer hold his anger, he exploded—not looking at Jesus (perhaps he was afraid to or didn't dare to or was just an angry coward) but at the crowd. And he raged that, after all, there are six days in the week to be healed and that was plenty. One shouldn't sully the Sabbath with one's sicknesses.

But Christ had had quite enough. He went to bat for this dear woman. He defended her. He reminded these proud men that they actually cared more about their animals than they did about this woman, his daughter. He called them hypocrites. He spared no words.

When you trust Christ with your now as well as your future, he will defend you. You will have no defender like your Savior. Give

your cares to him today, and ask him to be your defender. He loves to do that.

Giving Her a Title of Honor

Sixth, Jesus gave her a title of honor. While Jesus publicly condemned the supposed spiritual leaders, he totally affirmed this woman. He called her "a daughter of Abraham." He publicly declared her as a valued member of the covenant community. Never would a man or another rabbi have even considered giving a woman this title.

The Jewish religious leaders prided themselves on being "sons of Abraham." But here Jesus lifted the woman up, into an equal status with all those who had faith like Abraham. And in so doing, he blessed her, not only by healing her but also by verbally bestowing on her the dignity she truly deserved as a child of God.

When you trust Jesus, you are honored as a daughter of the King, a child of God, favored, redeemed, made part of a chosen race, a royal priesthood, one of God's very own people, loved for eternity, and empowered to proclaim his mighty acts (1 Peter 2:9–10).

This woman, because she "raised her fork" and nourished that flame of belief enough to take a step out of her bondage, became a cause of rejoicing for the whole crowd that was watching and listening. She stepped forward, and the living Christ met her.

He will do the same for you today. Come to him. He sees you. He calls you by name. He will speak words to you, touch you, and heal you. And as you keep in step with him, he will be your defender, the lifter of your head.

As your eyes lift to meet his gaze, he will bestow on you great peace within, great love, and great mercies. Stand tall; stand strong; stand straight. Worship and serve only him.

divine encounter . . .

So sad,
bent out of line:
wrong person,
wrong place,
wrong time.

So swift,
life all aligned:
right person,
right place,
right time.

For the Christ
who had formed her,
always had loved her,
and eternally
held her in mind.

— Ruth Tuttle Conard

7

DESIGNED TO BE QUIET

Anna

When you saw this chapter title, I wonder if you skipped past it, thinking, *Hmm . . . quietness? That doesn't really appeal to me, and, anyway, there's just no time for it in my life right now.* If you did, you're probably not alone in your thinking.

I know I'm really going out on a limb here, because in this chapter, we're not only going to look at the aspect of being quiet, but we're even going to touch on age, uh, advanced age, uh, like . . . gotta say it . . . old . . . really old age!

Being quiet and growing old are not real high on our advancement list toward the American Dream, right? Rather, beauty, beauty aids, being or aspiring to look like a twentysomething or thirtysomething, working out, brightness, music, drama, clothes, fun, health, goals, travel, accomplishments, shopping, reading *People* magazine,

hobbies, building a dream house—now, that's life, right? Is it? Has there ever been a lurking, nagging, tiny question within your being, whispering quietly, "Uh . . . is this all?"

Have you ever thought or even said aloud, "Maybe there's a better way to do life. Oh, dear Lord, give me more; please satisfy the deep, deep longing in my soul." I think at some critical juncture in Anna's life, that was her cry.

At first glance, Anna, in Luke 2, seems so remote from us. Yet let's take a deeper look into her life, who she was, and why Dr. Luke, the author of the Gospel of Luke as well as the Acts of the Apostles, would even mention her. By the way, Dr. Luke lived while Mary, the mother of Jesus, was living. Was it Mary herself who told Luke about her encounter with Anna in the temple? A strong possibility.

In the very beginning of Jesus' earthly life, three women are mentioned as principal characters, along with two men (Joseph and Simeon). Anna is one of those three women. Mary and Elizabeth are the other two.

As we look at Anna, we're going to consider four basic points about her that will guide our thoughts. We'll look at Anna's place, pleasure, posture, and promise.

Anna's Place

Of all the women we are looking at in this book, Anna lived in the biggest house. You see, Anna lived in the temple in the most sacred of all Jewish cities, Jerusalem. So, think with me a few moments about this place in which she lived.

The temple embodied the very core of Judaism with its ancient ritual of sacrifices. It was magnificent, and that is what Herod the

Great, an indefatigable builder, desired it to be. Herod the Great was not, in any form, desiring to please God, but rather to lift up himself and ingratiate himself in the eyes of the Judean people.

He also rebuilt many cities and heathen temples, plus various and glorious residences for himself.[1] Herod's spectacular temple was under construction for forty-six years (John 2:20). Then thirty more years passed before it was really completed, only to be leveled to the ground by the conquering Romans in AD 70.

All the historians of the time speak of the temple's grandeur.[2] It was made of white marble, much of it overlaid with plates of gold that reflected the rays of the rising sun. It dominated the whole city and spread across an area of twenty-six acres, surrounded by a high wall. Near the northwest corner of the temple area was the huge Roman fortress called Antonia.[3] This was the headquarters of the Roman guard that patrolled the temple and very often was needed to keep the peace.

Entering the temple complex, there were four successive walled courts surrounding the temple building itself. Each court was more exclusive the closer it was to the inner building.

First was the outer court of the Gentiles. It was not holy ground, and non-Jews were permitted there. This was where sacrificial animals were sold and money exchanged. Stairs led up to a high platform on which were situated the temple and inner courts. Surrounding the stairway was a stone wall with writing in Greek and Latin forbidding non-Jews from entering, on pain of death.[4]

On this platform was an inner court divided in two. The first and smaller area was the women's court. Here women as well as men were permitted.

Into the next area only men were permitted, for reasons of ceremonial purity. In this second area stood the temple proper. Any Jewish man could enter the men's court called the court of Israel. The men would gather there when the service was being carried on, to pray and to observe the offering of the sacrifices.

Deeper in, around the actual temple, was the priests' court. Into the temple itself only the officiating priests could enter to bring in the incense, morning and evening, to trim the lamps daily, and to replace the bread of the presence every Sabbath.[5]

In this huge, magnificent, busy, and holy setting, within the court of the women, we find our unique woman, Anna, designed to be quiet.

Luke 2:36–38 says this: "There was also a prophetess, Anna, the daughter of Phanuel, of the tribe of Asher. She was very old; she had lived with her husband seven years after her marriage, and then was a widow until she was eighty-four. She never left the temple but worshiped night and day, fasting and praying. Coming up to them [Joseph and Mary] at that very moment, she gave thanks to God and spoke about the child to all who were looking forward to the redemption of Jerusalem."

We find baby Jesus in the arms of his parents as they came to the temple for "their" purification (Luke 2:22). Really, it was probably for Mary's purification. According to Old Testament law in Leviticus 12, a woman was unclean for forty days after birthing a son. She was unclean for eighty days after birthing a daughter.[6] "Until the beginning of the twentieth century, infection of puerperal fever was the scourge of new mothers. The purity laws of Israel did much to safeguard maternal health."[7] When that time period was fulfilled,

the mother was to go to the temple and offer a year-old lamb for sacrifice. If she couldn't afford a lamb, she was to bring two doves or two young pigeons. The priest would sacrifice these, and then the mother was clean. Joseph and Mary brought the offering assigned to the poor, so, right from the very beginning, Jesus identified with the poorest of the poor (Luke 2:24).

There were two people watching intently that morning. One was a "righteous and devout" man named Simeon. What was he waiting for? He was waiting for someone he knew as the "consolation of Israel" (Luke 2:25–35). Scripture also says that "the Holy Spirit was upon him."

The Spirit of God had revealed to Simeon that he would not die before he had seen the Messiah. He was "moved by the Spirit" of God to go into the temple that morning. And, amid all the young couples in that court on that morning, gathered there for the same reason as Joseph and Mary, Simeon recognized the baby Jesus, who probably didn't look much different from any other Jewish baby. (No, I don't think there was a halo around his head nor, for that matter, around Mary's or Joseph's either.) He took Jesus in his arms as blessing and praise poured from his lips for Christ, as well as special words directed to Mary and Joseph.

But there was another very unusual person in the court of the women on that exceptional morning—Anna. And this was her place, the actual temple of Jerusalem.

However, not only was her place of dwelling unusual but also was her place in life unusual. She was "very old," at least eighty-four years old (v. 37).

Now if you entered this chapter feeling a little skittish about quietness, which our culture does not normally reinforce, how about this added dimension of old age? That's certainly not prized in our society either.

My sisters and I experienced this personally when my eighty-six-year-old father became ill and was hospitalized. One day we went to visit him and found, to our amazement, that he had been moved to another floor. We soon realized that people were dying on that floor, and there weren't many attendants available. And much to our horror, we also realized that they were no longer attending Daddy, but just waiting for his death as well.

Quickly, we worked to remove him from that place. We set up hospice care for him in our mother's house. With the tender attention of my oldest sister, Charlotte, a nurse, along with hospice caregivers, Daddy lived in peace and comfort several more months. Our family was lovingly present at his side when Christ took him home.

God loves all people and does not favor certain people. Age is insignificant to God, as are gender, race, last name, skin color, and body proportions.

Several years ago the Spirit of God, I believe, gave me a new view of life. In our twenties when my husband and I went as missionaries to South America, we both felt the urging of the Spirit, "Go quickly. There's not much time."

But as I became older and began to wonder if God's purposes for me had come to an end, it was as if the Spirit whispered, "Ruth, life is long. Keep preparing!"

If you're in your teens: Life is long. Keep preparing. Keep serving God!

If you're in your twenties or thirties: Life is long. Keep preparing. Keep serving God!

If you're in your forties, fifties, sixties, seventies, eighties plus: Life is long! Keep preparing! Keep serving God!

At age fifty-three, I wrote my first book. I found I was in good company. James Harriott wrote his first book, *All Things Bright and Beautiful*, at age fifty-three. At age fifty-eight, I graduated from five years of seminary training; I had worked forty hours a week for three of those years. At sixty I was ordained. Since that time, God has continued to be gracious. He has literally taken me into all the world to preach the gospel of Jesus Christ to thousands of women and men.

As I work on this chapter, I am sitting in Shenyang, a city in northern China. Two days ago, through an interpreter, I listened to a young Chinese woman tell her story of accepting Christ three months ago in Beijing. I was able to answer her questions and encourage her. What a privilege.

I'm not telling you this to exalt myself. It's all of God. Totally. Rather, I want to encourage you not to give up. God has a future and a hope for you, no matter your *place*—meaning age as well as location.

It wasn't until she was fifty that Corrie ten Boom (a single woman) was taken captive by the Nazis. Her life became a blazing testimony to the power of Jesus Christ as she escaped the hellish furnace that consumed so many of her Dutch sisters and brothers. I heard Corrie preach a powerful sermon on forgiveness when she was eighty-two years old.

Just tonight I answered a letter from an eighty-six-year-old friend, Linda Finkenbinder. She still travels into South America with her husband, Paul (they lived there most of their married life), to encourage leaders to be faithful in their marriages.

Do not limit God by limiting yourself according to the culture's lies and misplaced values.

Regarding place—wherever you are and whatever age you find yourself at this moment—what is God nudging you toward? What opportunities is he setting before you?

For Anna, neither her secluded dwelling, advanced age, nor being a single woman—poor and widowed after just seven years of marriage—kept her from what God had for her. She lived the truth of 2 Corinthians 4:16–18: "Therefore we do not lose heart. Though outwardly we are wasting away, yet inwardly we are being renewed day by day. For our light and momentary troubles are achieving for us an eternal glory that far outweighs them all. So we fix our eyes not on what is seen, but on what is unseen. For what is seen is temporary, but what is unseen is eternal."

Anna's Pleasure

Anna is identified, amazingly, first and foremost, by something that gave both God and her great pleasure. It wasn't that she was an old widow or poor, but that she was a prophetess. This was a gift given her by a loving God, and she had obviously tended to that gift.

The word *prophetess* in the Old Testament is the feminine form of the word *prophet*, and her gifting carried the same weight as the writing prophets such as Isaiah, Jeremiah, and Ezekiel. Three

major women in the Old Testament are mentioned as prophetesses: Miriam, the sister of Moses; Deborah, the judge and leader of Israel for forty years; and Huldah, whom King Josiah sent his men to inquire of (even though Jeremiah was in the nearby vicinity) when they found the book of the law in the rubble of a rundown temple. Huldah could have identified with Anna, for Huldah lived in very close proximity to the temple as well, although a few hundred years before Anna.

In 1 Corinthians 14:3 the apostle Paul said that "the one who prophesies speaks to people for their upbuilding and encouragement and consolation" (ESV). So it's a gift much broader than foretelling the future. It is a gift very needed today. Anna had this gift.

Can you identify your top three spiritual gifts? Many women I converse with reply, "Oh, I just like to be behind the scenes." Funny, but I've never seen that listed as a spiritual gift. The listing of spiritual gifts is found primarily in three New Testament texts: Romans 12:3–8; 1 Corinthians 12; and Ephesians 4:11–13. There are a number of good books written regarding the spiritual gifts. There are tests that you can take to explore your own gifting.

Our gifting comes from the way God has designed us. The gifting embraces our personality, our temperament, and our character. It all fits together because we are God designed. Each of us is unique. God has designed you in a way that he hasn't designed me. Your gifting will not be exactly like mine nor mine like yours, though we may be similar in other ways.

So, it is possible that you may like to be behind the scenes. Is that because you are more introverted? Is that because you are called to prayer? Or called to serve others without anyone knowing? Or

given the gift of mercy? Or called to write? There are many gifts given by God that involve being behind the scenes, but it is still important to know what your gift is.

If you have the gift of leading, teaching, preaching, or something similar, you may find it harder to say that you like to be behind the scenes. That is not because of pride, but rather because your personality and gifting have prepared you for visibility. The Holy Spirit is kind and will let us know if we are puffed up with pride. People who like to work behind the scenes can also be filled with pride. Our main task is to know and do our gifting.

Scripture names these God-given, Spirit-breathed abilities as *gifts*. It is of utmost importance that we unwrap these gifts, explore them, practice and hone them, and work on their use for the glory of God and the building up of his body, which is the church. You and I are not given spiritual gifts for our own pleasure (although we will find our greatest pleasure in putting them to use), but "for the common good" (1 Corinthians 12:7). If we do not take seriously the development of these God-given gifts, other people may be kept from a portion of God's blessing that could come through us.

We will talk more about gifting in a later chapter. I encourage you to enter a Christian bookstore and pick up one or two books on spiritual gifts. Also, think about taking a personality test. It is important that we understand ourselves and how God has designed us for his glory, as well as for our joy.

What gifts has God given you? What brings you the greatest pleasure in your service to and for God?

Anna's Posture

Because Anna took seriously what God had given her, she assumed a posture that, I believe, brought even greater pleasure both to her and to God. This was the posture of worship. Anna worshiped God through prayer and fasting.

Anna must have made some choices early in her life. She came from the tribe of Asher, a tribe in northern Palestine. Since we find her living in Jerusalem, this may mean that she was separated from her family. We can imagine that as a young bride she longed for a child, but it seems that was not God's purpose for her. And through those cycles of anticipation and then disappointment, I believe, Anna learned something about patience and trust.

When her husband died, she would have had important choices to make in the midst of her grief. As a childless widow, her options would have been few.[8] Normally, she would have returned home to her father's household, or she would have been given in marriage to her husband's brother or another unmarried relative. But perhaps Anna, for whatever reason, had no family available to her. Or perhaps she simply chose the radical route of dedication to and reliance on God. Eugenia Price once wrote, "Anna permitted her heartbreak to force her to God. . . . Those of us who have faced tragedy of any kind . . . know that nothing heals the wounds like being consciously with God."[9]

"Being consciously with God" speaks of being in communication with God. It speaks of prayer, worship, even of fasting—going without food—not to lose weight, but to sharpen our senses toward the unseen, toward God, toward listening to what God is trying to

speak to us, and toward a deeper longing to be close to him and to sense his closeness to us.

Anna had the courage to be quiet. Anna had the courage to seek God. Do you have that kind of courage?

Fifteen years ago we moved to Minnesota. Bill moved six weeks before I did, so that I could finish out my year of work at a graduate school in the Midwest. During those weeks apart, I was awakened one night with severe aching in my left arm. It seemed to consume the whole left side of my body. I was frightened. All I could think about, of course, was my heart, even though I had never heard my parents talk about heart disease within their families of origin.

The second time it happened I was off and running to my doctor, a Christ follower. She suggested that I take a battery of tests, which took one entire day and were in themselves quite frightening, not to mention expensive. The conclusion to all of that was that my heart was fine.

A week later I met my doctor in her office. She sat me down and said, "I'm so glad there's nothing wrong with your heart. But, Ruth, you are a very busy lady. I give you permission, Ruth, to go away for twenty-four hours and be alone with God. This practice has changed my own life."

My mouth dropped open, and I just stared at her. What had she said? "Go away . . . and be alone with God?" I began to weep. Who, in all my life, in all the years of ministry, in all the hardships of daily living had ever offered me such a gift as this? No one had ever suggested such a remedy as this or had ever taken the time to look deeply into my soul and place such a gift into my thinking.

Her words touched a place in the depths of my being. She continued, "Ruth, go to a retreat center or a convent or a monastery. There are some around here, and those people understand the value of silence. They know how to protect your silence. You may cry; you may read or write or sleep, sit on the floor, or take a walk outside. But go. I give you the liberty to go. God will lovingly meet you there."

Be alone. Be quiet. Reflect. Listen to God. What a gift! From that silence came the conviction of the gifts God has given me to minister to his body. From that silence came the wisdom to reconfigure relationships within my own family. From that silence came the courage to go to seminary. From that silence came health and healing in mind, body, and spirit. From that silence has come this book. And from that silence has come the greatest message of all: *God loves me.*

As I began to walk into this unknown territory, *Invitation to a Journey: A Road Map for Spiritual Formation*, written by M. Robert Mulholland Jr., was such a help to me. He talks about the difficulty of staying with a spiritual discipline "when God begins to work with the deep-down brokenness of your life."[10] How we need others to support us in this because when we begin to offer a spiritual discipline back to the God who has called us into it, we discover that a warfare is going on inside of us.

The apostle Paul spoke to this reality in Galatians 5:17: "The desires of the flesh are against the Spirit, and the desires of the Spirit are against the flesh" (ESV). In this passage Paul was talking about walking by the Spirit (Galatians 5:16). When we begin to do that, a war does indeed break out; the flesh (our natural inclination) wars against the Spirit, and the Spirit wars against the flesh.[11]

Yes, you will find it hard to do. I found it hard to do. There were many roadblocks at first regarding time, my own fears, and others' perceptions. Persevere. Ruth Haley Barton has written extensively and practically on this topic in two beautiful books published by InterVarsity Press, *Invitation to Solitude and Silence: Experiencing God's Transforming Presence* and *Sacred Rhythms: Arranging Our Lives for Spiritual Transformation.*

But the good news is that this very discipline, offered back to God and pursued, "becomes a means of grace through which God works and moves to transform that dead portion of our body into life in the image of Christ."[12]

Dear sister, today I give you that same permission: *Go away alone for twenty-four hours and be with God.* God longs for your total attention. He is an ardent, yet patient, lover. He will meet you there. Take your Bible. Take a journal. Leave your cell phone behind and anything else that encourages noise. Seek God and he will be found.

This spiritual discipline has become one of the greatest joys of my life. I attempt to go away alone for twenty-four hours every month and for forty-eight hours every three months. I must warn you though—you could become addicted . . . addicted to God and his love.

One small caution as we think of seeking God. *Spirituality* and *contemplation* have become buzzwords in these recent years. The Scriptures warn us that Satan is the ultimate deceiver and the father of lies and at times parades as an angel of light. So, in bookstores you may find many books on these subjects. Watch carefully. Satan knows how to deceive women.

Recently, I picked up a book directed to women telling us to "claim the Goddess [capital G] within us" and "pay attention to the Goddess within because all the answers are inside yourself." Or you may be encouraged to "welcome the wisdom and compassion of your inner Priestess." All of this seeks to turn over to us the power and authority of Jesus Christ, Son of God and God himself. In this faulty thinking, we are the important one; we are the Goddess or the Priestess. Another form of this lie is to worship and pray to the "Goddess Sophia." *Sophia* is the Greek word for wisdom.

But in the New Testament, the apostle Paul made it clear over and over again that the wisdom of God (*sophia*) is personified in Jesus Christ. Paul wrote in 1 Corinthians 1:21–24, "For since, in the wisdom of God, the world did not know God through wisdom, it pleased God through the folly of what we preach to save those who believe. For Jews demand signs and Greeks seek wisdom, but we preach Christ crucified, a stumbling block to Jews and folly to Gentiles, but to those who are called, both Jews and Greeks, *Christ the power of God and the wisdom of God*" (ESV, emphasis added). And verse 30 in the same chapter states, "And because of him [God] you are in *Christ Jesus, who became to us wisdom from God*, righteousness and sanctification and redemption . . ." (ESV, emphasis added).

It is very important as well that Paul connected God's "master workman" in creation (mentioned in Proverbs 8:27–30 ESV) with Jesus Christ, in Colossians 1:16: "For by him all things were created: things in heaven and on earth, visible and invisible, whether thrones or powers or rulers or authorities; all things were created by him and for him."

As we seek silence and solitude, Jesus Christ—God—is our focus, listening to his voice through the Word of God and prayer. Jesus Christ is our wisdom. In Isaiah 30:15 the Lord said, "In returning and rest you shall be saved; in quietness and confidence shall be your strength" (NKJV). It is to God, our loving Creator, that our hearts long to return. He is the only one who can fill the void with his love, his rest, his quietness, and his hope.

In every Gospel of the New Testament, we find Jesus getting alone, in seclusion, drawing away from crowds, disciples, and friends to be in the presence of his Father.[13] Mark 1:35–37 says, "Very early in the morning, while it was still dark, Jesus got up, left the house and went off to a solitary place, where he prayed. Simon and his companions went to look for him, and when they found him, they exclaimed, 'Everyone is looking for you!'" "If the Son of God needed seclusion, how much more do we need it? What happens in seclusion determines, for the most part, what happens publicly."[14]

We must assume that Anna rested and drew strength, new perspective, guidance, and hope from the presence of her heavenly Father. Will you?

Anna's Promise

Because Anna accepted the *place* of her life, because she knew and honed the gifts God had given her and found great *pleasure* in that, because Anna assumed the *posture* of a worshiper of God no matter her circumstances, she also recognized the *promise* of God's word to her. Psalm 37:4 says, "Delight yourself in the LORD and he will give you the desires of your heart."

How could Anna have known in that busy, normally people-packed court of the women that day that *this* was the Christ child she had awaited? She knew because she had formed a lifelong habit of listening and worshiping, remaining patiently faithful to the lover of her soul. I think as she hobbled out that day, with perhaps the support of a cane, she felt the familiar tug of the Holy Spirit, the inner prompting to head in the direction of young couples who might need her help. Only this time, something seemed unusually different. She stopped for just a moment. Could it be?

There before her she recognized her friend Simeon. As she came closer, she heard his words of blessing: "Sovereign Lord, as you have promised, you now dismiss your servant in peace. For my eyes have seen your salvation, which you have prepared in the sight of all people, a light for revelation to the Gentiles and for glory to your people Israel" (Luke 2:29–32). I can imagine that suddenly her steps quickened and her heart beat rapidly as she reached the young mother.

She gazed on that small baby boy. Then this dear, old prophetess broke out in spontaneous praise to God. She'd been waiting for this day for how long? Here he is! Here he is! Praise to God! Our Redeemer, the Messiah, is here at last! Her little old feet carried her out into the streets of Jerusalem where she proclaimed to all who shared her longing the wonderful arrival of the long-awaited Messiah.

What longing has Christ placed in your heart? What *promise* that you do not yet see fulfilled?

Like Anna, keep delighting yourself in your Lord. Keep praising him every day. He will lovingly bring your desires into line with his,

and in his grace and good timing, he will give you the desires of your heart.

to be . . .

I want to be like Anna,
when I'm old and gray,
(now *that* will be the day!)
Giving place—whatever space,
for God to have full sway.

Taking pleasure in God's ways,
Bent before His throne,
Rising strong, proclaiming loud
the love that He has shown.

I want to be like Anna,
when I'm old and gray,
With feet still strengthened by His power,
to share redemption's way.

— Ruth Tuttle Conard

8

DESIGNED TO EMBRACE

Elizabeth

Imagine dear, older, and pregnant Elizabeth standing on the flat rooftop of her house, gazing down on her Judean village. Suddenly, her eyes focus on the slight figure drawing near. It's young Mary from Nazareth, headed toward her door.

What thoughts entered her mind as she made her way down the stone steps toward that door?

But before we continue, let's take an inventory. What do you notice first when you meet another woman? What kind of woman annoys you? What kind of woman threatens you?

I remember attending a summer camp at age ten. I have never forgotten my counselor, Sue. That week I wrote home and told my parents all about the marvelous time I was having. But the best part

of all, I said, was my counselor who was so kind, so fun, and so *pretty.*

Neither have I forgotten a conversation with my parents as we drove away the last Sunday afternoon from camp. After reminiscing about all the cool things I'd experienced, my dad said, "I thought you said your counselor was pretty."

Sitting in the back seat of the car, I immediately came to the defense of my new heroine, "Well, she *is . . .* " And then I went quiet. Because, suddenly, in my mind, I saw what my father had seen. In actuality, Sue's face was pockmarked; she had straight black hair, and she wore very thick glasses.

But guess what? For an entire seven days, I had not noticed that. What I saw, what I felt, and what I experienced with Sue was the *presence of God,* even though I couldn't have verbalized that at age ten. To me, Sue was beautiful.

We women can so easily send very negative messages to one another—sometimes, I'm convinced, fully unaware of what we're doing. I'm sure that I too have been guilty of that. A few years ago when I was working at a college, there was a very interesting conference going on in the area of my office. I would like to have attended it, but couldn't because of my job.

I left my work for a break in the afternoon and went for coffee. In the coffee center there was a woman I'd seen before—a woman from another city who had a major role in this conference. I engaged her in conversation and found that in her forties she had pursued higher education. I congratulated her and asked how she had been able to do that. She quickly told me that her husband was a lawyer and had funded her studies. My heart sank. My husband is not a

lawyer, and, at that time, I could see no possibility of furthering my education.

She asked me what I was doing at this college. I briefly described my job. She said, "My, what a boring job that must be for you. I'm sure you'd much rather be at this conference." Our conversation ended abruptly as she returned to her conference. I returned to my job, feeling very unsettled, not affirmed, and with no hope for the journey ahead.

Within the Bible, from cover to cover, we find women having trouble connecting with one another, trouble supporting one another, and difficulty in giving each other hope. Miriam, the sister of Moses, is the first prophetess mentioned in Scripture, and she is also the first one mentioned in this light (Exodus 15:20). In Numbers 12:1, we find that she and her brother Aaron spoke against Moses because of his Cushite (Midianite) wife, Zipporah.

Why? Because she wasn't an Israelite? Because she was dark skinned and beautiful? Because of jealousy, since she was Moses' wife and closer to the power, the leadership? The Bible doesn't tell us the specifics, but Miriam—who seems to have been the initiator of the discontent—was struck with leprosy, not her brother Aaron.

In the New Testament we find the apostle Paul pleading with two of his coworkers—women leaders and evangelists who had labored arduously beside him. Their names are Euodia and Syntyche, and he begged them "to agree with each other in the Lord" (Philippians 4:2), undoubtedly because their position of influence affected the well-being of the church at Philippi.[1]

There are other very direct and harsh words from the prophets regarding women. Sometimes those words bring a chill to my soul.

Designer Women

One such example is in Isaiah 32:9–14, as Isaiah gives words of hope and warning about a righteous king coming: "Listen, you women who *lie around in lazy ease*. Listen to me, and I will tell you of your reward. In a short time—in just a little more than a year—you *careless ones* will suddenly begin to care. For your fruit crop will fail, and the harvest will never take place. Tremble, you *women of ease*; throw off your *unconcern*. Strip off your *pretty clothes*, and wear sackcloth in your grief. . . . Your joyful homes and happy cities will be gone. The palace and the city will be deserted, and busy towns will be empty" (NLT 1996, emphasis added).

May God speak to you and to me. May we not become women of such ease that we are lazy in our attitudes toward other women unlike ourselves in ethnicity, background, looks, language, social status, or religion. May we not be unconcerned for others because of our main focus on self or on pretty clothes, pretty houses, or pretty things.

We women always have a choice. We can view each other either as *obstacles* to growth or as *opportunities* for growth. Sometimes that means taking a personal inventory. Do I judge myself on how God sees me or on how other women view me? Is my relationship with others based on who I am in Christ (including the fruit of his Spirit) or on how well I can control others? Would it be good for me to read some books or take some seminars on communication and the whole area of teamwork and negotiation? Why *is* this woman a threat to me? Why and with what standard do I judge her? On the other hand, what can I learn from her? How can I get to know her better? Obstacle or opportunity—that's our personal choice.

Obstacles to Growth

What comes to your mind when you think of obstacles to growth in women's relationships? Where do you see yourself needing to grow in this area of getting along with other women? I've certainly needed to eat "humble pie," ask forgiveness, and withdraw incorrect judgment calls on the women God has put in my life. How about you? I think of four main components in seeing other women as obstacles: jealousy and envy, comparing, telling secrets, and clinging to another.

Jealousy and Envy

Feeling jealous or envious toward other women usually involves physical appearance, marital status, having children, money, gifting, or personality. In the Old Testament most of the wrangling between women was about something over which they had little or no control: the womb and what gender came from that womb. Some examples of this type of behavior are found in the relationships of Leah and Rachel (Genesis 29–30), Peninnah and Hannah (1 Samuel 1), and Sarah and Hagar (Genesis 16). Boys were prized above girls and continue to be in many parts of our world.

In 1 Corinthians 3:3 the apostle Paul spoke directly to the issue of jealousy: "For you are still of the flesh. For as long as there is jealousy and quarreling among you, are you not of the flesh, and behaving according to human inclinations?" (NRSV). Paul judged jealousy as "according to human inclinations" and "of the flesh," which in the Scriptures is always in opposition to what is spiritual and of the Holy Spirit. In other words, when we are envious or jealous of another

woman, we are imitating the world and acting like people who don't know God. We have to work hard *not* to allow our focus to be where the world wants it to be.

Who is your favorite female Bible character? Think for a moment; what does she look like? When we consider this, we find that very few women in the Bible are described physically. What *is* described is their heart after God, their life as God followers, and the good actions flowing out of their relationship with God.

Here is another question: What part of the body is called beautiful, according to God, in the Old and New Testaments? Look at Isaiah 52:7: "How beautiful upon the mountains are the feet of the messenger who announces peace, who brings good news, who announces salvation, who says to Zion, 'Your God reigns.'" (NRSV). And Romans 10:15 reads, "How beautiful are the feet of those who bring good news!" (NRSV).

Yes, it's our *feet!* Have you ever judged a woman by her feet?

One morning I was on my way to the open market in Chiclayo, Peru. Because it is a desert area and very hot later in the day, every wise woman markets early in the morning. As I approached the market, two young boys were sitting on the sidewalk with their wares spread out to sell: potatoes, sweet potatoes, onions, and garlic. One glanced up and saw me approaching. His eyes grew wide, and not ever thinking that I spoke Spanish, said clearly to his companion (in Spanish), "Oh my! Pedro, look what's coming! It's the *white giraffe!!*"

Well, to say the least, I was offended and did *not* buy from him that morning! (I did, by the way, get over that offense quite quickly and have since used it to encourage thousands of women.)

It doesn't matter how you look—how tall or short you are, whether you're round or slim, what color your skin is, what your last name is, what your nationality is, whether you're young or old, male or female. What matters to God are *your feet!* And I need to tell you that my feet are not small and lovely. They are exceptionally long and narrow and not beautiful by human standards.

Yet, God longs that our feet carry the tidings of the good news of salvation and God's love all over his earth. And he calls our feet beautiful when we use them for his glory. God focuses on the heart, which propels the feet, and whether a woman is his truly devoted disciple. All else matters not: not looks, clothes, womb production, or whatever. May our cry be to look at others as Christ looks at them.

Comparing

Consider comparing ourselves to others—oh yes, here the list could be very long, couldn't it? We can spend hours comparing our body with hers, our status as married or unmarried with hers, our gifts set up against hers, our monetary situation over against hers, our children, our house, and the list goes on and on. In fact, we can spend our entire life comparing ourselves with others.

But the One who made us knows that this, as well as jealousy, will eat us up and spit us out. We will be entirely ineffective as women and as God followers until we learn to stop comparing ourselves with others.

If our daily diet revolves around fashion magazines and keeping up with the highs and lows of celebrities, we will be prime targets for comparison to do its evil and debilitating work in us. We will come

to believe the lies lifted high in these magazines in regard to our body, our dress, and even our ways of acting. What, for me, is even more sad and frightening is that, through this negative example, we teach younger women around us to also imbibe these attitudes. It might help us to consider: "What other reading material, magazine, or book can I keep close at hand to help me focus on reality and not on fantasy?"

One would think that as women of the church, we would be so happy to see other women use their gifts, but, alas, here too we need to ask forgiveness for being threatened by other women's giftedness. James had some pretty strong words about this in his book: "But if you harbor bitter envy and selfish ambition in your hearts, do not boast about it or deny the truth. Such 'wisdom' . . . is . . . of the devil" (James 3:14–15).

Ruth Tucker, a powerful Christian historian, recounts well the stories of missionary women and their difficulties with one another. One of those she chronicles is Lottie Moon (1840–1912), who served in China for thirty-nine years and is known as the "Patron Saint of Southern Baptist Missions."[2] Lottie was a passionate woman with gifts of leadership, evangelist, church planter, and writer. But there were those women around her who found her "signs of female liberation 'repulsive.'" Mrs. Arthur Smith, a missionary wife, suggested Lottie was "mentally unbalanced for craving such 'lawless prancing all over the mission lot.' . . .[She] argued that the proper role of a female missionary was to attend with *a quivering lip* her own children."[3] Lottie was single. Upon her death, the highest tribute afforded her by the *Foreign Missions Journal* was to write that she was "the best man among our missionaries."[4]

Paul, in Galatians 6:4–5, wrote, "All must test their *own* work; then *that* work, rather than their neighbor's work, will become a cause for pride. For all must carry their *own* loads" (NRSV, emphasis added). In other words, each of us is to work on our own work, what God has given to *us*, instead of focusing on someone else's work. I am to do the best with what has been given to me and not worry about what has been given to *her*. I am to know and develop the work at hand that God has provided for me and not compare my work with hers.

When we lived in Mexico City, we were part of a growing church. I loved teaching a Bible class to new believers. However, a Mexican woman much younger than I, and much younger as a Christian, felt that she should teach it. And she took over. I was crushed. What would I do?

My husband helped me to realize that usually we don't have just one gift. God really isn't that stingy. I began to help out in his office, learn new skills, and minister in a different way (not without complaining at times, mind you, and having a few pity parties along the way!). However, peace came, and my young Christian friend grew in her teaching skills as well as in many other areas. I also grew in other areas.

One day, fourteen years later, long after we had left Mexico, I opened the in-box of my e-mails to find a message from this dear friend. She wrote to apologize for the misunderstandings we had weathered years before and to say that she loved me and hoped to see me again. What a surprise! What joy to write back to tell her how much I loved her and how much I'd also learned from that experience.

May we keep letting God teach us how to be patient, to continue developing and doing good with what he's given us, to wait, to pray, and to support our sisters in their gifts.

Telling Secrets

Proverbs 11:12–13 says, "Whoever belittles another lacks sense, but an intelligent person remains silent. A gossip goes about telling secrets, but one who is trustworthy in spirit keeps a confidence" (NRSV).

With what do you fill your mind so your conversation does not compose itself of other people? What interesting book are you reading? Do you have a reading plan? This year I am reading books on China and central Asia. But that may not be your interest. Do you read biographies? We can learn so much from other people's lives.

How are you seeing God at work in the world and in your life? Can you talk about thoughts, concepts, a hobby, and items of interest to avoid talking negatively about other people, whether it's your children or someone else's, the faults of your husband, coworker, or neighbor?

It is a good discipline to consider what we will allow ourselves to talk about, listen to, and comment on *before* we meet with other women. As David said in Psalm 141:3, we may also ask God, "Set a guard over my mouth, O LORD; keep watch over the door of my lips."

To help guide the conversation, we can think ahead of time about questions to ask the other person in regard to hobbies, family, background, or how she's seen God's goodness to her in recent days.

And, as the writer of Proverbs said above, sometimes it is better to remain silent about a subject or person rather than divulge something that will be of no help to anyone and, in the long run, prove damaging to another person and possibly to ourselves as well.

Clinging to Another

We women can quickly become exclusive in our relationships. We can so easily send the unspoken message: This is my friend or friends; please do not intrude. However, God desires that we become mature and not be enmeshed in relationships. Enmeshment involves not only living to please another (either to get something or out of fear about what others think of us) but also keeping outsiders away from those we believe we have exclusive rights to. We are to prize and cultivate friendships, but we must realize that we all need many other people in our lives.

David and Jonathan are a great example of two best friends who strengthened and encouraged each other: "And Saul's son Jonathan went to David at Horesh and helped him find strength in God" (1 Samuel 23:16).

One of my best friends in life is Marilyn, whom I first knew in Bolivia when I'd been married five months and she, only three. We became quite close at that time. Moving to Mexico some thirteen years later was exciting for me because Marilyn lived there.

I remember when she first introduced me to Marta, a lovely Mexican woman with a beautiful heart for Christ. I was a little worried and, frankly, more than a little threatened. Later Marilyn and I decided to form a ministry team, and she suggested that Marta be an integral part of that.

This became a time of growth for me—growth in an area where I needed to grow. Actually, the three of us had distinct gifts. I came to love both of these women deeply. We became an effective threesome in God's kingdom. The three of us remain lifelong friends, though living far apart. *Mature* relationships between women will not embrace exclusivity; they will embrace other women as well.

David and Jonathan encouraged one another *in the Lord*. In your relationships, as you seek to encourage one another toward God and the Scriptures, you will find that God will also open your arms toward others; and the friendship will not diminish, but rather, expand.

Opportunities for Growth

There is another way in which we can view women, that is, as opportunities—opportunities to share life together, opportunities to share Christ together, and opportunities to grow and learn of God's grace together.

Even though I've mentioned examples of women in the Bible not getting along, there are many instances of women joining together. And when they did, how powerfully God used them for great good.

There are the midwives Shiphrah and Puah, standing together against the Egyptian pharaoh to protect the lives of newborn Israelite baby boys. There's the mother-daughter team of Jochebed and Miriam, protecting the life of baby Moses. There are Queen Esther and her maids fasting together for wisdom, to face a powerful Persian king. The list could go on.

Think about your own life for a moment. How many relationships have you actually chosen in life? Almost none. You were placed

in a family. Your schoolmates were not with you because of your selection. Did you choose who would be your colleagues in the workplace? In the community groups we join and even in the church, there are people we like, and there are others we have to learn to get along with. Many young people, even today, do not choose their spouses; marriages are arranged for them. And if we have children, most of us did not have a choice in picking those out either!

It should begin to occur to us that, perhaps, God has a reason for placing around us the people he has. At this moment, I'm especially thinking of the women in our lives. Is it for us to learn from them? Is it for them to learn from us? Is it for us to learn together?

Let's take a close look at Elizabeth. Luke 1:5–7 says this about her: "In the time of Herod king of Judea there was a priest named Zechariah, who belonged to the priestly division of Abijah; his wife Elizabeth was also a descendant of Aaron. Both of them were upright in the sight of God, observing all the Lord's commandments and regulations blamelessly. But they had no children, because Elizabeth was barren; and they were both well along in years."

I doubt that Elizabeth was fully prepared for the *opportunity* that knocked on her door that special day in the hill country of Judea—a knock that could have resulted in an *obstacle* for this saintly older woman.

So, what made the difference? Why did Elizabeth see this as an opportunity instead of an obstacle?

Each of the four inspired Gospel writers brought something unique to the unfolding of Jesus' life as he walked on this earth. Luke was no exception. This Gentile medical doctor and author took great pains to include women in his biographical sketch of Jesus'

life. Often he paralleled men and women, as in this case of the priest Zechariah and his wife, Elizabeth.

Not only was Zechariah from the priestly line of Aaron, but Luke wanted us to know that Elizabeth was also. Not only was Zechariah "upright in the sight of God," but Luke underscored the fact that Elizabeth was also. They both observed "all the Lord's commandments and regulations blamelessly."

Yet, for all this spirituality, Elizabeth's life was not without sadness and suffering. In Luke 1:25, Elizabeth revealed the "disgrace" she endured among her people (similar to her ancient sister Rachel in Genesis 30:23), because she had no children. We can imagine that through the long barren years she felt shame when she overheard comments like, "How sad for dear Zechariah. Such a good and godly man. To think that Elizabeth cannot bear him a child, especially a son. My, my!"

Perhaps again and again, Elizabeth returned to Psalm 116:7, pondering its truth: "Return, O my soul, to your rest, for the LORD has dealt bountifully with you" (NRSV), affirming the goodness of the Lord to her in so many other areas of her life and believing that this sorrow was God's good choice for her and Zechariah. Not that she understood it, but in humility and love to God, I believe she accepted it.

Certainly, she could say along with David in that same psalm, "I kept my faith, even when I said, 'I am greatly afflicted'" (v. 10 NRSV). So, from our sisters in the Scriptures, we can learn that following God does not mean that everything will be lovely and rosy, but that he will never take his presence from us. He will be our strength

and our victory in and through it all, which includes those times of sorrow and suffering.

Most Jewish women longed to birth the Messiah. They knew from prophecies in the Old Testament, such as Micah 5:2, that he would come from a Jewish woman and that he would be born in Bethlehem. Although Elizabeth was not living in Bethlehem, neither was Mary when she became pregnant. God knows how to work out the impossible, messy details when we work with him in accomplishing his will.

We can just imagine this elderly couple's great joy when they found that the impossible had happened—Elizabeth was pregnant! Remember, Elizabeth had lived a full, long life of dedication to God, upright before him and before others. Had they ever wondered, dared to hope, that perhaps Elizabeth would birth the Messiah?

So, Elizabeth looked out and saw young Mary almost to her door. The meeting is described beautifully in Luke 1:39–45:

> At that time Mary got ready and hurried to a town in the hill country of Judea, where she entered Zechariah's home and greeted Elizabeth. When Elizabeth heard Mary's greeting, the baby leaped in her womb, and Elizabeth was filled with the Holy Spirit. In a loud voice she exclaimed: "Blessed are you among women, and blessed is the child you will bear! But why am I so favored, that the mother of my Lord should come to me? As soon as the sound of your greeting reached my ears, the baby in my womb leaped for joy. Blessed is she who has believed that what the Lord has said to her will be accomplished!"

Designer Women

But let's back up and imagine this scene a little differently. As Elizabeth carefully makes her way down the open, stone stairway (after all, she is six months pregnant), she hears Mary call out, "Elizabeth, Elizabeth, it's Mary." What if Elizabeth would have turned inward when she realized what was happening through the work of the Holy Spirit and the response of her child, John, within her own womb? What if Elizabeth had become jealous and mumbled to God, "How can this be? This young upstart? *She's* going to birth the Messiah? I just can't believe it! Not after all I've suffered, not after the longevity of my faith in you, Lord. *I* deserve to birth the Messiah!"

What if Elizabeth had cracked open just an inch of that upper wooden part in her door and rasped out to Mary, "Mary, dear, how nice to see you. I'd love to invite you in, but I'm quite far along in my pregnancy and not feeling at all up to par. Do forgive me, but would you mind just crossing the road over to your cousin Sarah? I know she'd love to have you. I'll be seeing you later." *Slam!*

I am so grateful to older, godly women in my life, who (though very different from me in temperament, rearing, and even perception of Scripture) had the grace and patience to allow me (as a younger woman with many questions and some rather harebrained ideas) into their lives, sharing the intimacy of their faith journey with me. Several come to mind, but one in particular.

Her name is Colleen Elliott. Our daughter, to whom this book is dedicated, is named after her. She and her husband, Bert, in their eighties now, have been missionaries in northern Peru for more than fifty years. They still live there. Their entire adult lives are a living testimony to the greatness, power, and goodness of God. Through

them, thousands have come to know Jesus Christ, and over one hundred churches have been planted.

When we arrived in their lives as a very young couple, we brought with us our first daughter, Melody, who was only five months old. Colleen was already past birthing age by then. Colleen and Bert loved Melody. For many months over several years, we lived with them, right in their modest house at times and then in shared houses, as we evangelized together, on land as well as on the Huallaga River in a tiny riverboat. They were like second parents to Melody. They played with her, laughed with her and at her, and watched over her, taking great delight in her antics and growth.

When our son, Timothy, was born, Colleen left Bert in the jungle—the first separation in their married lives—and came to help me out on the Peruvian coast where we were living at the time. When Christina was born, both of them came out to the coast and stayed with Melody and Tim during the entire time that Bill and I were in another city, awaiting and birthing Christina.

A couple of times during those years, I talked with Colleen about her experience of not having her own children. Hesitantly (because she models a woman of praise and not of pity), she told me about their dream, as newlyweds, of being the parents of a dozen children. And, believe me, they would have made great parents! When I probed, she also told me of times when she had wept over their childlessness, of unkind things people had—probably ever so unknowingly—said to her, even intimating that she must not want children or God would send them. Nothing could have been further from the truth.

I look back and am so thankful for the patience, acceptance, and love this dear, godly woman showed me, a young twentysomething

with much heart, perhaps, but so little understanding of many areas in which Colleen had excelled. I'm sure that at times she must have wondered why God had dropped *me* into her life. I know that it would have been almost impossible for me to have made it as a missionary in those early years without her help, wisdom, laughter (she once said, "Ruth, if you don't laugh, you won't last as a missionary"), and faithful example of a godly woman. Like Elizabeth embraced Mary and her unborn child, Colleen embraced me and my family.

Elizabeth *did* open that door! She *did* embrace Mary and her situation. She *did* share her house and her life with Mary. She did not miss this great opportunity!

Several years ago in the St. Paul Monastery in Minnesota, while spending two nights there in quietness before the Lord, I saw a quilt in their dining room that gave me a key to Elizabeth's maturity and ability to embrace God's will. I have found this key to be very beneficial in relationships.

This large and beautiful quilt is of Elizabeth, the older woman, and of Mary, the younger. Obviously, Elizabeth is bowing before the younger woman. The title of the quilt says it all: "Bowing to the Presence."

Elizabeth is not bowing to Mary; she is bowing to the presence of Christ within Mary. Elizabeth's own words express this truth when she said, "Blessed are you among women, and blessed is the child you will bear! But why am I so favored, that the mother of my Lord should come to me?" (Luke 1:42–43).

What changes would happen in our relationships if we always viewed a woman as one created and loved by God, though she may not yet know him? What if we approached every woman as a God-

given opportunity, bowing, in a sense, to the One who designed her?

What if we trained ourselves so that whenever we met a woman who knows God, we would look first into her eyes and, mentally, bow to the presence within her—that of the living, loving Holy Spirit of God?

What if each of us, no matter where God has us, started living like Elizabeth? What if we really trusted God and embraced the women God has placed in our lives, opening our hearts to them, as well as doors of service for them. What if we shared together our journey of faith, seeing them not as obstacles but as opportunities, even as others once did for us?

Someone near you, dear sister, needs you. Embrace her and be blessed!

daughters of Elizabeth ...

Arms outstretched, she welcomed in
one she could have scorned.
For Elizabeth, mature in faith,
sensed Mary's need for home.

In step with God and His good will,
in spite of age and pain,
She dances with her babe's sweet joy,
and Spirit-filled, exclaims,

"Blessed are you, oh sister mine,
with courage, without shame.
Belief has filled your womb with life,
and now I bow to Him."

Oh, may we, Lord, with outstretched arms,
deny our selfish ways;
Be doors of welcome, gifts of grace,
to sisters on the way.

— Ruth Tuttle Conard

9

DESIGNED TO PERSEVERE

Mary

How would you like to be remembered after you die?

Do you have a favorite photograph of yourself? Or maybe you've been lucky enough to have a portrait painted and you think, *Now that's the way I want people to remember me.* What are a couple of good traits you would hope people might mention about you when you're gone?

I'm sure we all hope that it doesn't go like this: "Hey, Suze, did you know that so-and-so passed away last week?"

"For goodness' sake, no! But you know what? She was such a grouch, so totally out of touch, wasn't she? I mean, I hope her family is okay, but frankly, I can't say that I'll miss her."

Nope! None of us want that.

Well, what if after your death you could look back, and you found that the representation of you was just the opposite of what you had wanted painted? Or the way people remembered you was just the opposite of who you'd really been? How would that make you feel?

Regarding women in the Bible, I find two who have been severely misunderstood and misrepresented. Eve is remembered most for her sin, and she has been unfairly made the scapegoat for all kinds of vice by some of the leading church fathers. An example is given of a treatise written in the third century by the church father Tertullian. He wrote:

> And do you not know that you are (each) an Eve? The sentence of God on this sex of yours lives in this age: the guilt must of necessity live too. *You* are the devil's gateway: *you* are the unsealer of that (forbidden) tree: *you* are the first deserter of the divine law: *you* are she who persuaded him whom the devil was not valiant enough to attack. *You* destroyed so easily God's image, man. On account of *your* desert—that is, death—even the Son of God had to die. And you think about adorning yourself over and above your "tunics of skins" (Genesis 3:21)?[1]

Over the centuries this writing, along with many others, has seriously impacted the church's view of women, because church tradition has stated or implied that by nature women are lower than men,[2] since many of its leaders have espoused the belief that sin entered through Eve and that women continue to carry the weight of her sin. It is important for us, as Christian women today, to understand

where this bias comes from. It does not come from the Word of God, nor is it perceived from the example of Jesus Christ (who is God) when he walked on this earth among women.

The second woman, also severely misunderstood and misrepresented, is the first key female in the narration of the New Testament: Mary, the mother of Jesus Christ.

Try to imagine with me how Mary would feel if she could see how she has been distorted, maligned, and misrepresented. This faithful, pious, humble, and, yes, *strong* woman—who followed God faithfully and continued throughout her life to grow in grace, always directing others to look to God and to Jesus Christ, God's Son—would not like what she would find. Let's consider how differently Mary is viewed today in contrast to her portrayal in the Holy Scriptures.

There is no record within the first four centuries following Christ of prayer being offered to Mary.[3] The apostles did not pray to her, nor did other Christ followers for four hundred years. However, from the middle of the fifth century through our own twenty-first century, Mary, the mother of Jesus, has been exalted with titles and positions far above and beyond anything the Scriptures testify to or support.

One important fact that is sustained by the Scriptures is that Mary and Joseph had other children after Jesus' birth. Matthew made a point of telling us that Joseph had no normal marital relationship with Mary "until" she had borne a son (Matthew 1:25), indicating there were others who came after Jesus. In the thirteenth chapter of his book, Matthew named four of Jesus' brothers and also mentioned "all his sisters" (13:54–58). The unbelief of Jesus' brothers is described by the apostle John (John 7:3–5).

Mary also came to embody the virtues of humility and compliance. Her words "I am the Lord's servant. . . . May it be to me as you have said" (Luke 1:38) signify humility and gentle obedience and are often seen as strictly feminine virtues. Yet, these virtues are also embodied in Jesus Christ, as he submitted to the Father's will. In many parts of our world where men are defined as dominant, strong, and leaders while women are to be submissive, self-effacing, and lowly, those feminine virtues are upheld as "Mary-like."

The real Mary, who was strong and *chose* personal and spiritual growth, has been lost to us. She has been lost to the Protestant church as well as to other church groupings. The Reformers of the sixteenth century, in rightly refuting the ill-founded idolatry of Mary, went a step further in reacting to the cult of Mary by ignoring her and so removed from us a model and a mentor.

Let's take a look now at the real Mary. She is a woman we can readily begin to identify with. She was much like us, or as we aspire to be—a woman who loved God and longed to love him more. She was a woman with doubts, troubles, and grief, but a woman who continued to grow in her faith.

How did she have the courage to persevere, this special woman chosen to birth the very Son of God? What can we learn from her? How can we continue to persevere and grow in our faith no matter what circumstances surround our life? What do the Scriptures say about her?

We can draw a realistic portrait of Mary by using the acronym of her name: "M" for making the Word of God her first priority, "A" for addressing the issue of her identity, "R" for refusing to hold grudges,

and "Y" for saying yes to God. We will look at these individually below.

Making the Word of God Her First Priority

Luke 1:46–55 reads like this:

> And Mary said:
>
> "My soul glorifies the Lord
>> and my spirit rejoices in God my Savior,
> for he has been mindful
>> of the humble state of his servant.
> From now on all generations will call me blessed,
>> for the Mighty One has done great things for me—
>> holy is his name.
> His mercy extends to those who fear him,
>> from generation to generation.
> He has performed mighty deeds with his arm;
>> he has scattered those who are proud in their
>> inmost thoughts.
> He has brought down rulers from their thrones
>> but has lifted up the humble.
> He has filled the hungry with good things
>> but has sent the rich away empty.
> He has helped his servant Israel,
>> remembering to be merciful
> to Abraham and his descendants forever,
>> even as he said to our fathers."

We call this the Magnificat or the "Song of Mary." It is a weaving together of several psalms, and it also reflects the prayer of Hannah in 1 Samuel 2. How did this scriptural song just roll off Mary's tongue with such liberty and joy? It was because Mary was not only aware of the Scriptures, but also *knew* them. She read or heard them consistently, and she must have memorized some of them.

She was aware of angels in the Old Testament who appeared to both men and women. So, although she was probably terrified at the appearance of the angel Gabriel, she also knew that this did happen and that it was extremely special. When Gabriel divulged to her private information about the pregnancy of her relative Elizabeth, Mary was convinced that this angel was from God and cried out, "I am the Lord's servant. . . . May it be to me as you have said" (Luke 1:38).

Listen to what Mary's ancestor King David said about the Word of God in Psalm 19. He said that the Word of God revives the soul, is trustworthy, makes wise the simple, gives joy to the heart, gives light to our eyes, and in keeping the Word "there is great reward" (v. 11). Mary's life is a testament to that.

Do you long for your very being to be revived? Read the Word! Do you long to be made wise—given discernment with all the decisions before you? Read the Word! Would you like your heart to be filled with joy and have that light of hope come back into your eyes? Read the Word!

My dear cousin Diana surprised me one night with a telephone call. We are the same age and were very close during our growing-up years. She was on dialysis for nineteen years. Each kidney weighed over forty pounds and continued to grow. She tried a kidney transplant,

but her body rejected it, and the whole process injured her heart. Despite all her suffering, she told me the night when she called that it was only in reading God's Word that she could sleep at night. She placed her confidence in God, who revived her soul even when her kidneys were failing. And she kept her good sense of humor. I was so proud of her. Not long afterward she went home to Christ, but her testimony to the power of the Word of God in her life continues to encourage me.

What priority does the Word of God have in your life? How much time do you give in meditating, studying, reading, and memorizing portions of Scripture?

Addressing the Issue of Her Identity

Do you ever ask yourself, "Who am I?" Mary found her identity in doing God's will. She said, "I am the Lord's servant." But it's certainly not as if she understood herself completely (she was a young teenager at that time), nor did she understand what God was asking of her. And she could not have understood her relationship to her son Jesus. How was she to relate to him? At times, she seemed confused as to who he was (see Mark 3:21, 31–32). So, what did she do to figure out her identity and who she was in relation to her son Jesus, the Son of God?

Luke 2:19 says this about Mary after the birth of Jesus and the appearance of the shepherds to her and Joseph: "But Mary treasured up all these things and pondered them in her heart."

Later when Jesus was twelve years old, his parents lost him in a huge crowd because he had stayed behind in Jerusalem—without telling them—to dialogue with the seasoned scholars in the temple.

After returning to Jerusalem and searching for three days, they finally found him. Luke recounted this: "'Why were you searching for me?' he [Jesus] asked. 'Didn't you know I had to be in my Father's house?' But they [his parents] did not understand what he was saying to them. Then he went down to Nazareth with them and was obedient to them. But his mother treasured all these things in her heart" (Luke 2:49–51).

Mary reflected; she "treasured all these things [experiences/words] in her heart." She pondered; she thought; she may have journaled. What we do know is that she read or heard the Word consistently and considered carefully her life circumstances in relation to that Word, seeking God for meaning to it all. It's quite clear that she did *not* understand all that she was involved in or the whole scope of her life. Do you?

Through Mary's knowledge of the Word, I believe she had become convinced of God's great love for her. That formed the basis for her identity—a woman loved by God, her Creator. Psalm 145 says, "The Lord is good to all; he has compassion on all he has made." And again, "The Lord is righteous in all his ways and loving toward all he has made" (vv. 9, 17). And that love of God so filled her up, so resonated in the depths of her being, that in one critical moment she could say with conviction, "I am the Lord's servant."

God's Word is a book of love to you and to me. Again and again he says through stories, direct words, poetry, songs, and symbols how *much* he loves us:

- enough to die for us
- enough to forgive all our sins
- enough to rise again

- enough to never leave us or desert us
- enough to long for our wholeness in every aspect of life
- enough to send his Holy Spirit to counsel and comfort us along the way
- even enough to come back and take us to his home

Do you know and believe the great love God has for you today? It's the best place to start in recognizing who you really are—from God's point of view. John Calvin echoed the belief of many godly people from the past when he said, "Nearly all wisdom we possess, that is to say, true and sound wisdom consists of two parts: the *knowledge of God and of ourselves*"[4] (emphasis added). Through reading the Word, we come to know God better. By knowing God more intimately, we begin to understand ourselves better. Mary operated out of the love she knew God had for her. From that God-given identity, she moved forward.

Refusing to Hold Grudges

This was a big issue for Mary and probably for us also . . . right? John 2:1–5 tells us: "On the third day a wedding took place at Cana in Galilee. Jesus' mother was there, and Jesus and his disciples had also been invited to the wedding. When the wine was gone, Jesus' mother said to him, 'They have no more wine.' 'Dear woman, why do you involve me?' Jesus replied, 'My time has not yet come.' His mother said to the servants, 'Do whatever he tells you.'"

Mary, Jesus, and his disciples were attending a wedding celebration in the city of Cana. Mary believed—rightly so—that her son Jesus could do something about the lack of wine. It was here that

Jesus first drew the line between his earthly family and his heavenly duties. Jesus let Mary know that he did the bidding only of his heavenly Father, not his earthly mother.

How would you have felt as Jesus' mother at that point? But Mary did not hold a grudge against her son; she didn't go off in the corner and sulk. She caught a glimpse of the possibility that *if* it was the Father's will, her son would act. She bowed to her son. She instructed the servants, "Do whatever he tells you." And, in the end, Jesus did save the day, but not because of his mother's wishes, but because of his Father's will.

As Jesus came into adulthood, it seems that Joseph had died. The Word only speaks of Mary's sons and daughters, the brothers and sisters of Jesus. Matthew 13:54–57 says: "Coming to his hometown, he [Jesus] began teaching the people in their synagogue, and they were amazed. 'Where did this man get this wisdom and these miraculous powers?' they asked. 'Isn't this the carpenter's son? Isn't his mother's name Mary, and aren't his brothers James, Joseph, Simon and Judas? Aren't all his sisters with us? Where then did this man get all these things?' And they took offense at him."

In that culture, upon a father's death, the firstborn son would be expected to take full responsibility for the family. Jesus would have been expected to care for his widowed mother, perhaps enlarge Joseph's carpentry business, help his brothers get on with life, and see that his sisters married well. Yet Jesus decided to go off and preach. We can imagine that his brothers did not appreciate that and that Mary was caught in the middle of feuding, offended siblings.

John 7:1–5 provides a view of how these brothers felt toward their oldest brother: "After this, Jesus went around in Galilee, purposely

staying away from Judea because the Jews there were waiting to take his life. But when the Jewish Feast of Tabernacles was near, Jesus' brothers said to him, 'You ought to leave here and go to Judea, so that your disciples may see the miracles you do. No one who wants to become a public figure acts in secret. Since you are doing these things, show yourself to the world.' For even his own brothers did not believe in him."

His brothers taunted him, as if saying, "Go on up to Jerusalem and be the big shot that you really want to be! Go ahead, Bro, stand up to those tough guys in Jerusalem. Anyway, they can't touch *you;* surely, you'll just pull off one of your miracles!" As the Scripture says, even his brothers did not believe that he was the Messiah. They didn't believe what he was preaching. And we know that they didn't until after the resurrection.

Oh, the sword that must have been turning in Mary's breast, the sword that the prophet Simeon spoke of in Luke 2:35, churning up fear, doubt, and worry, along with a growing belief in her son, God's Son.

And then the moment came when Mary and her sons went to where Jesus was preaching. Had Mary rehearsed what she might say, or were her sons pleading with her to say something like, "Please come home, Jesus! The religious rulers are after you. The Romans could crush you in an instant. Jesus, why do you have to push the envelope? Why do you have to raise questions and cause problems? And could you tell me why these unkempt and unholy women follow you around? Why, why, don't you just come home? You're such a good man. Jesus, I'm alone; I need you; our family needs you!"

We find the encounter recorded in Matthew 12:46–50: "While Jesus was still talking to the crowd, his mother and brothers stood outside, wanting to speak to him. Someone told him, 'Your mother and brothers are standing outside, wanting to speak to you.' He replied to him, 'Who is my mother, and who are my brothers?' Pointing to his disciples, he said, 'Here are my mother and my brothers. For whoever does the will of my Father in heaven is my brother and sister and mother.'"

Did Mary whisper in her heart, as she trudged back home with her very unhappy sons: "God, I am offended by *you*! What is going on?"

And then came that fatal day when Jesus was caught and put to death. And can you believe it? Matthew 26:56 reads: "Then all the disciples deserted him and fled."

Don't you think that for Mary everything became very dark during those hours of torture and then death for her precious son? Her other sons were not there to comfort her. They didn't believe that Jesus was the Messiah and were probably terrified that they too would be punished as Jesus' brothers. And then all of his closest friends, at least all the men except one, deserted him and ran away. One fled (Mark 14:51–52) in such a hurry, as the mob tried to grab him, that he left his clothes behind. Tradition says that this young man may have been John Mark, the writer of the book of Mark.[5]

Oh, how Mary must have wept and mourned and grieved. Oh, the resentment she *could* have held in her heart against almighty God—God, the One who had given her such an awesome privilege, such a heavy responsibility of birthing and nurturing this son, the very Son of God.

But I believe something happened for Mary there at the foot of the cross, as she looked up into the agonized eyes of her son, as she knelt there, comforted by her women friends, with the one male disciple, John, standing nearby. She heard her son, the Son of God, speak, "Father, forgive them, for they do not know what they are doing" (Luke 23:34). And later, "When Jesus saw his mother there, and the disciple whom he loved standing nearby, he said to his mother, 'Dear woman, here is your son,' and to the disciple, 'Here is your mother.' From that time on, this disciple took her into his home" (John 19:26–27).

Jesus' last familial act was that of an eldest son. He made sure that his mother had a safe home in which to live and to be loved. He didn't send her with one of his unbelieving brothers. He sent her with John, his beloved disciple, the one he knew he could trust to give her the very best care.

That day Mary became an integral part of those disciples she had sometimes, perhaps, misunderstood. Although Jesus' brothers did not yet accept him as God's Son, Mary truly believed that this One hanging before her was the Son of God. She cast in her lot with those disciples that very scary, dark, and dreadful afternoon.

Although Mary didn't understand all that was happening, she refused to hold grudges, to nurse resentment toward God and toward others. She became a part of those disciples who had deserted her son. How? She forgave. She followed the example of her son, who said, "Father, forgive them, for they do not know what they are doing."

Are you finding it hard to follow Christ today? Is resentment embedded in your soul? Is there someone you need to forgive? Christ

can help you to forgive today, if you will ask him. Give your resentment, grudges, and hate to the Lord Jesus Christ. He will forgive you. He will replace the resentment, grudges, and hate with great peace and joy. You will have renewed energy, courage, and love to persevere.

Saying Yes to God

Saying yes to God is for every decade and for every season of life. Saying yes to God made Mary a "dangerous" woman in the kingdom of God. Because of her love for God, what pleased her most was to do God's will, and she persevered in that.

Her yes brought her into alignment with God and his will. Her yes gave her a purpose. Her yes gave her a mission to fulfill. Her yes was a resolute yes, and the God who had called her walked with her, stood beside her, surrounded her, and lived within her. That is the kind of woman who is dangerous in God's kingdom. Adversity, calamity, sorrow, disappointment, being misunderstood and not understanding, fear, doubts, loneliness, setbacks—Mary experienced them all. Yet she persevered. Nothing could stop her from accomplishing what God had called her to, because Mary kept saying yes: "I am the Lord's servant." Mary kept pulling herself back to God's truths and kept falling madly in love with God and the ways of God.

I believe that Mary was among the first to hear the announcement that Jesus was alive. It is not hard to imagine that she had spent her darkest hours surrounded by the women disciples who followed her son. We can envision them weeping, praying, and encouraging one another before Mary Magdalene led some of them back to the

tomb with prepared spices for the body of Jesus (Luke 24:1). What inexpressible joy for Mary to hear this greatest news: Jesus had risen from the dead and was alive (Luke 24:5–7)!

Mary had kept believing God; she had not given up. What must it have been like to see her son alive once again? What delirious joy! What peace! What celebration over the fulfillment of God's promises! Mary experienced all of this because she kept saying yes to God's will.

And Mary was among the first to receive the Holy Spirit:

> Then they returned to Jerusalem from the hill called the Mount of Olives, a Sabbath day's walk from the city. When they arrived, they went upstairs to the room where they were staying. Those present were Peter, John, James and Andrew; Philip and Thomas, Bartholomew and Matthew; James son of Alphaeus and Simon the Zealot, and Judas son of James. They all joined together constantly in prayer, along with the women *and Mary the mother of Jesus, and with his brothers . . .*
>
> When the day of Pentecost came, they were all together in one place. Suddenly a sound like the blowing of a violent wind came from heaven and filled the whole house where they were sitting. They saw what seemed to be tongues of fire that separated and came to rest on each of them. All of them were filled with the Holy Spirit and began to speak in other tongues as the Spirit enabled them. (Acts 1:12–14; 2:1–4, emphasis added)

Oh, happy day! We find Mary named among the disciples. And what's this? "*And . . . his brothers.*" What joy for Mary, the mother of Jesus—her other sons had believed and were praying in that room together with the disciples! Mary's questions were resolved and her faith rewarded. She had witnessed the resurrection of Jesus, and clarity had been given her and her sons regarding Jesus' mission and his essential nature as the Son of God. Rightly so, we find Mary on her knees, in prayer, bowing to the One whom she finally understood.

Mary was in that upper room with the rest, believing the last words of Jesus when he said, "You will receive power when the Holy Spirit comes on you; and you will be my witnesses" (Acts 1:8). She experienced the "sound like the blowing of a violent wind . . . from heaven" (Acts 2:2). She watched in awe and wonder as what seemed like "tongues of fire" filled the room. The tongues of fire separated and came to rest on each of them, including her. Surely, with a deep peace and intense joy, Mary received the Holy Spirit of Christ. The woman who had been filled with the unborn Son of God then became filled with the Spirit of God.

Joyfully filled with the Spirit, Mary rose to her feet and followed the other disciples out into the streets of Jerusalem. And, in a language foreign to herself yet understood by her listeners, she proclaimed the living Christ!

What a beautiful last piece in the portrait of Mary, mother of Jesus.

Do you want to be a woman who perseveres as Mary did? Say *yes* today to whatever God is asking of you. You too will be blessed beyond your wildest dreams!

December prophecy . . .

"Be it unto me, O Lord, according to
Your Word."

Yes, Lord,
Do to and with me as
You take pleasure.
And I, yes, I,
take pleasure in responding,
"Be it unto me, O Lord, according to
Your Word."

And he, even as Joseph
would not have Mary stoned,
desires to lovingly tuck me away
into more comfortable perceptions.
Yet angelic "fear nots" keep
lingering near his eargate.
And it shall come to pass
that not I—nor he—
But *we* will do the bidding
of God's Word.

Yet first *I* must whisper,
"Be it unto me, O Lord, according to
Your Word."

— Ruth Tuttle Conard

10

DESIGNED TO SERVE

Dorcas and Priscilla

Do you have a dream deep within? Is there something you long to do but have not yet started? Do you remember some positive feedback you received when you attempted something for which you had a passion?

I hope you will concentrate on you, just on you, as you read this last chapter. Because right now I want you to have the courage to celebrate *you!* That's right. Don't be bashful.

As women, we expend great energy celebrating our children, our siblings, our parents, our husbands, our friends. And we want to. We do it gladly. But right now, I want you to celebrate you. Don't worry about pride.

If you do something special for someone, doesn't it make you happy when he or she says, "Hey, thank you!"? Well, I think it makes

God happy too when we acknowledge how he's made us and we say, "Thank you, God!"

Romans 12:3 says, "For by the grace given to me I say to everyone among you not to think of yourself more highly than you ought to think, but to *think with sober judgment, each according to the measure of faith that God has assigned*" (NRSV, emphasis added).

In other words, we are to think sensibly, to be truthful. Thinking truthfully about yourself isn't being proud. It is trying to assess who God has made you to be. That's being wise and intelligent. That is honoring to the One who designed you. Ask God for faith to believe and put into practice what he is showing you.

I have found that many women receive abusive words, day in, day out. Words that demean them and make them feel small. Words that do not build up. Words that instill doubt about themselves and the way they have been designed—even Christian women. This is not Christlike on the part of those who express this behavior. God rejoices in you and over you! There is no one like *you* on this earth, and that is *by design*, the Creator's intentional design.

So, I'd like for you to finish these two sentences, inserting something *positive* about yourself:

I am _____.

I love to _____.

I hope you are happy with what you put on those lines. I hope you will call a friend and say those sentences to her. Ask her—but I think she will already naturally do so—to be happy with you. It is appropriate and wonderful to recognize and even rejoice in how God has uniquely designed *you*. And it is good to let God know how

happy you are with *your* design. You have been designed *by design*. No mistake about it; God knew exactly what he was doing!

Yes, yes, you and I know there's always room for improvement. But don't we all hear that message in many and varied forms every day?

This chapter is not about improvement. This chapter is about having the courage to accept yourself, the courage to embrace the giftedness God has given you, and the courage to live out who God has really made you to be. This chapter is about having the courage to embrace your unique design.

Spiritual Gifts

In the New Testament writings, women are seen and acknowledged as full participants from the beginning of the church's existence. "They were fully present in the activities of the congregations. And they shared fully in the Spirit's endowment for service."[1]

There are three major lists of the gifts God gives us. They are found in 1 Corinthians 12:1–11, 27–31; Ephesians 4:11–12; and Romans 12:3–8. Some also add 1 Peter 4:9–11. These lists are not identical, and they vary in order and content. They are meant to be illustrative, not exhaustive. There are other passages of Scripture that mention gifts (often through examples of people doing their gifting) not listed in these passages. Don't let that confuse you.

Because I began playing the piano at age five and developed that ability over the years, I used to worry that music was not listed in any of the passages. So, was being a musician a "spiritual gift" or just a talent or what? If you commit to God *any* talent he's given you, he will know how to develop that for his glory and for the joy of others.

(Of course, in regard to music, there are many passages in Scripture that speak of the spiritual use of music in God's kingdom, for example, 2 Chronicles 7:6 and Colossians 3:16.) When it is a *spiritual* gift, there will be moments when the Spirit will use it beyond what you can imagine or are even capable of doing, humanly speaking. And it will be an interest especially designed by God for you.[2] You will recognize, beyond the shadow of a doubt, that it is truly God at work and not you.

If you give to God what you love to do, God will use it in multiple ways to bless others and help them experience Christ's love. The gifting will draw them to Christ. There are three important points I want us to consider regarding the gifts God gives us: knowing your gifts, sharing your gifts, and the source of your gifts.

Knowing Your Gifts

In 1 Corinthians 12:1 we are told, "Now concerning spiritual gifts, brothers and sisters, I do not want you to be uninformed" (NRSV). I use this translation with the "brothers and sisters" because I believe it responds rightly to the *vocative* "*you*" in the Greek, which is more like our "you all," including women as well as men. We are not to be uninformed, or "ignorant" as the NIV says. If you are reading this and you think that you do not have a spiritual gift, or you don't know what it is, that does *not* let you off the hook. Saying it positively, the apostle Paul stated clearly that you *are* to be informed; you *are* to know. Why? Because *you* are so important to the body of Christ. What you have to bring is critical to the functioning of the body of Christ. You and the gifts given you by God are important.

Sharing Your Gifts

In 1 Corinthians 12:7 Paul wrote, "To each is given the manifestation of the Spirit for the common good" (NRSV). So, you and I don't have the option of saying, "Well, yes, I like to do this or that, but not today." Or, "I don't like the way I was asked, so I'm not going to do it!" Or, "Why are you asking me? *She* does it much better than I can." No, the gift given us is not for us to hoard, but to give away. It is a gift given to us for *everyone else*. It has been given to us by God and is to be used for his glory and for another's joy.

The Origin of Your Gifts

Continuing in 1 Corinthians 12 we find, "All these [gifts] are activated by one and the same Spirit, who allots to each one individually *just as the Spirit chooses*" (v. 11 NRSV, emphasis added). So, it is the Spirit of God who determines what gift or gifts he will give and whom he will give them to. Gender, race, or age is not a question when it comes to gifts. *All* the gifts, according to the Greek language in which these passages were written, are given to whomever; the words being used in the Greek mean "to each person," and "to each one," "to one," "to another." Dr. Gordon D. Fee, well-known New Testament scholar, says the use of the word "men" in 1 Corinthians 12:6 (NIV) "is needlessly sexist—and not carried through in vv. 7–12."[3] The gifts are not divided up according to male and female, his and hers. This includes leadership, preaching, teaching, and pastoring as well.

Some of the most powerful and effective churches Bill and I have had the privilege of visiting are in Asia, where brothers and sisters serve together, side by side, according to their gifts, not gender. Those who have studied the history of revivals around the world concur that

when there is true revival, people under the almighty influence of the Spirit of God serve according to gift, not gender. How I long for that day when in every land and in every group, men and women—true disciples of Jesus Christ, following him in obedience—will serve together side by side in humility, holiness, and power, according to their gifting given them by the Spirit of God.

In the church of Jesus Christ, Paul said, "There is no longer Jew or Greek, there is no longer slave or free, there is no longer male and female; for all of you are one in Christ Jesus" (Galatians 3:28 NRSV). And with the coming of the Holy Spirit in Acts 2, Luke documented the apostle Peter saying that this happening was in fulfillment of the prophecy of Joel 2:28–29: "And afterward, I will pour out my Spirit on all people. Your sons and *daughters* will prophesy. . . . Even on my servants, both men and *women*, I will pour out my Spirit in those days" (emphasis added). Sister, we are in those last days. With whatever gift God has given you, he has gifted *you* to minister.

If you've never taken a survey to discover your particular spiritual gifts, talk with a leader you have confidence in. Ask her or him where you can get one of these. Many churches offer courses on spiritual gifts, where you can read good materials and be tested. There are also very good books written on this subject. One is written by three authors, Kise, Stark, and Hirsh, called *LifeKeys—Discovering Who You Are, Why You're Here, What You Do Best*. Another by Bruce L. Bugbee is *What You Do Best in the Body of Christ: Discover Your Spiritual Gifts, Personal Style and God-Given Passion*, a Willow Creek publication, which can be purchased at Amazon.com. Buy one. Read it. Seek God. *Know* your spiritual gifts. They will be the "sweet spot" out of which you will serve with effectiveness and great joy.

Two Amazing Women

Considering gifts, there are two amazing women in the New Testament whom I feel an affinity with. One is *Dorcas* who was designed to *sew;* the other is *Priscilla* who was also designed to *sow.* Dorcas was designed to use her hands in sewing with needle and thread. Priscilla was designed to use her mouth to sow the Word of God.

Why do I feel an affinity with Dorcas? My mother was a seamstress. I mentioned that she stitched over forty quilts in her lifetime. She also made many of my clothes until I left home in my early twenties.

I never remember my mother saying an unkind word to me, which doesn't mean she didn't reprimand me or become frustrated with me. But she never used harsh words. Only one time did I feel crushed by her words. I don't believe she ever thought twice about what she said to me. As a young mother, just having returned from the mission field, I was standing with her at the dining room table. I was trying to understand a pattern spread out in front of us, when suddenly she blurted out in great frustration, "You mean you *still* don't get this?!!"

At that time in Peru where we lived, there were no stores in which to buy clothing. Everything had to be made. There were seamstresses, a dime a dozen. But I felt great guilt about not being able to sew. How could one possibly be a missionary and not sew? Every missionary woman I knew could mend, stitch, and sew.

When I arrived back in my country, I always headed for a fabric store where I bought fabric and patterns to salve my conscience. However, most of these items remained in a bottom drawer—never to

adorn the bodies of my children. They were probably lucky! Frankly, I could not sew.

Many in my church wanted to believe I sewed like my mother, even when I tried to explain that I didn't. And I never would. But my hands were adept in another area. I played the piano very well.

People who sewed always told me, "It's so easy, Ruth. You could do it." Yet inside I knew I couldn't. I am totally baffled by pattern instructions.

It wasn't until I was forty years old, standing in front of an audience of 350 women that I said point-blank, "I *cannot* sew." There was a moment of shocked silence, and then a great burst of applause spread across the auditorium. Women were laughing, some even with tears, as they rose to their feet as if to stand with me in that very personal confession. That day I was finally set free from the expectation of others as well as from my own guilt over not having a gift that was never given to me. And, I have a feeling that in that moment, many other women, along with me, were also set free.

Are you carrying the weight of doing something you were never designed to do? Are you pretending to carry a passion that really is not yours? I hope you'll be on your way to freedom, even today, as you consider where your true passion lies and how you have been designed to fulfill that.

I am not talking about doing something out of commitment or responsibility that we may not particularly enjoy. I think we would agree that making tents was not the apostle Paul's great passion. Preaching and teaching and planting churches were his passion. But he spent long hours in tent making in order to live. I am talking about *God's gifts to you* that connect with your innate *passion*.

Although I was not designed like Dorcas to sew, I have been designed like Priscilla to sow the Word of God. I'm using these two particular women because they are excellent examples of distinct designs—probably in temperament as well as gifts—to demonstrate that God will use every gift he gives, *including yours,* creatively and for his glory.

Dorcas is found in Acts 9:36–42:

> In Joppa there was a disciple named Tabitha (which, when translated, is Dorcas), who was always doing good and helping the poor. About that time she became sick and died, and her body was washed and placed in an upstairs room. Lydda was near Joppa; so when the disciples heard that Peter was in Lydda, they sent two men to him and urged him, "Please come at once!"
>
> Peter went with them, and when he arrived he was taken upstairs to the room. All the widows stood around him, crying and showing him the robes and other clothing that Dorcas had made while she was still with them.
>
> Peter sent them all out of the room; then he got down on his knees and prayed. Turning toward the dead woman, he said, "Tabitha, get up." She opened her eyes, and seeing Peter she sat up. He took her by the hand and helped her to her feet. Then he called the believers and the widows and presented her to them alive. This became known all over Joppa, and many people believed in the Lord.

This is all we are told about our sister Dorcas. But here are some fascinating points. First, she lived in the port city of Joppa;

today it is the city of Tel Aviv. Since her name was interpreted in two languages—Greek and Aramaic—we know that this city was bilingual and bicultural.

Dorcas is the only woman in all of Scripture called a "disciple." She is the only woman raised from the dead. Was she single by choice? Was she a widow? We don't really know, but nothing is mentioned about any other close family members.

Could Dorcas have been in the core group of the "list of widows" that Paul referred to in 1 Timothy 5:9? Possibly so. The widows cried and mourned deeply her passing away. Who would be their friend now? Who would help them? Who would sew for them and, in so doing, encourage them in the Lord? Actually, she can be lifted up as one of the finest examples of a philanthropist, defining philanthropy as "voluntary actions for the public good."[4] She acted voluntarily, took action beyond just words, acted on behalf of the public within her reach, especially those ignored by society such as widows and children, and concentrated on doing the good that would bring the greatest benefit to those in need.[5]

Verse 10 of 1 Timothy 5 may be a description of our quiet friend Dorcas, seeing how the widows responded to her death: "[She] is well known for her good deeds, such as bringing up children, showing hospitality, washing the feet of the saints, helping those in trouble and devoting herself to all kinds of good deeds."

I can't imagine Dorcas saying at some point, "Well, Lord, all I can do is sew. But I don't sew nearly as well as Susanna down the road. So, I don't think I'm going to offer my services to anybody else. What good would it do? I'll just make my own clothes and that's that!"

Look how God used Dorcas and her gifting. Because of her love and service to the body of Christ, especially to a group of widows, God raised her from the dead, and many more came to know Christ. Dear sister, whatever God has given you, let him take it, enhance it, give you joy, and use it for his great glory.

I remember once being at a women's luncheon. We were seated at tables of ten. We were to go around the table and tell what we enjoyed doing in life. Out of the ten women at my table, only one said she enjoyed traveling to other cultures, living there, and eating their food. Most of the women said they were "homebodies." I think Dorcas would have identified with the homebodies. She had the gift of helping and perhaps hospitality and mercy as well. Look how God delighted in her and used her.

Among those ten women, I was the only one who said I liked to travel. And that's my connection with Priscilla, along with proclaiming (or preaching, since the word *preach* comes from the Greek word *kerysso*, meaning to "herald" or "proclaim"[6]) the Word of God. I doubt that Dorcas and Priscilla ever met. They lived far from each other at opposite ends of the Mediterranean Sea. Priscilla was definitely not a homebody. Yet she too was used mightily of God.

We read in Acts 18:1–3 about Paul's first encounter with Priscilla and her husband, Aquila. "After this Paul left Athens and went to Corinth. There he found a Jew named Aquila, a native of Pontus, who had recently come from Italy with his wife Priscilla, because Claudius had ordered all Jews to leave Rome. Paul went to see them, and, because he was of the same trade, he stayed with them, and they worked together—by trade they were tentmakers" (NRSV).

But this is not the only reference to Priscilla and her husband. They are also found in Acts 18:18–19, 24–28; and Romans 16:3–5. I hope you'll look at those passages, since each one gives us a broader picture of Priscilla.

The first text tells us that her husband was a Jew from Asia Minor. Priscilla's national origin is never mentioned, but she is thought to have been Roman and of a higher social rank than Aquila, because her name appears first in four out of the six times that they are mentioned. The other thought is that because she was more prominent in the church, both Luke and Paul acknowledged the decisive part she played in the spread of the gospel by placing her name first, not normal for that time and setting. She and her husband could have been forced out of Rome in AD 49 by the emperor Claudius, who got tired of the Jews in Rome fighting with the converted Christian Jews.[7]

Look at what Priscilla did: she traveled extensively (Rome, Corinth, Ephesus, Rome) and in each place planted a house church with her husband. These would have, normally, begun in their own house. From Acts 18 we also know that Priscilla was a teacher of God's Word, and not just to women. "Together, with her husband, she possessed sufficient biblical knowledge—and authority—to instruct an important male evangelist."[8] This instruction was given in their home because the home, in the first century, was the primary location for worship; it was the church. With Aquila she ran a business in the marketplace—that's where Paul first met them. She obviously practiced hospitality. And she was courageous. Paul wrote that Priscilla and her husband "risked their lives for me" (Romans 16:4). That passage also says that all the Gentile churches were thankful to

Priscilla and Aquila because of their participation in the advancement of the gospel.

The Apostle Paul and Women

We cannot speak of Priscilla without considering the apostle Paul in all of this. The church has labored long and hard to try to figure out what Paul actually meant when he talked about women and their involvement in the church. Many good books, as well as many confusing ones, have been written. Some of the books I consider to be among the best in guiding us to a proper understanding of this topic are *Women in the Church: A Biblical Theology of Women in Ministry* by Stanley J. Grenz with Denise Muir Kjesbo; *Paul, Women and Wives: Marriage and Women's Ministry in the Letters of Paul* by Craig S. Keener; and a more recent one, *Men and Women in the Church* by Sarah Sumner. These authors treat fairly both sides of the discussion. And we do need to remember that this is not a women's issue, but rather, the church's issue.

Of course, there are some who will probably keep laboring over the minutiae of certain words and customs and never come up with the perfect answer to all of this. In the meantime, centuries pass, and women are born and die.

What is extremely fascinating to me is that this continual battle over women does not seem to have caused any problem for God and how he has designed his daughters. The reading of church history shows us that in every century since the beginning of time, and in every land where Jehovah God has been acknowledged and the gospel has reached, women have always carried the good news of salvation, have always served God with whatever gift he has given

(whether quieter gifts or more visible gifts), and, alongside their brothers, have died for the cause of Christ. It's happening today, even as I write. Ruth Tucker says, "The vast subject encompassing women in the history of Christianity would be impossible to cover fully in a single volume. The scope of the subject is virtually limitless, considering that it covers two millenniums, has a worldwide geographical breadth, is denominationally pluralistic, and has an endless cast of characters. In numbers, women have dominated the church, and the source material relating to their ministry and status is simply overwhelming. Therefore, any effort to summarize the story must be an exercise in careful selectivity."⁹

And God is still creating baby girls, all over his world, who grow, confess Jesus as Savior, and are given spiritual gifts from the complete list of gifts, *as the Spirit wills*, even while men and women continue to say that it just isn't possible!

Paul's Problem Passages

So we have labored long over Paul's words, which even Peter found hard to understand at times (see 2 Peter 3:15–16). Briefly, there has been much discussion over three principal passages, which theologians call "problem passages." Remember that neither God nor the Bible gives these passages the title "problem." This is a human title for these passages. These are the main New Testament Scriptures that some churches have used to marginalize women in using their God-giftedness: 1 Corinthians 11; 1 Corinthians 14:33–36; and 1 Timothy 2:11–15. As I said above, I am not setting out to explain these passages. Others have already done that much better than I possibly could, and earlier in this chapter I've given three books that

can aid you greatly in understanding more fully what those chapters are about.

My point is this: There are those who begin with these problem passages in regard to women. From there, they proceed backward in the Scriptures until they reach Genesis 1–3, where they continue, based on their improper reasoning of the New Testament passages, to misinterpret God's fundamental creation of woman and her relationship with man. It is not that the *woman* is a problem; it is the *misinterpretation of these texts* that has truly caused a problem.

These passages are from what are called "occasional papers or letters." They were written to local churches by the apostle Paul on the occasion of some problem, argument, or situation that had occurred, and the leaders of these new churches did not know how to deal with it. So, in each of these passages, Paul was dealing specifically with a cultural problem that this particular local church was facing.

In 1 Corinthians 11 the problem was that this church was located in a culture in which prostitution flourished. Undoubtedly, some of these prostitutes repented, gave their lives to Christ, and came into the Corinthian church. So, Paul wrote down guidelines for how a married woman was to show that she was submissive and properly married to her husband. However, that passage begins with Paul making it clear in verse 5 that women also prayed and prophesied publicly in the meetings. And according to his words in 1 Corinthians 14:3, prophesy meant speaking to other people for "their strengthening, encouragement and comfort." He also went on to say in verse 5 that he wished that "every one of you" would prophesy—the "every one of you" meaning exactly that, women as well as men.

Designer Women

In 1 Corinthians 14 the issue was orderliness in the meetings of the church. Among the problems in this new, fledgling church, in which probably most of the women were illiterate, was that the women would publicly ask a question when they didn't understand something.

Working in another culture for many years, Bill and I were at times in churches where the men sat on one side of the room and the women with their children on the other side. Sometimes the men had the Bibles, but the women, none. Sometimes the women became bored and chatted among themselves. If a child misbehaved, sometimes the wife would call out to her husband for help. She really needed help, and he was totally engaged with what was happening at the front of the room. Basically, the women, as well as the men, needed teaching to know how to function properly in this new social setting.

Paul said that the women should ask their questions in the home, to their own husbands in order to promote orderliness in the church meeting. This injunction was given for a specific public problem at that time. Paul wasn't saying that women should not ask questions or learn or that they should not publicly participate on any level; on the contrary, he was encouraging their learning. And remember, at the beginning of 1 Corinthians 14, Paul encouraged everyone to prophesy and, in verse 26, to bring hymns or teaching in order to encourage the entire group. *Everyone* meant the women as well as the men.

In 1 Timothy 2:11–15, undoubtedly the problem being addressed stemmed from the worship of the great mother goddess, Artemis (called Diana among the Romans) in the city of Ephesus,

where "feminine supremacy in religion" reigned.[10] Within that powerful and prolific cult, there were priestesses, with prostitution also in the mix of worship inside their temple. Diana was worshiped there as the mother of gods and humans. It was here in this setting that Gnosticism, which radically compromised and changed biblical stories, developed and began to enter the church. One of these distortions revolved around the story of Eve. It was believed that she actually gave life to Adam and was the giver of true knowledge to humankind. From this, Eve became the "mediator of truth and special hidden knowledge."[11] Women were strong leaders in this ancient, demonic cult.

This is where Priscilla and Aquila were ministering. We can again imagine that Priscilla and other Christian women saw a number of these cultic women turn to Christ. Then, they would have come to the simple house church in Priscilla's home.

These new women believers were not only used to participating, but also used to leading. Paul gave an injunction as he would to a new male believer, a positive injunction. He told them in verse 11 to be quiet and submissive and to learn. That was the posture that both males and females would have been expected to take in the presence of a rabbi or a teacher. They were also told that they were not to "have authority over a man." Certainly, they had been accustomed to doing that in their cult of priestesses and prostitutes. But because they were new creations in Christ and were to be clothed in humility and Christ's love, they were to serve one another—as also were the men.

I hope you will refer to the books I have listed above as well as in the Notes section to understand better the other issues involved in Paul's statements within these difficult passages.

So, we have quickly looked at some of the words Paul said regarding women. These words have often been misconstrued in a way I don't believe Paul or God ever intended, considering the varied and unique examples of women throughout the Scriptures that we have already talked about and, more importantly, God's original design of woman in Genesis.

But I don't think we've considered adequately Paul's actions in regard to women. Remember the saying "Actions speak louder than words"? That can also apply in the case of the apostle Paul. His actions show us his practice. Let's close this section on Paul by considering his actions. Paul, following the example of his primary leader, Jesus Christ, modeled and encouraged partnerships with both women and men in his ministry.

Paul's Persecutions of the Church

Paul, as Saul the persecutor of Christians, dragged women as well as men off to prison and possibly to death. He saw their zealousness for the Lord Jesus Christ and considered them dangerous. He knew their strength and commitment to the Savior.

Paul's Teams

Paul had women on his gospel teams. We've already seen his side-by-side working with Priscilla and Aquila. But there were others as well. He spoke very highly of Euodia and Syntyche in Philippians 4:2–3. They were of such value on his team that he pleaded with

another leader to please persuade them to get along together. He testified that these two leading women "struggled beside me in the work of the gospel" (NRSV).

The word *struggle* mirrors the Greek word used here, which means to contend as an athlete straining every muscle to achieve victory in the games.[12] These two women had contended for the gospel alongside the apostle Paul in such a way that they had gained a position of influence that made their personal conflict a risk to the well-being of the church, especially the church at Philippi. Also, the term *in the gospel*, "may suggest an official ministry, including an active role in preaching the gospel."[13]

When we consider that women are also gifted to lead, which could mean that a woman might become the senior pastor of a church, there are two questions that may come to our mind. The first is: How can a woman be a senior pastor since that would make her the authority over men? I would like to say first that in my experience of working with scores of churches around the world, I have never known a senior pastor (male or female) who was put into office just by women. Any female pastor I have known has been affirmed or voted into that office by both males and females. So men, as well as women, always have a voice in that choice. Second, he or she as senior pastor is *never* the ultimate authority. In all the churches with which I am acquainted, there is always the authority of a board or council over that pastor, to whom he or she must give account. So when a woman is gifted in areas to lead and approved by a congregation, she remains *under authority* to others. When she teaches and/or preaches, she is *under authority* to that group. I see that as being the way Christ intended his body to function as a healthy body.

The second question that may come to mind is: What is Christ's view of leadership? I don't know about you, but I often forget about our Leader's view of leadership. Not long ago I was conversing with one of my life mentors, Dr. Michael Holmes, professor of biblical studies at Bethel University and Seminary in St. Paul, Minnesota. He reminded me that Jesus Christ declared the purpose of Christian leadership very clearly in Mark 10:42–45, as he responded to the request of the brothers James and John. Dr. Holmes stated that many times we see this passage only in reference to eschatology (future events), but it should certainly be applied to ecclesiology (church issues) as well. Jesus called them (the disciples) together and said, "You know that those who are regarded as rulers of the Gentiles lord it over them, and their high officials exercise authority over them. Not so with you. Instead, whoever wants to become great among you must be your servant, and whoever wants to be first must be slave of all. For even the Son of Man did not come to be served, but to serve, and to give his life as a ransom for many."

Jesus contrasted worldly leadership with Christlike leadership. Worldly leaders "lord it over" those they lead. Christ's people are to *be a servant* among those they lead. Worldly leaders "exercise authority over them." Christ's people are to *be a slave to all*. Leadership, according to Christ, is not defined by authority but by being a servant.

We have all seen too many Christian pastors and leaders fail and fall as leaders precisely because they thought that *they* were the authority. They didn't listen to anyone else; for some reason they didn't feel they needed to be accountable to anyone. In other words, they were not *under authority* to anyone. They chose power, prestige,

and prominence over being a *servant* and a *slave to all*. This applies to both men and women.

Jesus defined leadership with his own example for both men and women: "For even the Son of Man did not come to be served, but *to serve*, and *to give his life* as a ransom for many" (emphasis added). That is real leadership, according to Jesus, and it is not gender based.

Paul's Affirmations

Paul trusted women with God's work and affirmed their leadership. If we look carefully at the person of Phoebe in Romans 16:1–2, we find that Paul called her a *minister* (*diakonos*) in the Cenchreaen church, not just a servant or deacon, as some have translated it. The word Paul used for her, he also used for himself (1 Corinthians 3:5; 2 Corinthians 3:6) as well as for his male collaborators, such as Timothy (1 Thessalonians 3:2) and Epaphras (Colossians 1:7). Paul applied it most often to ministers of the Word.[14]

Paul wrote this letter to the Roman Christians. It is his most theological and profound book. He was commending to them this wonderfully gifted leader, Phoebe, explaining who she was. Not only was she a minister of the Word, but she had also been a benefactor (contributed large sums of money) for those in need within the church, as well as helped Paul himself. He wanted the Roman believers to attend well to her, meeting any need she had. She was undoubtedly the one who actually carried, by ship, this letter of Romans to the Roman Christians, and Paul wanted them to know, beyond a shadow of a doubt, that she was qualified to explain his writings.[15]

Paul's Writings

Paul exalted and valued women throughout his writings. In Romans 16 the apostle Paul sent personal greetings to many people he had worked with. One-third of the many names he mentioned are women. In verse 7 Paul mentioned Junia (not Junias as some have translated the name), whom he included with the apostles, stating that she and Andronicus (possibly a married couple, relatives of Paul, and who were in prison with him) were "outstanding"—or prominent—"among the apostles."

"In the second century, Origen assumed that Paul's friend was a woman. The fourth-century church father John Chrysostom, who was no supporter of women bishops, expressed high regard for Junia: 'Oh how great is the devotion of this woman, that she should be even counted worthy of the appellation of apostle.'"[16]

To read a decisive, well-researched documentation of this woman leader, lost to us for many centuries, pick up *Junia, The First Woman Apostle* by Eldon Jay Epp, written in 2005 and published by Fortress Press.

Paul also affirmed women as equal partners within the marriage structure. In the first-century Roman culture, society adhered to a "household code."[17] This code was hierarchical in the sense that the men ruled while women, children, and slaves submitted. However, we find that Paul was careful in 1 Corinthians 7:3–5 (the only New Testament passage that speaks of the authority one spouse has over the other) "to state symmetrically that the exercise of authority is always reciprocal in the marital relationship. Both husband and wife have the same rights over each other."[18] Paul also spoke of mutual decision making (1 Corinthians 7:5), that is, decisions are not to

be imposed by one or the other but should be "based on consensual partnership."[19]

In 1 Corinthians 11, we find a set of hierarchical relationships in verse 3 and verses 7–10: Christ as the head of man, man as the head of woman, and God as the head of Christ. However, in this same passage, we find "both Paul's affirmation of the privilege of both men and women equally to pray and prophesy in the congregation as the Holy Spirit leads (vv. 4–5; cf. 12:11) and his emphasis that while man may be the head of woman, nevertheless *in the Lord* neither is independent of the other (vv. 11–12)—and that ultimately all things come from God (v. 12)."[20]

Dr. Holmes also stated that while Paul pointed to ordered relationships, at the same time, he stressed the Spirit's "egalitarian leading and gifting of men and women alike to pray and prophesy in the congregation. What for us is a matter of contention and debate—either complementarian *or* egalitarian—was for Paul in 1 Corinthians a matter of both-and."[21]

In the Ephesians 5 passage Paul, in verse 21, stressed mutual submission among all believers, men and women. That is the basis, then, for the rest of the chapter. In 5:22–6:9, Paul explained how this submission one to the other works within marriage and the home. Remember that the "head" (husband) and "body" (wife) described here is a metaphor. Paul was using a picture to try to help us understand what he called a "profound mystery" (v. 32) and stated that he was talking about "Christ and the church." This image of head and body is meant to especially emphasize that the couple should see themselves as one and work together purposefully toward a common goal.[22]

What comes to mind when we think of someone being the head of something? Culturally (and it was so as well in the first century), we may think of a boss, the president, *the* leader, a CEO, someone with power and authority. But Paul defined it differently. He said that the man, as the head, is to love and to give himself up for his wife, caring and providing for her, even as Christ has done for the church. The husband's love is to be the same as Christ's example of self-sacrifice and humility (which also point to submission). The passage does not speak of a husband exercising power or authority over his wife.[23] This goes along with what we said above about Christ's definition of "gospel headship" in Mark 10:35–45. "All those *cultural* images that involve the exercise of authority get tossed out by Jesus in this Scripture."[24] In essence, Paul said that the husband is to put his wife first.

Depicted as the body, the wife's submission to her husband is to have the same quality as her submission to the Lord. She is to submit and respect (vv. 22, 33). The significance of that word *submit* (*hypotasso*, a continuous activity in the present tense, also in the middle voice) indicates that it is something she chooses and does for herself. Her will is not lost in this submission; she chooses, without force or coercion, rather out of love. In essence, Paul said that the wife is to put her husband first.

What wives are instructed to do in Ephesians 5:22 (submit), *all* Christians are instructed to do in 5:21. And what husbands are especially instructed to do in 5:25 (to love as Christ loved and gave himself), *all* Christians are instructed to do in Ephesians 5:2—they are to "live a life of love, just as Christ loved us and gave himself up for us."[25]

What is so important for us to remember is that whether we are single or married, our identity is grounded in who we are in Jesus Christ, not in our spouse or anything or anyone else. Our first allegiance is to Christ, and we can see from the above paragraph that all our relationships should flow out of our discipleship to Christ. In marriage we are two people, two disciples, "seeking to grow together into our mutual head—Jesus Christ! Two people seeking to live out together the great commandment: to love God with all one's heart, mind, soul, and strength, and to love one's neighbor as oneself."[26]

Obviously, the apostle Paul affirmed Christian women in every sphere of life and their God-given gifts. There is no doubt about it. If we have doubts, let's keep looking at the culture within which Paul wrote and what Paul actually did—what he practiced. That will help clarify the confusion.

Six Traits to Develop

We close this book with the two women, Priscilla and Dorcas, who are excellent models for us—different in temperament and gifting, and yet there are at least six traits they both embodied and for which they were used greatly by the Lord. These six traits build the acronym DESIGN. These traits will be true of you as well, as you develop what God has given you:

Drawing Others to God

When you dedicate to God what he has entrusted to you, he will use you and that gift so that others will want to know him. The gift is given, not to lift us into the limelight, but to exalt him. Give what you love to Christ. He will use it in amazing ways.

Eager to Share It

I believe that Dorcas loved what she did for those other women. I also believe that Priscilla loved teaching Apollos, as well as opening her home so that others could worship God. If you love doing something, you will be eager to share it with others—to bless them. If what you are doing drains you, bores you, and becomes total monotony without meaning, then you will not be eager to keep on or share it with anyone.

Serious in Its Development

No matter how much Dorcas loved to sew, we can imagine that there were times when she said, "Oh, dear! I don't think I can stand to sew on one more button!" No matter how much Priscilla felt called to open her home to others, I'm sure there were times when she groaned to Aquila, "You know what, dear, I've about had it with so many people in our house every Wednesday night, Sunday afternoon—plus those who drop by for unexpected meals!"

No matter what gift combined with calling that God has given you, it will take some stretching, sacrifice, and just plain hard work on your part to develop it and use it well. Are you willing? I know there are those of you reading these lines who are called to writing, pastoring, preaching, leading, helping, counseling, praying, interceding, communicating, administrating, painting, teaching—and the list could go on. Are you willing to develop that gift so it can be used to its fullest for the kingdom of God? It will take discipline. But *God will give you everything you need to fulfill what he has called you to do.* Are you willing?

In Step with God's Timing

I wonder if Priscilla ever cried, "Why is it time to leave Corinth, Lord? We just got settled here. I like our little house. The business is finally going well." I wonder if Dorcas said as she lay dying, "Jesus, the timing seems so off. Three new women knocked on my door today. Who will care for them?"

Bill and I have lived in six different countries of the world and traveled extensively. There have been times when I've definitely not understood the *whys* of our moves. I've fussed and fumed and worried myself almost sick. God does not make mistakes. His timing is always perfect. In a new place, God has always developed new gifts in me or developed previous ones to a depth I could never have imagined. Keep in step with God's timing. His timing is ultimately the best.

God Blessing Others

Think about the reaction to Dorcas's death. Think about Paul's tribute to Priscilla. These women gave their all; they let themselves be "used up" in the building up of Christ's church. They blessed scores and scores of people. That's what God wants to do with you, my friend. It may be a small group you'll bless; it may be one particular individual. It may be a large group where God will use you mightily. The size is of no importance. What is important is that you give yourself and the gifts given you back to your Creator. Believe me, others will be blessed! There's no doubt about it. Some reports from a few may trickle in to you down here; many more will radiate their gratitude in eternity!

Nothing Else as Satisfying

Believe me, nothing else in the world will make you as happy as living out who God has made you to be. You will be tireless at times. Others won't understand your stamina and joy. They'll marvel. But you will know that it is God at work in you, and you will be filled up to overflowing with joy, doing what you were created to do!

Whatever your gifts, dear sister, treasure them, work on them, then give them away for the blessing—as bread broken for the multitude—of many.

Let Jesus shine in you.

Walk in the freedom he has won for you.

Stand tall as a pillar in his kingdom.

Own your God-given, unique design for the sake of the gospel!

leaning in . . .

May we lean in toward
each other,
listening, learning,
in holiness
and grace.
May we lean in toward
each other.
Together,
run the race.

The Trinity leans inward
Holy Spirit, Father, Son.
Yes, distinctive works—
yet One.
Through Trinity,
salvation given.
Through Trinity,
salvation won.

May we lean in toward
each other,
accept the gifts,
acknowledge Spirit
in each woman,
in each man,

as we lean in toward
each other,
bringing *hope*
to
every land.

— Ruth Tuttle Conard

ABOUT THE AUTHOR

Ruth Tuttle Conard, pastoral director of Designed to be Pillars, an inspirational women's ministry, loves God and women. And she loves bringing them together!

She is a missionary, ordained minister, speaker, writer, and mentor of many across the world. Ruth's mentoring is referenced in Ruth Haley Barton's book *Becoming a Woman of Strength*, pages 240–243. On several continents and in over seventeen countries, women have been inspired through Ruth's conferences, seminars, and semi-silent retreats.

During the Billy Graham Amsterdam 2000 international conference, Ruth was chaplain to five hundred women stewards representing twenty-five countries, living with them. She also served for a time as adjunct professor of Bible and theology at Bethel University

in St. Paul, Minnesota. Ruth served on two church pastoral staffs for several years in that same geographical area.

In addition to writing *Designer Women: Made by God*, Ruth is the author of *Devotions for New Moms* (Shaw).

Ruth enjoys hiking, jogging, playing the piano, and reading. She and her husband, Bill, reside in South Carolina, spending as much time as possible with each other and with their three grown children and families.

Ruth is available for conferences, seminars, and retreats. She may be contacted at designedtobepillars@yahoo.com. Visit Ruth's website at www.designedtobepillars.org.

NOTES

Part I: God Values Women in the Old Testament

Introduction

1. Sue Richards and Larry Richards, *Every Woman in the Bible* (Nashville: Thomas Nelson, 1999), 60.
2. Ibid., pp. 60–63.
3. Bernard L. Ramm, *God's Way Out: Finding the Road to Personal Freedom through Exodus* (Ventura: Regal, 1987).
4. Richards, *Every Woman*, pp. 26–27.

Chapter 1: Designed to Be Loved: Eve

1. William Dyrness, *Themes in Old Testament Theology* (Downers Grove: InterVarsity Press, 1977), 46.
2. Leland Ryken, James C. Wilhoit, and Tremper Longman III, eds., *Dictionary of Biblical Imagery* (Downers Grove: InterVarsity Press, 1998), 339.
3. Sue Richards and Larry Richards, *Every Woman in the Bible*

(Nashville: Thomas Nelson, 1999), 11.

4. J. D. Douglas and Merrill C. Tenney, *The New International Dictionary of the Bible* (Grand Rapids: Zondervan, 1987), 15.

5. Stanley J. Grenz and Denise Muir Kjesbo, *Women in the Church: A Biblical Theology of Women in Ministry* (Downers Grove: InterVarsity Press, 1995), 164.

6. Richards, *Every Woman*, p. 4.

7. Larry Richards, *Expository Dictionary of Bible Words* (Grand Rapids: Zondervan, 1985), 433.

8. David Freedman, "Woman, a Power Equal to Man," *Biblical Archaeology Review* 9, no. 1 (January–February, 1983): 58.

9. Grenz, *Women in the Church*, p. 170.

Chapter 2: Designed to Speak Up: Zelophehad's Daughters

1. Lorry Lutz, *Women as Risk-Takers for God: Finding Your Role in the Neighborhood, Church, and World* (Grand Rapids: Baker Books, 1997), 5–6.

2. Debra Evans, *Women of Courage: Inspiring Stories of Faith, Hope, and Endurance* (Grand Rapids: Zondervan, 1999), 128.

3. Ibid., p. 131.

4. Bernard L. Ramm, *God's Way Out: Finding the Road to Personal Freedom through Exodus* (Ventura: Regal, 1987).

Chapter 3: Designed to Be Different: Zipporah

1. Sue Richards and Larry Richards, *Every Woman in the Bible* (Nashville: Thomas Nelson, 1999), 73.

2. *Zondervan Handbook to the Bible* (Grand Rapids: Zondervan, 1999), 135.

3. D. Guthrie, A. Stibbs, and D. Wiseman, *The New Bible Commentary: Revised* (London: InterVarsity Press, 1970), 124.

4. *Life Application Study Bible: New Living Translation* (Wheaton: Tyndale, 1996), 101 and 216 notes.

5. *International Standard Bible Encyclopedia IV* (Grand Rapids: Eerdmans, 1988), 1201.

6. Hoffmeier, James K., ed., *New Commentary on the Whole Bible, Old Testament Volume* (Wheaton: Tyndale, 1990), 176.

Chapter 4: Designed to Wait: Hagar

1. *Webster's Ninth New Collegiate Dictionary* (Springfield: Merriam-Webster Inc., 1991), 670.

2. Ibid., p. 298.

3. *The Jewish Encyclopedia*, vol. VI (New York: Funk & Wagnalls, 1902), 138.

4. Louis Bahjat Hamada, *Understanding the Arab World* (Nashville: Thomas Nelson, 1990), 75.

5. *Jewish Encyclopedia*, p. 138.

6. Hamada, *Arab World*, pp. 73–74.

7. John F. Walvoord and Roy B. Zuck, eds., *The Bible Knowledge Commentary* (Wheaton: SP Publications, Inc., 1985), 56.

8. Ibid., p. 57.

9. Ibid., p. 57.

10. Joann Nesser, *Contemplative Prayer: Praying When the Well Runs Dry* (Minneapolis: Augsburg Books, 2007), 24.

Chapter 5: Designed to Take Charge: Ruth

1. Ruth A. Tucker, *From Jerusalem to Irian Jaya: A Biographical History of Christian Missions* (Grand Rapids: Zondervan, 1983),

239–242.

2. Fred R. Shapiro, ed., *The Yale Book of Quotations* (New Haven: Yale University Press, 2006), 418; Helen Keller from *Let Us Have Faith* (1940).

3. Sue Richards and Larry Richards, *Every Woman in the Bible* (Nashville: Thomas Nelson, 1999), 104.

4. John F. Walvoord and Roy B. Zuck, eds., *The Bible Knowledge Commentary* (Wheaton: SP Publications, Inc., 1985), 56.

5. J. D. Douglas, James K. Hoffmeier, eds., *Old Testament Volume—New Commentary on the Whole Bible* (Wheaton: Tyndale, 1990), 331.

Part II: God Values Women in the New Testament

Introduction

1. Craig A. Evans and Stanley E. Porter, eds., *Dictionary of New Testament Background* (Downers Grove: InterVarsity Press, 2000), 610.

2. Jacob Neusner, *The Mishnah: A New Translation* (New Haven: Yale University Press, 1998), 893.

3. Ibid.

4. Ibid., pp. 179–208.

5. Craig S. Keener, *Paul, Women and Wives: Marriage and Women's Ministry in the Letters of Paul* (Peabody: Hendrickson Publishers, 1992), 165.

6. Ibid., p. 165.

7. Philo of Alexandria, *Volume X: Embassy to Gaius* (London: Harvard University Press, 1962), 161, line 319.

8. Wayne A. Meeks, *The Harper Collins Study Bible, NRSV* (New

York: HarperCollins, 1993), 1563.

9. Joel B. Green, Scott McKnight, and I. Howard Marshall, eds., *Dictionary of Jesus and the Gospels* (Downers Grove: InterVarsity Press, 1992), 782.

10. Ibid., pp. 881–884.

11. Pamela Hiscock, "A Woman's Call to Evangelism," *The Mission of an Evangelist: Amsterdam 2000, A Conference of Preaching Evangelists* (Minneapolis: World Wide Publications, 2001), 363–364.

Chapter 6: Designed to Worship: The Crippled Woman

1. J. D. Douglas and Merrill C. Tenney, *The New International Dictionary of the Bible* (Grand Rapids: Zondervan, 1987), 972–973.

2. Craig S. Keener, *Paul, Women and Wives: Marriage and Women's Ministry in the Letters of Paul* (Peabody: Hendrickson Publishers, 1992), 162.

Chapter 7: Designed to Be Quiet: Anna

1. J. D. Douglas and Merrill C. Tenney, *The New International Dictionary of the Bible* (Grand Rapids: Zondervan, 1987), 434.

2. Ibid., p. 995.

3. Ibid., p. 996.

4. Ibid.

5. Ibid., p. 997.

6. Catherine Clark Kroeger and Mary J. Evans, eds., *The IVP Women's Bible Commentary* (Downers Grove: InterVarsity Press, 2002), 60.

7. Ibid., p. 567.

8. Debra Evans, *Women of Courage: Inspiring Stories of Faith, Hope, and Endurance* (Grand Rapids: Zondervan, 1999), 82.

9. Eugenia Price, *The Unique World of Women*, as quoted in Gien Karssen, *Her Name Is Woman*, bk. 1 (Colorado Springs: NavPress, 1975), 149.

10. M. Robert Mulholland Jr., *Invitation to a Journey: A Road Map for Spiritual Formation* (Downers Grove: InterVarsity Press, 1993), 132.

11. Ibid., p. 133.

12. Ibid.

13. Jay Dennis, *The Jesus Habits: Exercising the Spiritual Disciplines of Jesus* (Nashville: Broadman and Holman Publishers, 2005), 5.

14. Ibid., p. 7.

Chapter 8: Designed to Embrace: Elizabeth

1. Stanley J. Grenz and Denise Muir Kjesbo, *Women in the Church: A Biblical Theology of Women in Ministry* (Donwers Grove: InterVarsity Press, 1995), 84–85.

2. Ruth A. Tucker, *From Jerusalem to Irian Jaya: A Biographical History of Christian Missions* (Grand Rapids: Zondervan, 1983), 234–235.

3. Ibid., p. 236.

4. Ibid., p. 239.

Chapter 9: Designed to Persevere: Mary

1. Tertullian, "On the Dress of Women," trans. S. Thelwall, *Ante-Nicene Fathers*, ed. Alexander Roberts, 10 vols. (Peabody: Hendrickson Publishers, 1994), 4:14.

2. Sarah Sumner, *Men and Women in the Church* (Downers Grove: InterVarsity Press, 2003), 40–42.

3. J. D. Douglas and Merrill C. Tenney, *The New International Dictionary of the Bible* (Grand Rapids: Zondervan, 1987), 628–629.

4. John Calvin as quoted by Reuben P. Job and Norman Shawchuck in *A Guide to Prayer for All God's People* (Nashville: Upper Room Books, 1990), 54.

5. *Life Application Study Bible: New Living Translation* (Wheaton: Tyndale, 1996), 1522.

Chapter 10: Designed to Serve: Dorcas and Priscilla

1. Stanley J. Grenz and Denise Muir Kjesbo, *Women in the Church: A Biblical Theology of Women in Ministry* (Downers Grove: InterVarsity Press, 1995), 78.

2. Jane A. G. Kise, David Stark, and Sandra Krebs Hirsh, *LifeKeys—Discovering Who You Are, Why You're Here, What You Do Best* (Minneapolis: Bethany House, 1996), 33.

3. Gordon D. Fee, *The New International Commentary on the New Testament: The First Epistle to the Corinthians* (Grand Rapids: Eerdmans, 1987), 583, note 3 on 12:6; see also 52, note 22 on 1:10.

4. Catherine Clark Kroeger and Mary J. Evans, *The IVP Women's Bible Commentary* (Downers Grove: InterVarsity Press, 2002), 695.

5. Ibid.

6. J. D. Douglas, *The New Bible Dictionary* (Grand Rapids: Eerdmans, 1973), 1023.

7. Grenz, *Women in the Church*, pp. 82–83.

8. Ibid.

9. Ruth A. Tucker and Walter Liefeld, *Daughters of the Church: Women and Ministry from New Testament Times to the Present* (Grand Rapids: Zondervan, 1987), 16.

10. Ruth Haley Barton, *Equal to the Task: Men and Women in Partnership* (Downers Grove: InterVarsity Press, 1998), 40.

11. Ibid., p. 41.

12. Grenz, *Women in the Church*, p. 84.

13. Ibid., p. 85.

14. Craig S. Keener, *Paul, Women and Wives: Marriage and Women's Ministry in the Letters of Paul* (Peabody: Hendrickson Publishers, 1992), 238–239.

15. Ibid.

16. Ibid., pp. 92–96.

17. Ibid., pp. 146–147.

18. Kroeger, *Bible Commentary*, p. 703.

19. Ibid.

20. Michael Holmes, Lecture: "What Does Discipleship Have to Do with Marriage?" (Bethel University Chapel, St. Paul, MN, April 19, 2006), 1.

21. Ibid., p. 2.

22. Keener, *Women and Wives*, p. 168.

23. Kroeger, *Bible Commentary*, p. 703.

24. Holmes lecture, p. 3.

25. Ibid., p. 4.

26. Ibid., p. 5.